Launching the Imagination

Three-Dimensional Design

Launching the Imagination

Three-Dimensional Design

first edition

Mary Stewart

McGraw-Hill Higher Education

A Division of The **McGraw-Hill** *Companies*

LAUNCHING THE IMAGINATION, VOLUME 2: THREE-DIMENSIONAL DESIGN
Published by McGraw-Hill, an imprint of The McGraw-Hill Companies, Inc. 1221 Avenue of the Americas, New York, NY, 10020.
Copyright © 2002 by The McGraw-Hill Companies, Inc. All rights reserved. No part of this publication may be reproduced or distributed in any form or by any means, or stored in a database or retrieval system, without the prior written consent of The McGraw-Hill Companies, Inc., including, but not limited to, in any network or other electronic storage or transmission, or broadcast for distance learning. Some ancillaries, including electronic and print components, may not be available to customers outside the United States.

This book is printed on acid-free paper.

1 2 3 4 5 6 7 8 9 0 KPH/KPH 0 9 8 7 6 5 4 3 2 1

ISBN 0-07-248284-2

Editorial director: *Phillip A. Butcher*
Sponsoring editor: *Joe Hanson*
Developmental editor: *Cynthia Ward*
Senior marketing manager: *David Patterson*
Lead project manager: *Mary Conzachi*
Production supervisor: *Susanne Riedell*
Senior designer: *Pam Verros*
Media producer: *Shannon Rider*
Lead supplement producer: *Cathy L. Tepper*
Photo research coordinator: *Ira C. Roberts*
Photo researchers: *Elsa Peterson Ltd.and Photosearch, Inc.*
Cover design: *Jenny El-Shamy*
Interior design: *Pam Verros*
Typeface: *10.5/14 Palatino*
Compositor: *GTS Graphics, Inc.*
Printer: *Quebecor World Hawkins Inc.*

Library of Congress Control Number: 2001097904

www.mhhe.com

Mary Stewart is currently an Associate Professor and the Foundation Coordinator in the Northern Illinois University School of Art. She also serves as the Regional Coordinator Advisor for Foundations in Art: Theory and Education, a professional organization devoted to excellence in college-level teaching. A long-time member of the Syracuse University Foundation Program, she has taught Two-Dimensional Design, Three-Dimensional Design, and Drawing for over twenty-five years. As an artist, Stewart uses the dialogs of Plato as a beginning point for visual narratives using drawing, visual books, and computer graphics.

The Design Continuum

My fascination with design dates back to 1980, the year I taught my first two-dimensional design course. As a graduate student at Indiana University, I had been teaching drawing since 1977. The transformation of perceptual reality into effective illusion was the main concern in basic drawing, and I knew many ways to accomplish this goal. It was far more difficult to determine either the form or the content for a course in design. In researching the subject, I discovered a dizzying array of skills to master and concepts to explore.

Auditing the courses of two master teachers raised even more questions. The first, taught by Professor William Itter, was derived from the approach developed by his teacher, Joseph Albers. Professor Itter's course was methodical, systematic, and highly analytical. The second course, taught by Professor David Hornung, offered a thorough investigation of unity and variety through an exploration of patterns in art and life. His approach was exuberant, synthetic, and often irreverent. Despite significant differences in their assignments, both teachers presented substantial design information effectively.

In developing my own course, I concluded that a comprehensive approach to design required exuberance as well as analysis and that rambunctiousness was the natural partner to rigor. Design is equally a noun and a verb. It offers a problem-solving process as well as a well-crafted product. Because the ideas and approaches to design are ever-changing, the educational possibilities are infinite. Thus, when McGraw-Hill invited me to write a new design book, I was determined to present substantial information in the liveliest possible way.

A Flexible Framework

Launching the Imagination: Three-Dimensional Design offers a clear, concise, and comprehensive overview of the elements, principles, and problem-solving processes of three-dimensional design. The book covers all of the topics common to foundations courses and found in other textbooks; however, I have attempted to refine, distill, and update the presentation of this core material. Additionally, *Launching* includes sections devoted to Plane, Volume, and Mass, often missing from other books currently available. Over two hundred and fifty images from a wide variety of

sources illustrate these points in a clear and engaging manner. A special effort has been made to include the broadest possible range of images, including examples from industrial design, ceramics, and metalsmithing, as well as traditional fine arts. *Launching the Imagination* showcases contemporary art, so that first-year students (many of whom are concurrently studying art history) have a fuller view of the art world they will be entering. The stylistic range is broad and the examples are drawn from many cultures.

This textbook also includes many unique features:

- *Launching the Imagination* is the only foundations text that includes an extensive discussion of concept development and creativity, including specific critical thinking and problem-solving strategies, time-management techniques, and a thorough discussion of critiques.

- Each chapter ends with a point-by-point summary, a list of key words, a brief list of recommended readings, and at least five key questions. These questions are designed to help students analyze their studio works in progress, rather than solely relying on a final critique for input.

- Profiles are special two-page spreads, found in every chapter, which highlight interviews with living artists and designers. Through these interviews, students learn about the working processes, career choices, obstacles overcome, and criteria for excellence of a remarkable group of masters in the field. These interviews help students see connections between basic design and professional practice while providing an introduction to potential careers.

A glossary, extensive bibliography, and comprehensive index provide further information and help readers access sections of the book of particular interest.

Launching the Imagination: Three-Dimensional Design is composed of the central six chapters from a larger book entitled *Launching the Imagination: A Comprehensive Guide to Basic Design*. The comprehensive text includes an additional three chapters on two-dimensional design and three chapters on four-dimensional design. A third book, *Launching the Imagination: Two-Dimensional Design*, provides a concise introduction to two-dimensional design. With three options available, teachers and students can use the book best suited to their curricular needs.

A Pedagogical Support System

In addition to the integrated pedagogy highlighted above, each copy of *Launching the Imagination* is packaged with Launching the Imagination's *Core Concepts in Art* CD-ROM, which features over 70 interactive exercises illustrating such fundamental elements as line, shape, and color; narrated video segments on a wide range of media; study resources correlated to each chapter; a research and Internet guide; and a study skills section offering practical advice on succeeding at college.

Instead of providing extensive exercises in the text, *Launching the Imagination* is accompanied by an extensive Instructor's Manual. Advice on course construction, critique skills, and technical resources is included, along with over fifty terrific assignments.

Finally, *Launching the Imagination* is supported by a dynamic Website featuring additional studio exercises, Web-based resources for students and teachers, and interactive problems for further study.

Acknowledgments

It has been quite a job and I've received a lot of help from my colleagues. At Northern Illinois University, School of Art Chair Adrian Tió has been relentlessly optimistic and highly supportive. From Syracuse University, I would like to thank Paul Nielsen and Sarah McCoubrey, who chaired the Art Foundation Department during this project, and were consistently helpful. Peter Forbes, Jude Lewis, Stephen Carlson, and Stan Rickel offered their encouragement and lots of help, and librarians Randall Bond and Terence Keenan provided prompt, gracious, and insightful advice on my many research questions. Mat Kelly, Ben Marra, and Akiyo Okura acted as my assistants at various points—each contributed ideas as well as energy to the book. I would particularly like to thank Jason Chin for commenting at length on many chapters, and Trisha Tripp and Cally Iden, whose critiques appear in chapter six.

Colorado College, where I worked as a scholar-in-residence in January 2000, also provided valuable support. I would especially like to thank Kate Leonard, who arranged my visit, librarian Leroy Smith, who created a storyboard Website for my students, and Carl Reed, whose advice substantially improved the three-dimensional design section of this book.

I would also like to thank the following artists and designers who contributed so generously to the Profiles which accompany each chapter:

Nancy Callahan	*Artist*
Bob Dacey	*Illustrator*
Diane Gallo	*Writer*
Heidi Lasher-Oakes	*Sculptor*
David MacDonald	*Ceramicist*
Rodger Mack	*Sculptor*
Rick Paul	*Sculptor*

I am also grateful for the advice of the following reviewers, who responded thoughtfully to the project in various stages of development. Their opinions, suggestions, criticisms, and encouragement helped shape the book:

Jeff Boshart	*Eastern Illinois University*
Brian Cantley	*California State University, Fullerton*
Michael Croft	*University of Arizona*
David Fobes	*San Diego State University*
Imi Hwangbo	*University of Louisville*
Michelle Illuminato	*Bowling Green State University*
Karen Mahaffy	*University of Texas at San Antonio*
Helen Maria Nugent	*Art Institute of Chicago*
Rick Paul	*Purdue* University
Paul Wittenbraker	*Grand Valley State University*
William Zack	*Ball State University*

Finally, the McGraw-Hill team has been knowledgeable, supportive, and unfailingly enthusiastic. Sponsoring Editor Joe Hanson was wonderfully encouraging, and strongly committed to the design of this book as well as its content. Development Editor Cynthia Ward, Editorial Director Phil Butcher, Designers Keith McPherson and Pam Verros, Production Manager Mary Conzachi, and Marketing Manager David Patterson were highly accessible and

preface

wonderfully supportive throughout. Christine Baker, Editorial Project Manager for GTS Publishing Services, offered clear production guidelines and kept the whole project on track. And, Picture Researchers Elsa Peterson and Judy Brody of Elsa Peterson Ltd. did a great job with my many requests and obscure sources: without their detective work, I could never have included such a wide range of images in this book.

concepts and critical thinking

part two

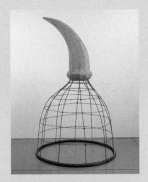

three-dimensional design

part three

Introduction
Beginner's Mind, Open Mind

You are ready to embark on a marvelous journey. New technologies and exhibition venues offer dazzling new ways to produce, perform, and publicize visual ideas. Contemporary sculpture has expanded to include performance art and installations (i.1), and metalsmiths now use everything from plastics to precious metals to create inventive small-scale sculptures (i.2). Graphic designers develop many forms of visual communication, from shopping bags and exhibitions (i.3) to Websites, logos, and brochures. Film and video, the most popular forms of public storytelling worldwide, are becoming increasingly integrated with the Internet, which promises to extend visual communication even further (i.4). And, as a result of the extensive experimentation

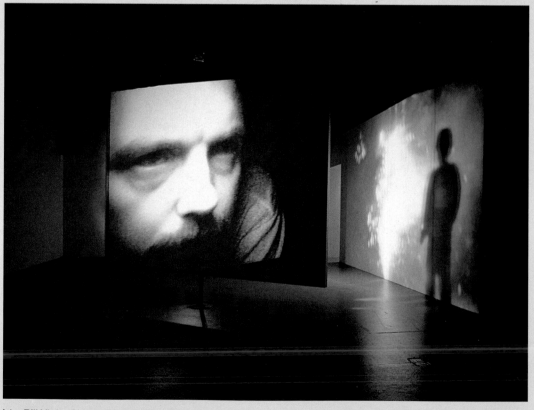

i.1 Bill Viola, *Slowly Turning Narrative*, 1992. Bill Viola's *Slowly Turning Narrative* consists of a large, rotating screen onto which moving images are projected. One side of the screen is a mirror, which reflects distorted images back into the room.

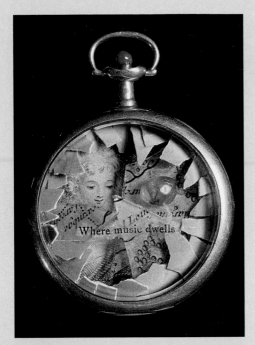

i.2 Keith E. LoBue, *Where the Music Dwells*, 1993. A broken pocket watch can become an evocative artwork when images and words are added.

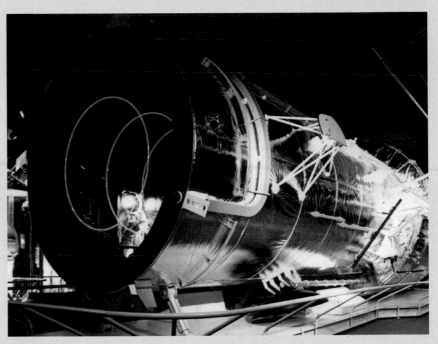

i.3 Bill Cannan & Co., NASA's Participating Exhibit at the 1989 Paris Air Show. To suggest the mystery of space travel and highlight individual displays, this NASA exhibition used dramatic pools of light within a mysterious dark setting.

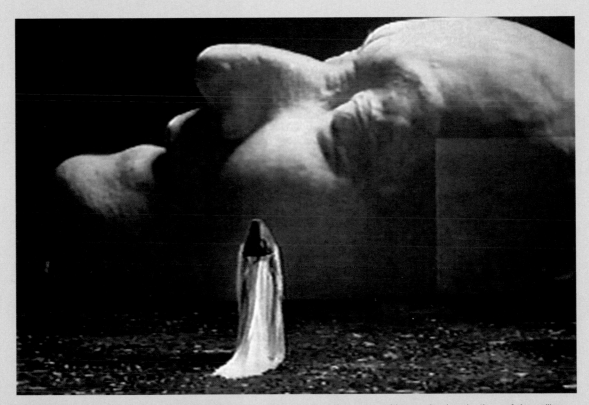

i.4 Hans-Jürgen Syberberg, *Parsifal*, 1982. Syberberg combined live actors with oversized projections of dreamlike landscapes in his filmic interpretation of Richard Wagner's opera.

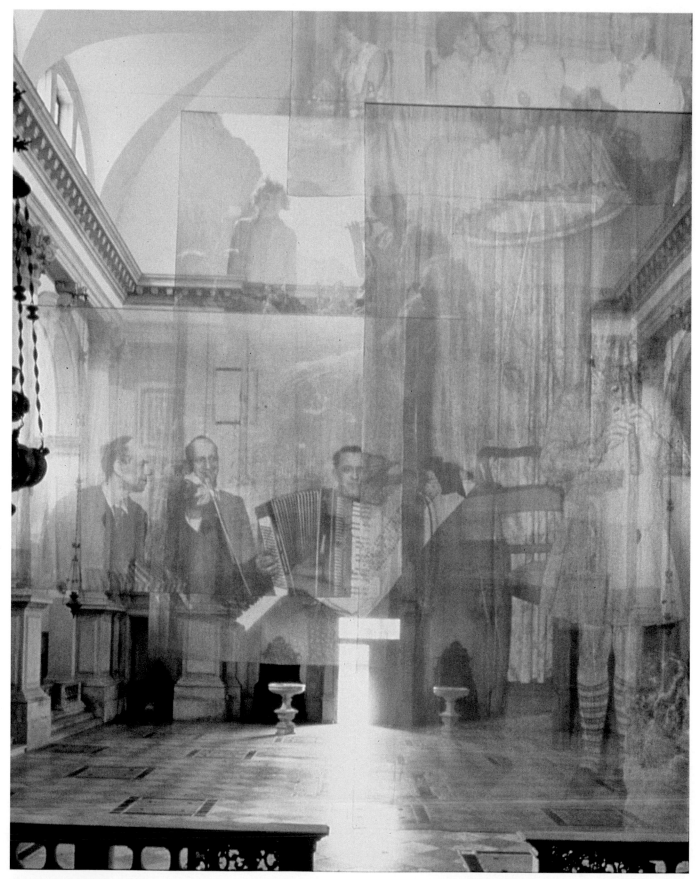

i.5 **Christian Marclay,** *Amplification,* **1995.** The photographic images in this installation shift, fuse, and divide, depending on the position of the viewer.

with expression and abstraction in the twentieth century, the traditional arts of painting, printmaking, and photography (i.5) now offer expanded opportunities for introspective thinking and the development of a personal vision. The opportunities for exploration are endless. It is a great time to be studying art and design!

A journey of a thousand miles begins with one step. As a beginner, your first steps are especially important. Free of the preconceptions or habitual patterns that often paralyze more advanced students, beginners enter the learning experience with an open mind and an intense desire to learn. With no reputation to defend, they can more easily make the mistakes that are so essential to learning. Having taught students at all levels (from freshmen to graduate students and beyond), I have found that beginners of any age are the most courageous students by far. The open, unencumbered "beginner's mind" is wonderfully receptive and resilient. As a result, remarkable changes occur during the first year of study.

Defining the Basics

Launching the Imagination is designed to supplement and support a variety of introductory courses. These courses provide a general overview of studio art and often serve as prerequisites for many specific majors, ranging from advertising design to sculpture and video. Because it is impossible to teach the specific skills required for all these majors in one year, first-year courses focus on general knowledge and essential skills. These **foundation** classes are designed to provide the base on which more advanced study can be built.

Most schools divide this essential information into a variety of drawing and design courses. Drawing helps us develop a heightened awareness of the visual world and gives us many ways to translate our observations into images. At the foundation level, "design" refers to all other types of visual organization, from photography and collage to cardboard constructions and simple Websites. *Launching the Imagination* is devoted to all aspects of basic design.

i.6 Harold Michelson, Storyboard for Alfred Hitchcock's *The Birds.* Storyboards are used to plan the sequence of events and compose the specific shots in a film. Alfred Hitchcock, who began his career as an artist, preplanned his films with exacting care.

Defining Design

The ideas and implications of basic design are extensive and complex. The compositions created by fine artists and the designs used in the applied arts are all derived from the same raw material. As a verb, design can be defined four ways:

- To plan, delineate, or define, as in designing a building.

- To create a deliberate sequence of images or events, as in developing a film storyboard (i.6).

- To create a functional object, as in product design (i.7).

- To organize disparate parts into a coherent whole, as in composing a brochure (i.8).

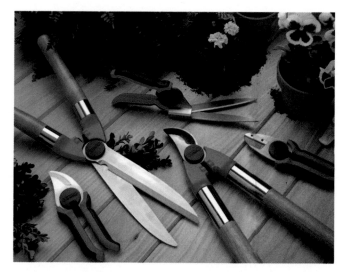

i.7 Designworks/USA, Home Pro Garden Tool Line. These five gardening tools are all based on the same basic combination of handle, blades, and simple pivot. Variations in proportion determine their use.

i.8 Bruce Geyman, Brochure for the National Park Service. Graphic designers often work with words and images equally. Blocks of text are carefully integrated into the visual composition.

i.9 Garden Design. An extensive layout is generally used for planning a garden. Matching the plants to the soil conditions, setting, climate, and overall intent saves money and improves results. In this case, the design is not an artwork in itself, but rather a plan of action.

As a noun, design may be defined as

- A plan or pattern, such as the layout for a garden (i.9).

- An arrangement of lines, shapes, colors, and textures into an artistic whole, as in the composition of a painting or sculpture (i.10).

Design is deliberate. Rather than hope for the best and accept the result, artists and designers explore a wide range of solutions to every problem, then choose the most promising option for further development. Even when chance is used to generate ideas, choices are often made before the results are shown. Design creates a bridge between artistic intention and compositional conclusion. As painter Joseph Albers noted, "To design is to plan and to organize, to order, to relate and to control."

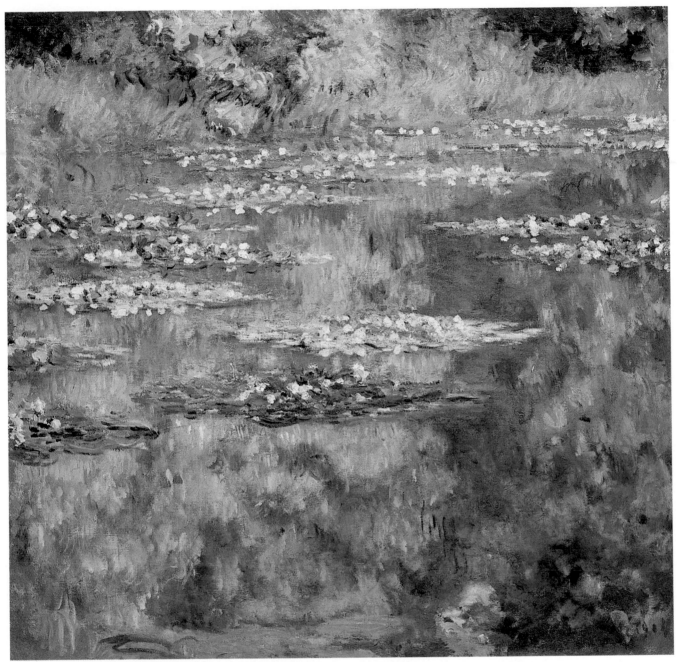

i.10 Claude Monet, *Waterlily Pond (Le Bassin des Nymphéas),* 1904. Impressionist Claude Monet moved to the village of Giverny in 1883 and built an extensive water garden. The waterlilies he grew there inspired his last major series of paintings. Monet combined lines, shapes, textures, and colors to create a compelling illusion of a shimmering space.

i.11A Bonnie Mitchell, *Chain Art* Index Web Page. Working with collaborators from around the world, Mitchell explores communication, cultural influences, and creativity in her projects.

Design Fundamentals

The title of this book defines its purpose. Painter Ken Stout has described the purpose of a foundation program clearly and simply. He says:

Imagine that each of your students is a rocket sitting on a launching pad. Each one has plenty of fuel and is ready to fly. As a foundation teacher, it is your job to fire them up, to get them off the ground. It is their job to keep the process going and to fly to the furthest reaches of their imagination.

The first year is indeed a launching pad. To help ignite your imagination, I have woven the following four themes into every chapter in this book.

Visual Communication Is Fundamental

Through the study of art, we can learn about ourselves and the world around us. For computer graphics master Bonnie Mitchell, the Web provides endless opportunities for innovation and expression. It all began with *Chain Art* (i.11) in 1992, at the very beginning of the Internet explosion. Mitchell sent an e-mail to six people, inviting their participation. They forwarded the message to many others, all around the globe. The respondents were then divided into 22 groups, and each received an incomplete starter image. One team member completed the image, which was then sent to another team member for further elaboration. This process continued until each team member completed a variation, producing a total of 136 images. All were shown on Mitchell's Website. Through this project, Mitchell and her collaborators explored their own ideas about creativity and learned about the creative processes of others. Using a new technology, they transformed personal expression into global communication.

Indeed, mastering the basics of visual communication is another reason to study art. The traditional Western emphasis on verbal communication is rapidly expanding. New technologies encourage us to integrate words, and images in Websites, books, and magazines. Some ideas are best expressed in words, while others can only be conveyed through images. This creates new applications for art and design in every field of knowledge, from anthropology to zoology.

Concepts Feed Communication

A concept may be defined as a well-developed thought. By developing rich concepts, we set the stage for the development of inventive objects and images. Dull concepts, on the other hand, generally result in dull images. In any foundation course, we often see predictable solutions to predictable problems. These include the use of a jagged red line to convey anger, or a skull and a pool of blood to suggest death. Each of these choices is usually effective—but rarely inspiring. We've seen it all before. By developing new approaches and new ideas, we can personalize our communication and make our messages memorable.

Developing concepts is just as much work as developing technical skills. As is the case with any new task, your first efforts at concept development may be frustrating. Initially, your ideas may seem foolish or inadequate. A willingness to explore and experiment is essential. With a combination of hard work and a sense of adventure, your ideas will improve rapidly. To help in this process, Chapter Six provides two major problem-solving strategies and many examples of concept development.

Concept + Composition = Communication

Developing a great idea is only half the battle. To reach an audience, the idea must be communicated visually, through composition. Composition may be defined as "the combination of multiple parts into a harmonious whole." For example, a simple musical composition consists of an arrangement of multiple notes to create melodies and harmonies that are sung or played in a particular rhythm.

i.11B Details.

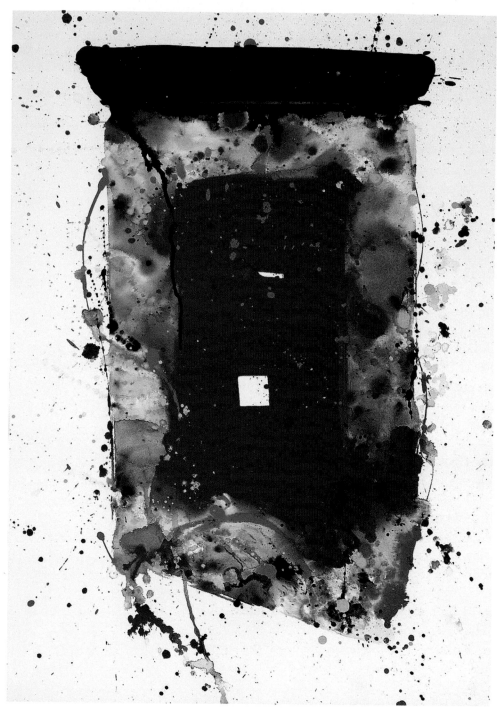

i.12 Sam Francis, *Flash Point*, 1975. Surrounded by explosive energy, the white square in the center of this painting provides a unifying focal point.

Two-dimensional compositions are constructed from lines, shapes, textures, values, and colors that have been arranged to create a unified whole (i.12). Lines, planes, volumes, masses, and space are the most basic components of a three-dimensional composition (i.13). Time design, including video, photography, performance, kinetic sculpture (i.14),

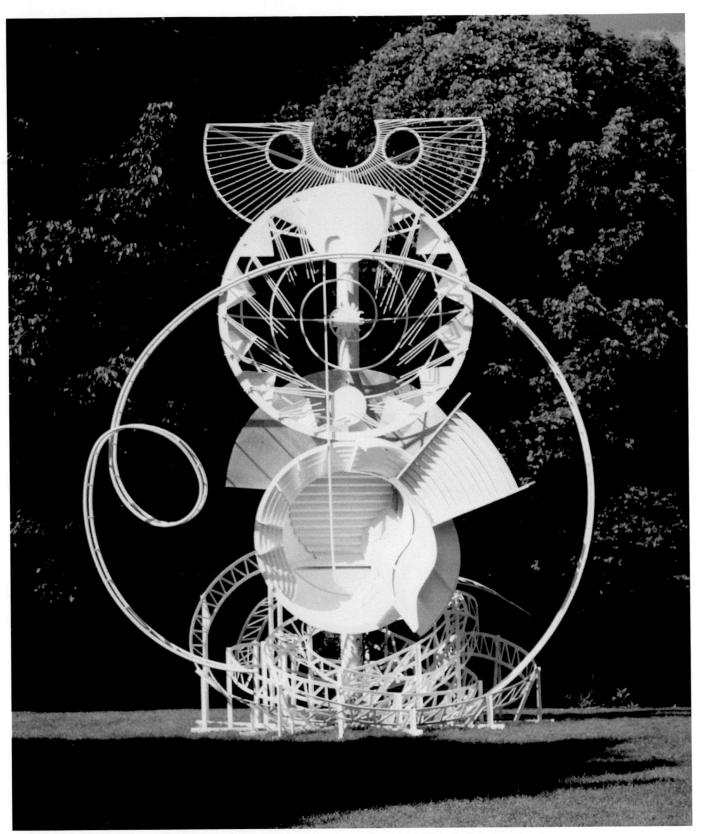

i.13 Alice Aycock, *Tree of Life Fantasy: Synopsis of the Book of Questions Concerning the World Order and/or the Order of Worlds,* **1990–92.** Inspired by the double-helix structure of DNA and by medieval illustrations representing the entrance to paradise as a spinning hole in the sky, Aycock has combined a linear structure with a series of circular planes and a lot of open space. The resulting sculpture is as open and playful as a roller coaster.

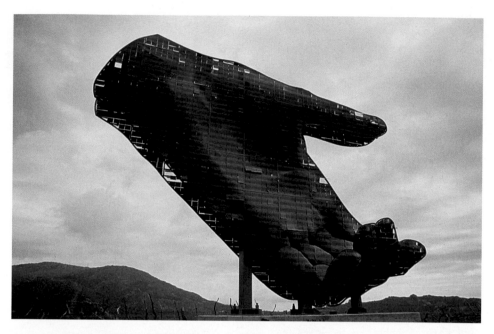

i.14 Todd Slaughter, *Mano y Balo* (details), 1997. Constructed using over one thousand movable panels, the monumental hand appears and disappears as the wind blows.

and the book arts (i.15), is based on the juxtaposition of images and events. A great idea never saved a bad painting. Art and design are visual forms of communication: without careful composition, a great idea may be lost.

Developing a wide range of solutions to every problem is the quickest way to master composition. Small, quick studies are often used to explore the

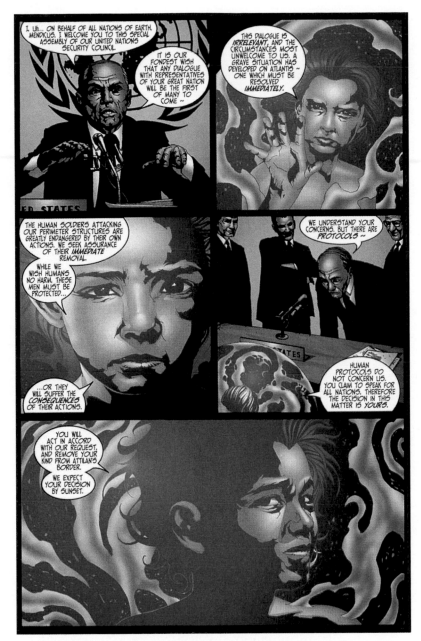

i.15 Paul Jenkins and Jae Lee, from *Inhumans:* "First Contact," March 1999.
Comic books, like films, rely on development of characters, use of "camera" angles, and the organization of multiple images.

possibilities. By translating a mental image into a rough sketch, you can immediately see whether the idea has potential. Furthermore, the best way to have a good idea is to have a lot of ideas. If you explore only one idea, you are far less likely to produce an inventive image. By selecting the best rough composition from 20 sketches, you will have a good beginning point for your final design.

While the compositions created by experienced artists and designers may convey all sorts of complex ideas, at the foundation level composition is often distilled down to **pure form.** Form may be defined as the physical manifestation of an idea. For example, Sam Francis' painting in Figure i.12 is formed by a small square surrounded by an irregular rectangular shape. A series of circles and curving lines creates the sculptural form of *Tree of Life Fantasy* (i.13) by Alice Aycock. Form is created whenever the elements of design are combined.

Translating elusive ideas and emotions into tangible form is one of the greatest challenges for any artist or designer. Simply inventing various ways to balance a circle, cross, and line provides a heightened understanding of basic visual relationships (i.16). When we tackle composition at such a fundamental level, we have only the elements and principles of design as companions. We cannot rely on our brilliant ideas or eloquent explanations to get us out of a compositional jam.

Critical Judgment Supports Creative Thinking

Imagine yourself ruby mining in North Carolina. It is a sunny day and you are surrounded by rolling hills. To your right is a series of pits, half full of mud. To your left, a stream has been directed into a wooden trough. Benches and open trays with wire mesh on the bottom face the trough. You start by shoveling mud into two buckets, then head to the trough to wash it out in the flowing water. When the mud is removed, small bits of gravel remain in the washing tray. If you are lucky, you may find rubies, sapphires, or garnets in this gravel.

However, you will only find these treasures if you know where to look. Except for its six-sided shape, an uncut ruby looks like any other stone. Likewise, determining which ideas and images have the most potential requires a trained eye. You must be able to spot the compositional gems while

i.16 Mary Stewart, *Formal Relationships* (Exercise), 2001. The relationships between the parts and the whole determine the visual quality of a design. To explore a wide range of relationships, artists and designers often complete many small studies before developing more elaborate work.

discarding the compositional gravel. Critiques, or group discussions of artwork, are the most common means by which such visual thinking is developed. By describing an image, comparing it to the other artworks on display, identifying its greatest strengths, or proposing alternative solutions, you can learn a great deal about composition and communication.

Putting It All Together

In the pages that follow, the ideas presented in this introduction are explored in depth. Over 600 images supply visual examples from many cultures and in all areas of art and design. A dozen interviews with living artists provide insight into the creative process.

Reading this book, however, is just the first step. True understanding comes through your own efforts combined with the direction your teachers can provide. Remember that basic drawing and design courses provide the foundation on which all subsequent courses are built. You are only a beginner once in your entire life: this is not a rehearsal. By using your time well, you really *can* get the rocket off the launching pad.

Georgiana Nehl, *Sun/Star* **(detail), 1996.** Oil paint on gessoed wood, 25¾ in. w. × 13¼ in. h. × 1 in. d. (65 × 34 × 3 cm)

Concepts and Critical Thinking

In *A Kick in the Seat of the Pants,* Roger Von Oech identifies four distinct roles in the creative process. An *explorer* learns as much as possible about a problem. Research is crucial. Ignorance of a topic may result in a superficial solution, while finalizing the first solution envisioned often results in a cliché. An *artist* experiments with a wide variety of solutions, using all sort of combinations, proportions, and materials. By creating 10 answers to each question, the artist can select the best solution rather than accepting the only solution. Next, the *judge* assesses the work in progress and determines what revisions are required. Innovative ideas are never fully developed when first presented; most need extensive revision and expansion. Being able to recognize the potential in a raw design is invaluable. Rather than discard an underdeveloped idea, you can identify its potential and determine ways to increase its strength. Finally, the *warrior* implements the idea. When the project is large and complex, implementing the plan requires great tenacity. When obstacles appear, the warrior assesses the situation, determines the best course of action, and then completes the project.

We will explore each of these roles in this section. Playing the right role at the right time is essential. Judging a design prematurely or galloping onto the visual battlefield before exploring the terrain can crush creativity. Strategies for cultivating creativity and improving time management are discussed in Chapter Four. Chapter Five deals with concept development and visual problem solving. Chapter Six is devoted to critical thinking and provides specific ways to improve any design.

A
IS FOR APOLLO, WHOSE
ARROWS NEVER MISS

U
IS FOR URANIA THE MUSE OF
CELESTIAL FORCES IS SHE

Cultivating Creativity

"The heart of all new ideas lies in the borrowing, adding, combining or modifying of old ones. Do it by accident and people call you lucky. Do it by design and they'll call you creative."

Michael LeBoeuf, in *Imagineering*

Design and Creativity

Design and creativity are natural partners. The quality of a design is determined by the integration of its parts into a cohesive whole. The design will work when the parts fit together well. Many compositional possibilities are invented and discarded during the design process. Likewise, creative thinking requires extensive exploration and innovative combinations. By looking at familiar elements in a new way and by combining ideas that have traditionally been separate, we can invent fresh ideas and create new images.

Once viewed as peripheral, creativity and innovation have become highly valued in the current business climate. In the Information Age, intellectual property can be the most important asset in a business. Innovation in art and design, always highly valued in Western culture, has accelerated. New technologies have expanded the range of approaches available, and new ideas drawn from literature, science, philosophy, and history inspire contemporary artists and designers. The sky is the limit. An effective artist or designer cannot simply follow instructions. Cultivating creative thinking is as important as mastering any technical skill.

Seven Characteristics of Creative Thinking

Creativity is inherently unpredictable. Through creative thinking, old habits are broken and familiar patterns of thought are transformed. Anything can happen. Predicting the future based on past experience becomes inadequate when a creative breakthrough occurs. Like a shimmering drop of mercury, creativity eludes capture.

Creative thinking can, however, be cultivated. Rather than passively wait for inspiration, we can set up the conditions favorable to creativity and pursue actions that encourage insight. Creativity takes many forms. Based on observation and on interviews, various researchers have noted the following characteristics in many creative people.

Receptivity

Creative people are open to new ideas and welcome new experiences. Never complacent, they question the status quo and embrace alternative solutions to existing problems. Rather than dismiss new ideas, they enthusiastically seek alternative solutions to existing problems.

Curiosity

A good designer brings an insatiable curiosity to his or her work. Researching unfamiliar topics and analyzing unusual systems is a source of delight rather than a cause for concern. Like a child, the designer is eager to learn new things and explore new places. "How does it work?" and "How can it work better?" are frequently asked questions.

Wide Range of Interests

With a broad knowledge base, a creative person can make innumerable connections. Consider the number of words you can create from the letters in the word *image*:

age, game, gem, am, aim

Try the same game with the word *imagination:*

gin, nation, gnat, ton, not, man, again, gain, aim, ant, no, on, tin, gamin, inn, ingot

With more components, the number of combinations increases. Likewise, an artist who has a background in literature, geology, archery, music, and history can make more connections than the single-minded art specialist.

Attentiveness

Realizing that every experience is potentially valuable, creative people pay attention to seemingly minor details. Scientists often develop major theories by observing small events which they then organize into complex patterns. Artists can often see past superficial visual chaos to discern an underlying order. Playwrights develop drama by looking past the surface of human behavior to explore the substance of the human condition. By looking carefully, creative people see possibilities that others miss.

Seeking Connections

Seeing the similarity among seemingly disparate parts has often sparked a creative breakthrough. For example, Egyptian hieroglyphs became readable when a young French scholar realized that they carried the same message as an adjacent Greek inscription on a slab of stone. By comparing the two and cracking the code, Jean-François Champollion opened the door for all subsequent students of ancient Egyptian culture.

Conviction

Creative people value existing knowledge. Since new ideas are often derived from old ideas, it is foolish to ignore or dismiss the past. However, creative people also love change. Never satisfied with routine answers to familiar questions, they constantly consider new possibilities and often challenge the authorities. Convinced of the value of their ideas, they tenaciously pursue an independent path.

Complexity

In lecture classes, we must accurately take notes during lectures, memorize facts, and collect and analyze data. We are encouraged to think rationally, write clearly, and present our ideas in a linear progression. In studio classes, exploration, experimentation, and intuition are encouraged, especially during brainstorming sessions. Synthesis, emotion, visualization, spatial perception, and nonlinear thinking are highly valued.

To be fully effective, a creative person needs to combine the rational with the intuitive. While intuition may be used to generate a new idea, logic and analysis are often needed for its realization. As a result, the actions of creative people are often complex or even contradictory. As noted by psychologist Mihaly Csikszentmihalyi,[1] creative people often combine:

- Physical energy with a respect for rest. They work long hours with great concentration, then rest and relax, fully recharging their batteries. They view balance between work and play as essential.

- Savvy with innocence. They use common sense as well as intellect in completing their work, yet remain naive, open to experience. Creative people tend to view the world and themselves with a sense of wonder, rather than cling to preconceptions.

- Responsibility with playfulness. When the situation requires serious attention, creative people are remarkably diligent and determined. They realize that there is no substitute for hard work and drive themselves relentlessly when nearing completion of a major project. On the other hand, when the situation permits, a playful, devil-may-care attitude may prevail, providing a release from the previous period of work.

- Risk-taking with safe-keeping. Creativity expert George Prince has noted two behavioral extremes in people.[2] Safe-keepers always look before they leap, avoid surprises, punish mistakes, follow the rules, and watch the clock. A safe-keeper is most comfortable when there is only one right answer to memorize or one solution to produce. Risk-takers are just the opposite. They break the rules, leap before they look, like surprises, are impetuous, and may lose track of time. A risk-taker enjoys inventing multiple answers to every question.

An imbalance in either direction inhibits creativity. The safe-keeper lives in fear, while the extreme risk-taker lives brilliantly—but briefly. Creative thinking requires a mix of risk-taking and safe-keeping. When brainstorming new ideas, open-ended exploration is used: anything is possible. But when implementing new ideas, deadlines, budgets, and feasibility become major concerns. The risk-taker gets the job started; the safe-keeper gets the job done.

- Extroversion with introversion. When starting a new project, creative people are often talkative and gregarious, eager to share insights and explore ideas. When a clear sense of direction develops, however, they often withdraw, seeking solitude and quiet work time. This capacity for solitude is crucial. Several studies have shown that talented teenagers who cannot stand solitude rarely develop their creative skills.

- Passion with objectivity. Mature artists tend to plunge into new projects, convinced of the significance of the work and confident of their skills. Any attempt to distract or dissuade them at this point is futile. However, when the model or rough study is done, most artists will pause to assess progress to date. This period of analysis and judgment may occur in a group setting or may be done by the artist alone. In either case, the emotional attachment required while creating is now replaced by a dispassionate objectivity. Work that does not pass this review is redone or discarded, regardless of the hours spent in its development. In major projects, this alternating process of creation and analysis may be repeated many times.

- Disregard for time with attention to deadlines. Time often dissolves when studio work begins. An artist or designer can become engrossed in a project: when the work is going well, six hours can feel like 20 minutes. On the other hand, an acute attention to deadlines is necessary when preparing an exhibition or working for a client.

- Modesty with pride. As they mature, creative people often become increasingly aware of the contributions to their success made by teachers, family, and colleagues. Rather than brag about past accomplishments, creative people tend to focus on current projects. On the other hand, as creative people become aware of their significance within a field, they gain a powerful sense of purpose.

Distractions are deleted from the schedule, and increasingly ambitious goals are set. When the balance is right, all these complex characteristics fuel even greater achievement.

Goal Setting

The "Imagineer" has one of the most prized jobs within the Disney corporation. Combining imagination with engineering, Imagineers create new ideas that can be effectively *realized*. This combination is crucial. Creativity without result accomplishes nothing.

Goal setting is especially important for the most highly creative people. A wide range of interests and a disregard for time constraints can make them scatterbrained. As humans, our behavior is goal-directed. Every action occurs for a reason. When we focus our attention on a specific task, we can accomplish just about anything. Goals help us channel our energy and manage our time. When we reach our goals, our self-esteem increases, which then helps us overcome obstacles. And, with each goal met, our knowledge increases. Michael LeBoeuf has diagrammed this effect clearly (4.1).

A Goal-Setting Strategy

Self-knowledge is essential. To be effective, goals must be authentic. No matter how hard you try, you will never really fulfill your potential by pur-

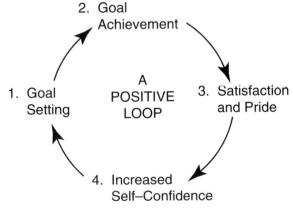

4.1 Michael LeBoeuf, *Imagineering*, 1980.

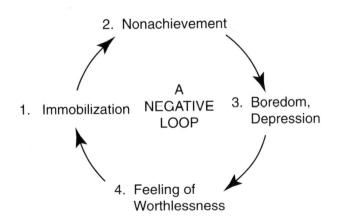

suing goals set by others. Identifying your real interests, strengths, and objectives can be liberating. The following exercise can help clarify your interests.

1. Get a package of small Post-it notes. Working spontaneously, write one of your characteristics on each note, such as "I am creative," "I love music," "I write well." Identify as many attributes as possible.

2. When you finish, lay out the notes on a table and look at them for a while. Consider the type of person they describe. What are this person's strengths? What additional interests might this person need to develop?

3. On a fresh stack of notes, write a new set of responses, this time dealing with the question "Why not?" as an expansion of these interests. Why not travel to Tibet? Why not learn Spanish? Why not master canoeing? Add these to the grid.

4. Then, leave the room. Go for a walk, have dinner, or head to class. Let your subconscious mind play with the possibilities suggested by your notes.

5. Next, organize the notes into four general categories: intellectual goals, personal-relationship goals, spiritual or emotional goals, physical fitness goals. If you are an extreme safe-keeper, add a category called "Adventure." If you are an extreme risk-taker, add a category called "Organization." Since a mix of activities helps feed the psyche, working with each of these categories is important. Even though spiritual, emotional, or social development is fluid and continuous, recognition of these categories can contribute to effective time management.

6. Prioritize the notes within each category. On the top note, write "This is first because _____." One the second, write "This is second because _____." Continue until you complete the grid. Discard notes that you now realize are unnecessary.

7. Choose one goal from each of the four categories. It is tempting to choose the top goal in each case, but this is unrealistic. Even the most experienced businessperson can rarely manage more than three major goals at a time. Choosing one primary goal and two secondary goals is more realistic.

8. Now, specify your goals. "I want to become a better artist" is too vague. Consider specific actions you can take to improve your artwork. "I need to improve my drawing" is more specific. "I want to learn anatomy" is better still. To learn anatomy, you can take a class, study an anatomy book, or draw from a skeleton. These are tangible actions: you now know what to do.

9. Determine how to achieve your goals and develop a rough timetable, listing weekly goals, semester goals, and one-year goals. It is not necessary to list career goals just yet. Most of us explore many ideas during our first year of college, and formalizing career goals prematurely is counterproductive. After you are clearly committed to a major field of study, you can add a page of long-term goals, projecting your priorities for the next three to five years.

10. At least once a month, review your chart and add or delete information as necessary, If you realize that you are overextended this term, shift one of your minor goals to next semester or delete it altogether. This system is intended to provide you with a target, not to create a straitjacket. Make adjustments as necessary, so that your primary goals are met.

11. If you achieve all your goals, congratulate yourself—then set more ambitious goals next term. If you achieve half of your goals, congratulate yourself—then prioritize more carefully next term. You may have taken on too many tasks and thus dissipated your energy. Because there is always a gap between intention and outcome, a 70 to 80 percent completion rate is fine.

Characteristics of Good Goals

Challenging but Attainable

Too modest a goal will provide no sense of accomplishment. Too ambitious a goal will reduce, rather than increase, motivation. No one wants to fight a losing battle! Knowing your strengths and weaknesses will help you set realistic goals.

Compatible

Training for the Boston Marathon while simultaneously trying to gain 20 pounds is unwise, since you will burn off every calorie you consume. Trying to save a thousand dollars while touring Europe is unrealistic, since travel always costs more than you expect. On the other hand, by taking a dance class or joining a hiking club, you may be able to combine a fitness goal with a social goal.

Self-Directed

Avoid goals that are primarily dependent on someone else's actions or options. "I want to earn an A in drawing" is a common example. Since your grade is determined by a teacher, your control in this area is limited. Instead, focus on improving your drawing as much as possible. This will increase your receptivity to learning and will focus your attention on actions you can control. When you do your best work, good grades generally follow.

Temporary

Set clear target dates, get the job done, and move on to the next project. Each completed task increases your self-confidence and adds momentum. Unfinished work, on the other hand, can drain energy and decrease momentum. If you are overloaded, delete secondary goals so that you can complete primary goals.

Time Management

Time management can help you achieve your goals. Working smarter is usually more effective than simply working harder. In a world bursting with opportunity, using your work time well can increase the time available for travel, volunteer work, or socializing. The following time-management strategies have been used by many artists and designers.

Setting the Stage

Choosing when and where to work can significantly increase your output. If you are a lark, bursting with energy and enthusiasm in the morning, tackle major projects before noon. If you are an owl, equipped with night vision and able to hunt after dark, work on major projects after dinner. If you are distracted by clutter, clean your desk before beginning your workday, and tidy up your desk before you leave. These seemingly minor actions can substantially increase your productivity.

First Things First

Use your goal list to help determine your priorities. Note which tasks are most *urgent* and which tasks are most *important*. Timing can be crucial. When you pay your phone bill on time, you easily complete an urgent but unimportant task. When your phone bill is overdue and the service is cut off, this unimportant task becomes a major headache. Dispense with urgent tasks quickly. Distribute important tasks over several weeks if necessary.

Step One, Step Two, Step Three

Many activities are best done in a specific sequence. If you are writing a 20-page paper, it is best to start with research, make an outline, complete a rough draft, make corrections, then write the final draft. If you are designing a poster, it is best to start with research, make thumbnail sketches, assess the results, make a full-size rough layout, consult the client, and *then* complete the poster. It is tempting to try to cut out the intermediate steps and move directly to the final draft, but this is rarely effective. With most large projects, you learn more, save time, and do better work by following the right sequence of events.

Use Parts to Create the Whole

Seen as a whole, a major project can become overwhelming. In an extreme case, creative paralysis sets in, resulting in a condition similar to writer's block. Breaking down big jobs into smaller parts helps enormously. In *Bird by Bird,* Anne Lamott gives a wonderful description of this process:

> Thirty years ago my other brother, who was ten years old at the time, was trying to get a report on birds written that he'd had three months to write. [It] was due the next day . . . he was at the kitchen table close to tears, surrounded by binder paper and pencils and unopened books on birds, immobilized by the hugeness of the task ahead. Then my father sat down beside him, put his arm around my brother's shoulder, and said, "Bird by bird, buddy. Just take it bird by bird.[3]

By doing the job incrementally, you are likely to learn more and procrastinate less.

Making the Most of Class Time

Psychologists tell us that beginnings and endings of events are especially memorable. An experienced teacher knows that the first 10 minutes of class sets the tone for the rest of the session, and that a summary at the end can help students remember the lesson. A choreographer knows that the first ten minutes of a performance can set the stage for the next two hours and that the end of a dance determines the overall impact. Similarly, the wise student arrives five minutes early for class, and maintains attention to the end of class.

Be an active learner. You can use that five minutes before class to review your notes from the previous session. This helps to create a bridge between what you know and the new information to be presented. Try to end the class on a high note, either by completing a project or by clearly determining the strengths and weaknesses of the work in

progress. By writing down your assessment, you can organize your thinking and provide a solid beginning point for the next work session.

Start Early

Momentum is extremely powerful. It is much easier to climb a hill when you are already moving forward, rather than reclining. When you receive a long-term assignment such as a 20-page paper, start it right away. Even one hour of research will help focus your attention on the problem and get you going. A slow start is better than no start!

When in Doubt, Crank It Out

Fear is one of the greatest obstacles to creative thinking. When we are afraid, we tend to avoid action and consequently miss opportunities. It is difficult to act decisively or pursue the unknown potential of a new idea. Both habit and perfectionism feed fear. If you consistently repeat the same activities and limit yourself to the most familiar friendships, you will become more and more fearful of new experiences. If you insist on doing each job perfectly, you can waste time on minor defects and avoid exploring new ideas. Perfectionism is especially destructive during brainstorming, which requires a loose, open approach.

Creativity takes courage. As IBM founder, Thomas Watson, noted, "If you are not satisfied with your rate of success, try failing more." Baseball player Reggie Jackson is renowned for his 563 home runs—but he also struck out 2,597 times. Thomas Edison's research team tried over 6,000 materials before finding the carbon-fiber filament used in lightbulbs.

"When in doubt, don't!" is the safe-keeper's motto. "When in doubt, do!" is the risk-taker's motto. Creativity requires risk-taking. By starting each project with a sense of adventure, you increase your level of both learning and creativity.

Work Collaboratively

Many areas of art and design, including filmmaking, industrial design, and ad design are often done

4.2 M. C. Escher, Part of *Metamorphosis II,* 1939-40. Woodcut in black, green, and brown, printed from 20 blocks on three combined sheets, 7½ × 153⅜ in. (19 × 390 cm).

in collaboration. Working together, artists and designers can complete projects that are too complex or time-consuming to be done alone. Through collaborative thinking, we can pursue unfamiliar lines of inquiry, try out our ideas on colleagues, and consider many different approaches to creative thinking. Collaborative thinking helps us break familiar patterns and teaches us to listen to alternative or opposing ideas.

Here is one example. Gather 20 people. Start with a copied fragment from an existing image, such as *Metamophosis II*, an 8 × 160 in. banner by M. C. Escher (4.2). In this case, students in a design class were provided with a one-inch strip of the banner to create a beginning point and another one-inch strip of the banner to create the ending point (4.3A). Each person invented an 8½ × 11 in. connection between the two strips. Participants drew buildings, plants, abstract shapes, chess pieces, and other images to bridge the gap between the strips at the beginning and the end. The images were then connected end to end, like cars in a train. When combined, they created a collaborative banner, 20 feet long (4.3B). Students had to negotiate with the person ahead of them in the line,

4.3A Examples of Escher starter images.

4.3B Mary Stewart and Jesse Wummer, Expanded Escher Collaboration. Student work.

and with the person behind them, in order to make a continuous image with graceful transitions. In effect, all 20 participants become members of a creative team. Finally, each 8½ × 11 in. section was photocopied and traded, providing each person with the completed artwork. In a collaboration of this kind, everyone gains, both in the learning process and in the sharing of the product.

Reduce Stress

Finally, good time management can help you avoid excessive stress. When you are pushing beyond familiar limits, some stress is inevitable. Excessive stress, however, leads to illness, anger, insomnia, mental paralysis, exhaustion, and depression. Here are some strategies that can help.

No Blame

No matter what happens, blaming yourself or others is never useful. Work on the solution rather than remaining stuck in the problem.

Keep Your Balance

A mix of emotional, spiritual, physical, and intellectual activities will help feed all areas of your psyche. No matter how significant a particular assignment may appear to be, remember that it is only one aspect of your life. Taking a break can often give you the fresh perspective you need to solve a difficult problem. Value rest. When the balance is right, your time off can actually increase your productivity.

Positives Attract

A creative person seeks change. Any change tends to present a combination of obstacles and opportunities. Focusing on the opportunities rather than on the obstacles increases confidence. Furthermore, an upbeat, positive attitude attracts other creative thinkers, while a negative, excessively critical attitude drives creative thinkers away. By assuming that you *can* do the job well, you start the spiral of accomplishment needed to fully realize your creative potential. Accentuate the positive!

Georgiana Nehl, *Sun/Star* **(detail), 1996.** Oil paint on gessoed wood, 25¾ in. w. × 13¼ in. h. × 1 in. d. (65 × 34 × 3 cm).

Profile:
Nancy Callahan, Artist, and Diane Gallo, Writer

Storefront Stories: Creating a Collaborative Community

Nancy Callahan (left in photo) is a leader in the field of artists' books and is known for her creative work in screen printing. She has exhibited her work widely, and in 1994, she was one of four artists chosen to represent the United States at the International Book and Paper Exhibition in Belgium. In 1999 she participated in the International Artists' Book Workshop and Symposium in Mor, Hungary. In addition to her full-time teaching at the State University of New York at Oneonta, Callahan has taught workshops at major book centers around the country, including the Center for Book Arts in New York City and The Women's Studio Workshop.

Diane Gallo (right in photo) is an award-winning writer, performance poet, and a master teacher. Her film work has received awards from the American Women in Radio & Television and nominations from the American Film Institute. Gallo teaches creative writing and life-story workshops at universities and cultural institutes throughout the country and is a visiting poet with the Dodge Foundation Poetry Program, a humanist scholar with the National Endowment for the Humanities Poets in Person program, and co-founder of the newly formed Association of Teaching Artists.

Callahan and Gallo began working together in 1984 as a photographer/writer team for the Binghamton Press. As a result of many years of collaborative teaching, they became the first teaching artist team working with the Empire State Partnership project, jointly sponsored by the New York State Education Department and the New York State Council of the Arts. In 1996 they received fellowships to the Virginia Center for the Creative Arts where they began working on a major project that led to their selection by the Mid-Atlantic Foundation for their millennium project. Funded by the National Endowment for the Arts, the project—Artists & Communities: America Creates for the Millennium— named Callahan and Gallo as two of America's 250 most creative community artists.

MS: You've gained a lot of recognition for your recent text-based installations. Please describe Storefront Stories.

NC: Over the past two years we've had an extraordinary collaborative experience. As an extension of our writing, we developed a new type of text-based installation. One day as we worked on a story about ironing, we playfully hung a single wrinkled white shirt in the front window of our studio in Gilbertsville, New York. Below the shirt, we placed a small sign that said, "No one irons anymore." As the lone shirt turned, it attracted attention, causing people on the sidewalk to stop, read the window, and react. Storefront Stories was born.

DG: Objects became words, words transformed objects. Week by week, using storefront windows as a public stage, we wrote and presented installments of autobiographical stories. In one town, a single window was changed every ten days, creating an ongoing narrative. In another, we used five windows in a row, like pages in a book. Bits of text and symbolic objects were used to tell stories about personal change. Stories and objects—combined with the unexpected street location—sparked curiosity and started a community dialog.

MS: How did members of the community become participants?

NC: They just began telling us their stories. An elderly woman on her way to the post office stopped to tell us the story of how she had learned to type on an old Smith typewriter, just like the one in the window. Eleven-year-old boys on bicycles stopped by. A mother brought her children to the windows each week to read the story aloud. Couples strolling by in the evening asked, "What's coming next?"

DG: People talked to us easily, asking questions and encouraging us. Many times, we'd return to find handwritten stories, comments, and suggestions. We watched passersby examine the windows and heard them laughing and talking to each other as they pieced together the story. When a viewer made a good suggestion, we incorporated the idea into the next window. When community members saw their ideas so quickly incorporated, they realized they were more than passive viewers. They were now active participants, with a vital involvement in the artistic process. The collaboration which began between two artists quickly expanded, engaging the entire town.

MS: In your household installations you create complete environments to frame your stories. To create these environments, you spend many hours scouting thrift shops and garage sales searching for just the right objects to evoke an exact time and place. Why are these objects so important?
NC: Household objects are the vocabulary of the everyday world. Everyone feels comfortable with them. The objects are a bridge—they allow the viewer to cross easily from everyday life into the world of our installations.
DG: After the object is safely in the viewer's mind, it becomes a psychic spark which triggers associations and amplifies memories. For example, while we were doing the ironing installation, a delivery man who stopped for a moment to watch us work said, "I don't know anything about art," and began talking deeply and at length about how when he was a boy, his mother took in ironing to make extra money so that he could have a bicycle.
NC: His narrative then created another layer of collaboration.

MS: When you began creating the installations, did you expect this kind of public reaction?
NC: No. It was a shock. From the moment we hung that first wrinkled shirt in the studio window, people on the street were responsive. The immediate feedback was exhilarating.

MS: What are the characteristics of a good collaboration?
DG: Quiet attention is crucial. We both have to really listen, not only to words but also to the implications.
NC: Always tell the truth. There can be no censoring. If something's bothering you, it's important to talk about it right away. Honesty and careful listening build trust. When you trust your partner, you can reveal more.

MS: When people first see your installations, many are almost overwhelmed. Why?
DG: We're balancing on a fine line between life and art, between the personal and the universal, the public and the private, the conscious and the unconscious. We're working on the edge of consciousness, looking for things you might only be half aware of under ordinary circumstances. It's like watching a horizon line in your mind, waiting for a thought or answer to rise.

Diane Gallo and Nancy Callahan, *Storefront Stories*, 1999. Mixed medium installation, 6 × 6 × 6 ft (1.83 × 1.83 × 1.83 m).

Summary

- Creativity and design both require new combinations of old ideas.

- Creative people are receptive to new ideas, are curious, have a wide range of interests, are attentive, seek connections, and work with great conviction.

- Creative people combine rational and intuitive thinking. While intuition may be used to generate a new idea, logic and analysis are often needed for its completion. As a result, the actions of creative people are often complex or even contradictory.

- Goals you set are goals you get. Establishing priorities and setting appropriate goals will help you achieve your potential. Good goals are challenging but attainable, compatible, and self-directed. Deadlines encourage completion of complex projects.

- Creating a good work area, completing tasks in an appropriate sequence, making the most of each work period, maintaining momentum, and reducing stress are major aspects of time management.

- Collaborative work can help us expand our ideas, explore new fields, and pursue projects that are too complex or time-consuming to do alone.

1. What qualities have you noticed in unusually creative people? Reading a biography of your favorite artist or designer may provide further insight into the creative process.

2. What are your primary goals? How can a general goal be translated into a specific action?

3. Under what conditions do you work best? How can you cultivate the conditions most favorable to your own creative thinking?

Anne Lamott, *Bird by Bird: Some Instructions on Writing and Life*. New York, Anchor Books,1998.

Mihaly Csikszentmihalyi, *Creativity: Flow and the Psychology of Discovery and Invention*. New York, HarperCollins, 1996.

John Briggs, Fire in the Crucible: *Understanding the Process of Creative Genius*. Grand Rapids, MI, Phanes Press, 2000.

David Bohm, *On Creativity*. New York, Routledge, 2000.

Michael LeBoeuf, *Imagineering: How to Profit from Your Creative Powers*. New York, McGraw-Hill, 1980.

Howard Gardner, *Art, Mind and Brain: A Cognitive Approach to Creativity*. New York, Basic Books, Inc., 1982.

Howard Gardner, *Frames of Mind: The Theory of Multiple Intelligences*, New York, Basic Books, Inc., 1985.

Denise Shekerjian, *Uncommon Genius: How Great Ideas Are Born*. Penguin Books, New York, 1991.

Doris B. Wallace and Howard E. Gruber, editors, *Creative People at Work*. New York, Oxford University Press, 1989.

Problem Seeking and Problem Solving

Artworks are generally experienced visually. By learning the basic elements of design and exploring many approaches to composition, you can increase the visual power of your work. Composition, however, is only part of the puzzle. With the continuing emphasis on visual communication throughout our culture, the ideas being expressed by artists and designers have become more varied and complex. As a result, conceptual invention is now as important as compositional strength. New ideas invite development of new images. When the concept is fresh and the composition is compelling, expression and communication expand.

Problem Seeking

The Design Process

In its most basic form, the creative process can be distilled down to four basic steps. When beginning a project, the designer asks:

1. What is required?

2. What existing designs are similar to the required design?

3. What is the difference between these designs and the required design?

4. How can we transform, combine, or expand these existing designs?

By studying the classic Eames chair, we can see this process clearly. Charles and Ray Eames were two of the most innovative and influential designers of the postwar era. Trained as an architect, Charles was a master of engineering and had a gift for design integration. Trained as a painter, Ray brought a love of visual structure, a sense of adventure, and an understanding of marketing to their work. Combining their strengths, this husband-and-wife team designed furniture, toys, exhibitions, and architecture, and directed over 80 experimental films.

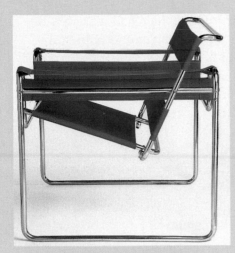

5.1 Marcel Breuer, Armchair, Dessau, Germany, 1925. Tubular steel, canvas. 28¹¹⁄₁₆ in. h. × 30⁵⁄₁₆ in. w. × 26¾ in. d. (72.8 × 77 × 68 cm).

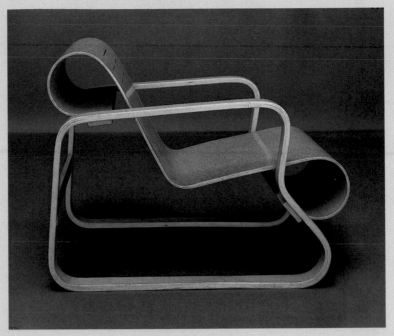

5.2 Alvar Aalto, Paimio Lounge Chair, 1931–33. Laminated birch, molded plywood, lacquered, 26 × 23¾ × 34⅞ in. (66 × 60.5 × 88.5 cm).

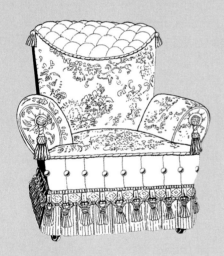

5.3 Overstuffed Chair.

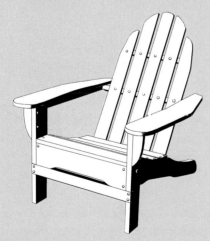

5.4 Adirondack Chair.

Their first breakthrough in furniture design began in 1940, when they entered a competition sponsored by the Museum of Modern Art. Many architects had designed furniture, and the Eameses were eager to explore this field. Many similar products existed. The most common was the overstuffed chair, which continues to dominate many American living rooms. Extensive padding on a boxy framework supported the sitter. Another popular design was the Adirondack chair, made from a series of flat wooden planes. Of greatest interest, however, were designs by architects such as Marcel Breuer (5.1) and Alvar Aalto (5.2). These designs used modern materials and clearly displayed their structure.

By comparing existing chairs with the chair required, Charles and Ray could identify some qualities they wanted to retain and some qualities that needed change. The familiar overstuffed chair (5.3) was bulky and awkward, but it was comfortable. The Adirondack chair (5.4) was easy to mass-produce, but too large for interior use. The modern chairs were elegant and inventive but were expensive and often uncomfortable. The Eameses wanted to produce a modern chair that was comfortable, elegant, and inexpensive.

During World War II, the Eames team had designed and manufactured molded plywood splints that were used by doctors in the U.S. Navy. After extensive research and

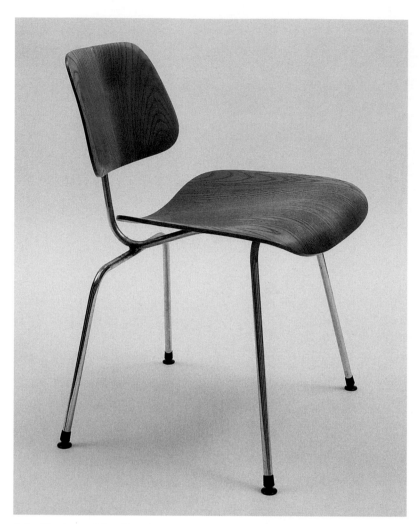

5.5 Charles and Ray Eames, Side Chair, Model DCM, 1946. Molded ash plywood, steel rod, and rubber shockmounts, 28¾ in. h. × 19½ in. d. × 20 in. w. (73 × 49.5 × 50.8 cm).

experimentation, they had mastered the process of steaming and reshaping the sheets of plywood into complex curves. In developing their competition entry, they combined their knowledge of splints, love of modern chairs, understanding of painting, and mastery of architecture. The first plywood chair, designed in collaboration with architect Eero Saarinen, was awarded the first prize.

A series of Eames designs followed, including a metal and plywood version in 1946 (5.5) and several cast plastic versions. One popular chair was mass produced by the hundreds of thousands.

By addressing a need, visualizing existing designs, making comparisons, and combining the best characteristics of existing chairs, the Eames team produced a new kind of chair and thus firmly established themselves as leaders in the design field.

The Art Process

For a designer, the problem-solving process begins when a client requests help or the designer identifies a specific need. With the Eames chair, the museum competition provided the impetus for an experiment that reshaped an industry. Design is generally utilitarian, and the problem is usually determined by a client.

Contemporary sculptors, printmakers, filmmakers, and other artists generally invent their own aesthetic problems. Ideas often arise from personal experience and from the cultural context. Combining self-awareness with empathy for others, many artists have transformed a specific event into a universal statement. For example, Picasso's *Guernica* (see Figure 5.21, page 5-21) painted in response to the 1937 bombing of a specific Spanish village, is now revered as a universal statement about the horrors of war. Working independently and without firm deadlines, artists can explore ideas and issues of personal interest.

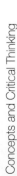

Sources of Ideas

Regardless of the initial motivation for their work, both artists and designers constantly scan their surroundings in an omnivorous search for images and ideas. As demonstrated by the profiles that appear throughout this book, the most improbable object or idea may provide inspiration. Memories of growing up in small-town America provide the stimulus for *Storefront Stories,* by Nancy Callahan and Diane Gallo. Biological systems inspire sculptor Heidi Lasher-Oakes. Ordinary vegetables and African vessels influence ceramicist David MacDonald, while sculptor Rodger Mack derives many of his ideas from mythology. If you are at a loss for an idea, take a fresh look at what you can do with your surroundings.

Transform a Common Object

Architect Frank Gehry based this exuberant armchair (5.6) on the wood-strip bushel basket used by farmers (5.7). If you consider all the ideas that can be generated by a set of car keys, a pair of scissors, a baseball glove, or a compass, you will have more than enough to get a project started.

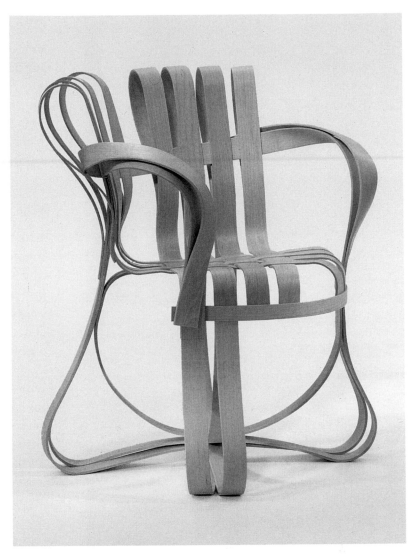

5.6 **Frank Gehry, Cross Check Armchair, 1992.** Maple, 33⅝ in. h. × 28½ in. d. × 28½ in. w. (85.3 × 72.4 × 72.4 cm).

5.7 A wood-strip bushel basket.

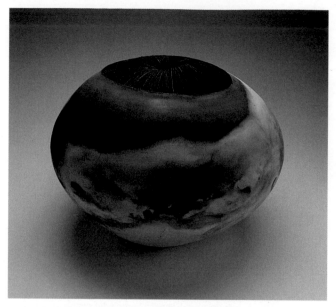

5.8 Ray Rogers, Vessel, New Zealand, 1984. Large, pit-fired (porous and nonfunctional) with "fungoid" decorative treatment in relief. Diameter approximately 21⅔ in. (55 cm).

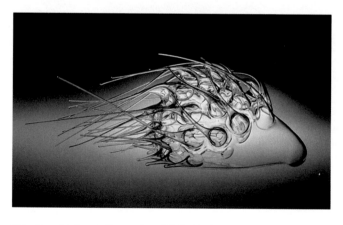

5.9 Vera Lisková, _Porcupine_, 1972–80. Flame-worked glass, 4¼ × 11 in. (10.8 × 28.2 cm).

Study Nature

Ceramicist Ray Rogers is inspired by many natural forms, including mushrooms, stones, and aquatic life. His spherical pots (5.8) often suggest the colors, textures, and economy of nature. In Figure 5.9, Vera Lisková used the fluidity and transparency of glass to create a humorous version of a prosaic porcupine. Through an inventive use of materials, both artists have reinterpreted nature.

Visit a Museum

Artists and designers frequently visit all kinds of museums. Carefully observed, the history and physical objects produced by any culture can be both instructive and inspirational. Looking at non-Western artwork is especially valuable. Unfamiliar concepts and compositions can suggest new ideas and fresh approaches. Beau Dick's _Mugamtl Mask_ (5.10) is one example. First developed by a man who had revived from a deadly illness, it depicts the supernatural abilities (including flight) that he gained during his experience. His descendants now have the right to construct and wear this special mask. By understanding the story and studying the mask structure, you can more readily generate your own mask based on your own experiences.

Characteristics of a Good Problem

Regardless of its source, the problem at hand must fully engage either the artist and the designer. By courageously confronting obstacles and seeking solutions, the artist/designer can develop increasingly ambitious work. Whether it is assigned or invented, a good problem includes many of the following characteristics.

Significant

When substantial amounts of time, effort, and money are being spent, it is wise to prioritize problems and focus on those of greatest consequence. Whether the project is the construction of the pyramids at Giza or completion of your bachelor's degree, assessing the importance of the project within a larger framework is important. Identifying and prioritizing major goals

can help you determine the significance of a job. Balancing this analysis with a sense of adventure can help you combine the best qualities of a risk-taker and a safe-keeper.

Socially Responsible

With the human population above six billion, it is unwise to pursue a project that squanders natural resources. In the past 20 years, designers have become increasingly aware of the environmental and social consequences of their actions. What natural resources will be required for a major project, and how will you dispose of resulting waste? Increasingly, designers consider the environmental as well as the economic implications of each project.

Comprehensible

It is almost impossible to solve a problem you don't understand. When working on a class assignment, ask questions if the assignment is unclear to you.

Leaves Room for Experimentation

It is important to distinguish between clear definition and restrictive limitations. Consider these two assignment descriptions:

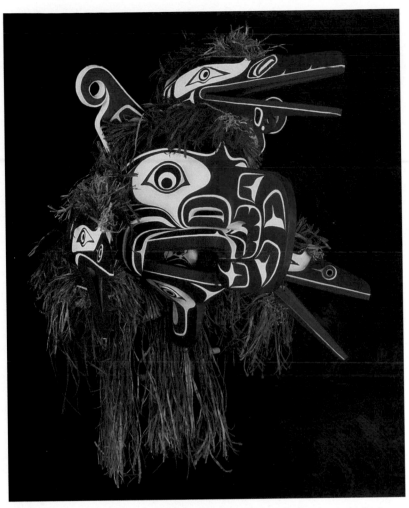

5.10 Beau Dick, *Mugamtl Mask (Crooked Beak)*, 1993. Red cedar, cedar bark, paint, 24 × 26 × 16 in. (61 × 66 × 40.6 cm).

1. **Organize at least 10 photocopies in such a way that they convey an idea or emotion.**

2. **Organize 10 photographs by American Civil War photographer Mathew Brady in order to tell a story about the life of Abraham Lincoln.**

In the first case, the requirements of the project are clearly stated, but the solution remains open to invention. In the second case, the *solution* as well as the *problem* is described. For the inventive artist or designer, there are no "bad" problems, only bad solutions. Nonetheless, when limited to a narrow range of possible solutions, even the most inventive person will become ineffective. If you find yourself in a straitjacket, rethink the problem and try a fresh approach.

Ambitious, Yet Achievable

When the problem is too easy or the solution is too familiar, little is learned and nothing is gained. When the problem is too difficult or the solution is too time-consuming, completion is delayed and costs increase. Continued indefinitely, even the most exciting project can become a trap!

Authentic

Regardless of the source, every person approaches each problem on his or her own terms. Each of us has a unique perspective, and the connections, which are so important in design, will vary. Likewise, as a design student, you will learn more when you really embrace each assignment and make it your own. Ask questions, so that you can understand the substance as well as the surface of each assignment. When you reframe the assignment in your own terms and plunge into the work wholeheartedly, the creative possibilities will expand and the imagination will ignite.

Problem-Solving Strategies

To see how it all works, let's work our way through an actual assignment.

Problem: Organize up to 20 photocopies from the library so that they tell a story. Use any size and type of format as appropriate. Any image can be enlarged, reduced, or repeated.

Solution #1: Using Convergent Thinking

Convergent thinking involves the pursuit of a predetermined goal, usually in a linear progression and using a highly focused problem-solving technique. The word "prose" can help you remember the basic steps:

1. Define the *problem*

2. Do *research*

3. Determine your *objective*

4. Devise a *strategy*

5. *Execute* the strategy

6. *Evaluate* the results

In convergent thinking, the end determines the means. You know what you are seeking before you begin. For this reason, clear definition of the problem is essential: even the most brilliant idea is useless if it doesn't solve the problem.

Convergent thinking is familiar to most of us through the scientific method, which follows the same basic procedure. It is orderly, logical, and empirical; there are clear boundaries and specific guidelines. Clearly focused on the final result, convergent thinking is a good way to achieve a goal and meet a deadline. Let's analyze each step.

Define the Problem

Determine the exact requirements of the assignment. Ask lots of questions so that you understand the purpose of the project and the objectives of the teacher. Determine the physical and technical requirements, and ask whether there are any stylistic limitations. Be sure that you understand the preliminary steps in the assignment as well as the final due date.

Next, assess your strengths and weaknesses relative to the problem assigned, and determine your best work strategy. Let's consider the approaches taken by two hypothetical students, Jeremy and Angela.

Jeremy decides to take a methodical approach to the assignment. He begins by defining "story," "images," and "library." From the dictionary, he finds that a *story* is shorter than a novel, that it may be true or fictitious, that a series of connected events is needed, and that it may take many forms, including a memoir, a play, or a newspaper article. Thus, he determines that the project is limited in length, and that the photocopies used should present a variety of characters or events in a cohesive way.

Next, he finds that an *image* is a representation of a person or thing, a visual impression produced by reflection in a mirror, or a mental picture of something: an idea or impression. This means that photographs from books or magazines, or reproductions of paintings, are fair game. Jeremy realizes that he can even include a mirror in the project, to reflect the viewer's own image.

Finally, by exploring the computer system in the *library*, he finds that Internet resources as well as books are available. He spends the first hour of the class on brainstorming, then decides on a story about Irish immigration to America at the turn of the century.

Do Research

Creativity is highly dependent on seeking connections and making new combinations. The more information you have, the more connections you can make. Through research, you can collect and assess technical, visual, and conceptual information. For this assignment, Jeremy develops a plausible story based on immigrant diaries. He begins to collect images of ships, cities, and people.

Determine Your Objective

Jeremy now has the raw material needed to solve the problem. However, many questions remain unanswered, including:

- What happens in this story? Is it fiction or non-fiction?

- Who is the storyteller? A 12-year-old boy will tell a very different story than a 20-year-old woman.

- What is the best format to use? A dozen letters, sent between fictitious brothers in Dublin and Boston? A Website, describing actual families? A photo album?

At this point, Jeremy pauses to determine his objective, both as an artist and as a student. What does he really want to communicate? He considers:

- *Does it solve the problem?* He reviews the assignment parameters.

- *Is the solution conceptually inventive?* Is it really intriguing, or is it something we've all seen before, a cliché? (Clichés have the virtue of being familiar, but to have real impact, you need a new idea or a fresh approach to an old idea.)

- *How visually inventive is the solution?* Through his work on previous assignments, Jeremy has learned that a familiar subject can have great impact when visualized well.

- *Can this solution be completed by the due date?* To meet the due date, it may be necessary to distill a complex problem down to an essential statement. In this case, Jeremy decides to simplify his project by focusing on one main character.

Devise a Strategy

While some assignments can be done in an afternoon, three-dimensional projects and multiple-image works tend to take longer. Jeremy determines the supplies he needs and considers the best time and place to work on the project.

Execute the Strategy

Now, Jeremy just digs in and works. He has found it best to work with great concentration and determination at this point, rather than second-guessing himself.

Evaluate the Results

At the end of each work session, Jeremy considers the strengths and weaknesses of the work in progress. What areas in each composition seem timid or confusing? How can those areas be strengthened? He finally presents the project for a class critique.

Convergent thinking is most effective when

- The problem can be defined clearly.

- The problem can be solved rationally.

- The problem must be solved sequentially.

- Firm deadlines must be met.

Because many problems in science and industry fit these criteria, convergent thinking is widely used by scientists, businesspeople, and graphic designers.

Solution #2:
Using Divergent Thinking

The advantages of convergent thinking are clarity, control, focus, and a strong sense of direction. For many tasks, convergent thinking is ideal. In some cases, however, convergent thinking can offer *too* much clarity and not enough chaos. Inspiration is elusive. Over-the-edge creativity is messy and rarely occurs in an orderly progression. If you want to find something new, you will have to leave the beaten path.

In **divergent thinking,** the means determines the end. The process is more open-ended; specific results are hard to predict. Divergent thinking is a great way to generate ideas and move beyond preconceptions: any number of lines of inquiry can develop.

There are two major differences between convergent and divergent thinking. In divergent thinking, the problem is defined much more broadly, with less attention to "what the client wants." Research is more expansive and less tightly focused. Experimentation is open-ended: anything can happen.

With divergent thinking, the process may be as highly valued as the product. It is necessary to make many mistakes, and deadlines are harder to meet. Because the convergent thinker discards weak ideas in the thumbnail stage, the final image is preplanned and, thus, predictable. The divergent thinker, on the other hand, generates many variables, is less methodical, and may have to produce multiple drafts of a composition in order to get the desired result.

While convergent thinking is usually more efficient, divergent thinking is often more inventive. It opens up unfamiliar lines of inquiry and can lead to a creative breakthrough. Divergent thinking is a high-risk/high-gain approach. By breaking traditional rules, the artist can explore unexpected connections and create new

possibilities. Let's try the same assignment again, now using Angela's divergent thinking.

Problem: Organize up to 20 photocopies from the library so that they tell a story. Use any size and type of format as appropriate. Any image can be enlarged, reduced, or repeated.

Realizing that the strength of the source images is critical, Angela immediately heads for the section of the library devoted to photography. By leafing though a dozen books, she finds 30 great photographs, ranging from images of train stations to trapeze artists. She photocopies the photographs, enlarging and reducing pictures to provide more options. Laying them out on a table, she begins to move the images around, considering the stories that might be generated. Twenty of the images are soon discarded; they are unrelated to the story she begins to develop. She then finds five more images to flesh out her idea.

At this point, her process becomes similar to the final steps described above. Like Jeremy, she must clarify her objective, develop characters, decide on a format, and construct the final piece. However, because she started with such a disparate collection of images, her final story may be nonlinear in nature. Like a dream, her images suggest ideas rather than describe specific actions.

Divergent thinking is most effective when

- The problem definition is elusive or evolving.

- A rational solution is not required.

- A sequential work method is unnecessary.

- Deadlines are flexible.

Many creative people have used divergent thinking to explore the subconscious and reveal unexpected new patterns of thought. Surrealism, an art movement that flourished in Europe between the world wars, provides many notable examples of divergent thinking in art and literature. More interested in the essential substance of ideas and objects

5.11 Yves Tanguy, *Multiplication of the Arcs*, **1954.** Oil on canvas, 40 × 60 in. (101.6 × 152.4 cm).

than in surface appearances, painter Yves Tanguy constructed *Multiplication of the Arcs* (5.11) from evocative abstract shapes. In *The Mystery and Melancholy of a Street* (5.12), Giorgio de Chirico used distorted perspective, relentless repetition, and threatening cast shadows to create a feeling of anxiety. More interested in stimulating the viewer's own response than in imposing a specific vision, the surrealists rejected rational thought.

Which is better—convergent or divergent thinking? A good problem-solving strategy is one that works. If five people are working on a Website design, a clear sense of direction, agreement on style, understanding of individual responsibilities, and adherence to deadlines are essential. Such a design team will usually use convergent thinking. On the other hand, when an artist is working independently, the open-ended divergent approach can lead to a real breakthrough. By understanding both approaches, you can select the work method that is best for you.

Brainstorming

Brainstorming plays an important role in both convergent and divergent thinking. It is a great way to expand ideas, see connections, and explore implications. Here are four common strategies.

Make a List

Let's say that the assignment involves visualizing an emotion. Start by listing every emotion you can, regardless of your interest in any specific area. Getting into the practice of opening up and actively exploring possibilities is crucial: just pour out ideas!

joy sorrow anger passion jealousy
sympathy horror exaltation

From the list of emotions, circle one that looks promising. To move from the intangible name of the emotion to a visual solution, develop a list of the *kinds, causes,* and *effects* of the emotion. Here's one example, using "Anger" as a starting point.

KINDS	CAUSES	EFFECTS
annoyance	wrong-number phone call at 5 A.M.	slammed down phone
smoldering rage	friend gets award you want	argument with friend
desperate anger	fired from job	shouted at your child
anger at self	poor performance on test	major studying

By investigating specific kinds of anger and determining the causes and the effects, you now have some specific images to develop, rather than struggling with a vague, intangible emotion.

Use a Thesaurus

Another way to explore the potential of an idea is to use a thesaurus. Be sure to get a thesaurus that lists words conceptually rather than alphabetically. Use the index in the back to look up the specific word you need. For example, *The Concise Roget's International Thesaurus* has a whole section titled "Feelings," including everything from *acrimony* to *zeal.* Here is a listing of synonyms from the section on *Resentment and Anger:* anger, wrath, ire, indignation, heat, more heat than light, dudgeon, fit of anger, tantrum, outburst, explosion, storm, scene, passion, fury, burn, vehemence, violence, vent one's anger, seethe, simmer, and sizzle! Thinking about a wide range of implications and connections to other emotions can give you a new approach to a familiar word.

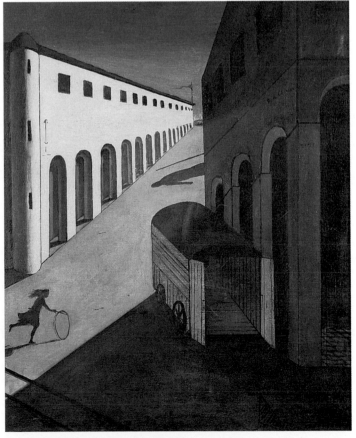

5.12 **Giorgio de Chirico,** *The Mystery and Melancholy of a Street,* **1914.** Oil on canvas, 24¼ × 28½ in. (62 × 72 cm).

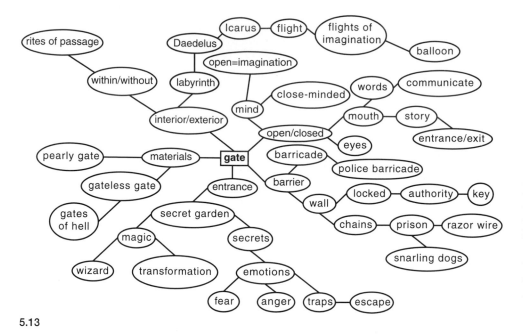

5.13

Make a Map

By creating a verbal diagram, you can create your own thesaurus. Start with a central word. Then, branch out in all directions, pursuing connections and word associations as widely as possible. In a sense, this approach lets you visualize your thinking, as the branches show the patterns and connections that occurred as you explored the idea (5.13).

Explore Connections

In *Structure of the Visual Book,* Keith Smith demonstrates the value of the mapping approach. Smith seeks immersion in his subject. He wants to know it so well that when he begins to work, he can pursue his images intuitively, with all the power and grace of a skillful cyclist. Try to follow all of the steps as he explores the word "bicycle."

If I am going to make drawings or photographs which include a bicycle, I might go for a bike ride, but more importantly I would fantasize about a bike. I would picture a bike in my mind. The most obvious depiction is the side view because this is the *significant profile.* I would then imagine a standing bicycle with no rider, looking from above, directly down on the bike, or from behind or in front of the standing bike with my eye-level midway between the ground and the handlebars. In these three positions the bicycle is seen from the least significant profile. It is a thin vertical line with horizontal protrusions of the pedals, seat and handlebars. The area viewed is so minimal that the bicycle almost disappears.

Before long in examining a bike I would become involved with circles. Looking at the tires, I think about the suspension of the rim and the tire, indeed, the entire vehicle and rider, by the thin spokes. It amazes me that everything is floating in space, connected only by thin lines. I imagine riding the bike through puddles and the trace of the linear journey from the congruent and diverging water marks left by the tread on the pavement. I might think about two friends together and separated. Symbolism.

I think about cycles of being with friends and apart. And again I would think literally of cycles, circles and tires.

I would think of the full moon as a circle and how in its cycle it turns into a line. I would see the tires from the significant profile and in my mind I would turn it in space and it would become an ellipse.

If I turned it further, until it was on an axis 90 degrees from the significant profile, it would no longer be a circle or an ellipse, but it would be a line. So again, line comes into my thoughts.

A circle is a line.

A circle is a straight line.[1]

Research

Library and Internet Research

Most libraries have computer systems that allow searches by subject, author, title, and keyword. Most offer searches on the Internet, including access to a variety of art-related databases. Some of the hits are very directly related to your basic idea, while others can be used to help expand an idea. A keyword search is especially broad: all sorts of books and Websites emerge. Websites are useful for getting an overview of possibilities and getting current information. Reading a book is preferable when more traditional, substantial, or extensive information is needed.

As practitioners of art and design, we can underestimate the value of research. Primarily concerned with technical and compositional problems, we may view research as extraneous. Professional artists and designers, however, value research highly. From experience, they learn that knowledge expands the imagination.

Visual Research

Thumbnail Sketches

While it is useful to generate many ideas verbally, it is in the visualization stage that the work really takes off. Return to your original list of emotions. Circle the most promising words or phrases you have generated, and look for connections between them. Start working on thumbnail sketches, about 1.5 × 2 in. in size (5.14). Be sure to draw a clear boundary for the sketches. The edge of the frame is like an electric fence; by using the edge wisely, you can generate a lot of power! As with the verbal brainstorming, move fast and stay loose at this point. It is better to generate 10 to 20 possibilities than to refine any single idea. You may find yourself producing very different solutions, or

5.14 Examples of thumbnail sketches.

5.15A Susan Cohn, *Cosmetic Manipulations*, 1992. Silver, binding wire, masking tape.

5.15B Susan Cohn, *Cosmetic Manipulations*, 1992. Earring. 750 yellow gold, 375 pink gold, anodized aluminum; earring piece: 2½ × 3½ in. (6.5 × 9 cm); earring line: 4 in. (10 cm).

you may make a series of different solutions to the same idea: either approach is fine. Just keep moving. An open, nonjudgmental attitude is essential.

Thinking with Your Fingers

It is useful to make physical sketches as well as visual sketches when planning a three-dimensional object. Most physical objects are seen from many angles. While it is possible to draw multiple views, compositions can often be constructed more quickly from inexpensive materials such as paper, cardboard, wire, or plasticine. As shown in Figures 5.15A and 5.15B, a sketched structure can often be refined and used to create a much more polished final piece. Jeweler Susan Cohn developed a whole series of earrings and brooches from these *Cosmetic Manipulations*.

Model-Making

When working two dimensionally, it is often necessary to make one or more full-sized rough drafts to see how the design looks when enlarged. Refinements made at this stage can make all the difference between an adequate solution and an inspired solution.

Prototypes, models, and maquettes serve a similar purpose when you are working three dimensionally. A **maquette** is a well developed three-dimensional sketch. Figure 5.16A shows Peter Forbes's maquette for *Shelter/Surveillance Sculpture*. In this chipboard "sketch" Forbes determined the size of the sculpture relative to the viewer and developed a construction strategy. As a result, when he constructed the final eleven-foot-tall sculpture, Forbes was able to proceed with confidence. A **model** is a technical experiment. A **prototype** can be quite refined, as with the fully functional test cars developed by automobile companies. In addition to the aesthetic benefit of these preliminary studies, it is often necessary to solve technical problems at this stage. Is the cardboard you are using heavy enough to stand vertically, or does it bow? Is your adhesive effective? If there are moving parts, is the action fluid and easy, or does the structure consistently get stuck?

5.16A Peter Forbes, Models for *Shelter/Surveillance Sculpture,* **1994.** Mixed media, 10½ × 9½ × 9 in. (27 × 24 × 23 cm).

5.16B Peter Forbes, *Shelter/Surveillance Sculpture,* **1994.** Mixed media, 11 ft 2 in. × 10 ft 4 in. × 10 ft (3.4 × 3.2 × 3 m).

By completing these preliminary studies, the artist or designer can refine the idea, strengthen the composition, and improve the craft of the final piece. As with a well-rehearsed performance, the work you bring to the critique is now really ready for discussion.

Conceptual Expansion

When we work creatively, the idea develops right along with the image. As the project evolves, we see other implications that go beyond our initial intention. By courageously pursuing these implications, we can exceed our original expectations. Just as the landscape appears to expand when we climb a mountain, so an image can expand when our conceptual understanding increases. Concepts can be expanded using variations on a theme, metaphorical thinking, and interdisciplinary thinking.

5.17A Katsushika Hokusai, *Thirty-six Views of Mount Fuji: Under the Mannen Bridge at Fukagawa,* **Edo period, c. 1830.** Color woodblock print, 10¹⁄₁₆ × 14¹¹⁄₁₆ in. (25.7 × 37.5 cm).

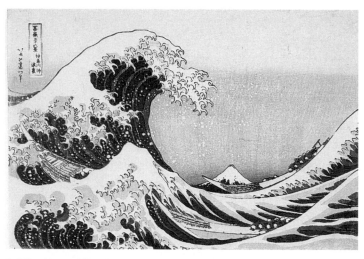

5.17B Katsushika Hokusai, *Thirty-six Views of Mount Fuji: The Great Wave off Kanagawa,* **Edo period, c. 1830.** Color woodblock print, 10³⁄₁₆ × 14¹⁵⁄₁₆ in. (25.9 × 37.5 cm).

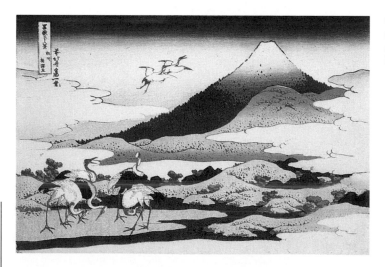

Variations on a Theme

A great deal of energy and commitment is needed to fully realize your vision, especially with complex sculptural or time-based assignments. One way to get a lot of mileage out of an idea is through variations on a theme. Professional artists rarely do just one painting or sculpture of a given idea—most do 30 or more variants before moving to a new subject.

Thirty-six Views of Mount Fuji is one example of the power of variations on a theme. Printmaker Katsushika Hokusai was 70 years old when he began this series. The revered and beautiful Mount Fuji appeared in each of the designs in some way. Variations in the time of year and size of the mountain helped Hokusai produce very different images while retaining the same basic theme (5.17 A–C).

A very different series of variations is presented in Figures 5.18 and 5.19. Here, the two artists offer very individual interpretations of the basic bracelet. Leslie Leupp's three bracelets present a playful dialog between form and space. Lines, planes, and simple volumes dance around the wearer's wrist. In contrast, Lisa Gralnick's three bracelets are dark, massive, and threatening. The crisp angles, simple forms, and black acrylic are more suggestive of armor than of jewelry.

5.17C Katsushika Hokusai, *Thirty-six Views of Mount Fuji: Near Umezawa in Sagami Province,* **Edo period, c. 1830.** Color woodblock print, 10¹⁄₁₆ × 14⁷⁄₈ in. (25.6 × 37.8 cm).

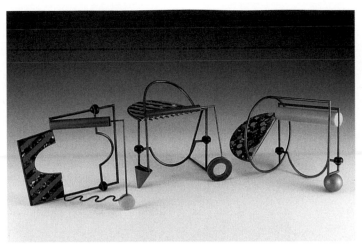

5.18 Leslie Leupp, Three Bracelets: Solidified Reality, Frivolous Vitality, Compound Simplicity, 1984. Steel, plastic, linoleum, laminate, aluminum. Constructed, each 3 × 4 × 3 in. (8 × 10 × 8 cm).

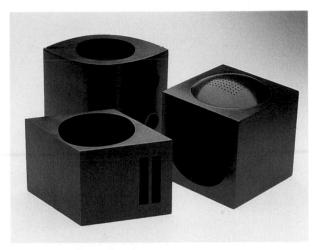

5.19 Lisa Gralnick, Three Bracelets, 1988. Black acrylic, gold, hollow construction, left to right: 3 × 3½ × 3½ in; 4½ × 3½ × 3 in; 3½ × 3½ × 3½ in; (7.6 × 8.9 × 8.9 cm; 11.4 × 8.9 × 7.6 cm; 8.9 × 8.9 × 8.9 cm).

Metaphorical Thinking

Metaphors, similes, or **analogies** are figures of speech that link one thing to another. Through this connection, the original word is given the qualities of the linked word. For example, when Robert Burns wrote the simile "My love is like a red red rose," he gave the abstract concept of "love" the attributes of a glorious, colorful, fragrant, thorny, and transient rose.

Metaphorical thinking creates a bridge between an image and an idea. Take the phrase, "I have butterflies in my stomach." This phrase is widely used to describe nervousness, often before a performance. Substitute other insects for "butterflies," such as bees or wasps. How does this change the meaning? To push it even further, start with the phrase, "My mind was full of clouds." What happens when "clouds" is replaced by mice on treadmills, rats in mazes, shadowy staircases, beating drums, screaming children—or even butterflies? When my mind is full of butterflies, I am happy, but butterflies in my stomach indicate fear. In addition to expanding your ideas, metaphors can help provide specific images for elusive ideas.

Metaphorical thinking and symbolism have always been used by artists and designers to heighten an idea or an emotion. Exaggerated metaphors are often used in advertising design.

5.20 "Y2K's coming. Don't just sit there." Iomega Corporation.

The massive wave that threatens the computer user in Figure 5.20 is a metaphor for the destructive power of the Y2K computer bug that once seemed likely to create massive computer failures on January 1, 2000.

Picasso's *Guernica* (5.21) is also full of metaphors. In *A World of Art,* Henry Sayre offers the following description:

> The horse, at the center left, speared and dying in anguish, represents the fate of the dreamer's creativity. The entire scene is surveyed by a bull, which represents at once Spain itself, the simultaneous heroism and tragedy of the bullfight, and the Minotaur, the bull-man who for the surrealists stood for the irrational forces of the human psyche. The significance of the electric light bulb at the top center of the painting, and the oil lamp, held by the woman reaching out the window, has been much debated, but they represent, at least, old and new ways of seeing.[2]

Rather than showing exploding bombs or collapsing buildings, Picasso filled his painting with abstracted animals, screaming humans, and various light sources. In so doing, he focused on the meaning and emotion of the event, rather than the appearance.

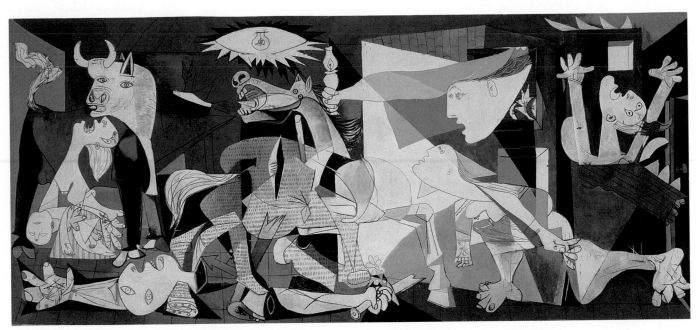

5.21 Pablo Picasso, *Guernica*, **1937.** Oil on canvas, 11 ft 5½ in. × 25 ft 5¼ in. (3.5 × 7.8 m).

Interdisciplinary Thinking

As noted in Chapter 4, most creative people have a wide range of interests. The very best artists and designers are often accomplished in more than one field. For example, Michelangelo was acclaimed as a painter, sculptor, and poet, while da Vinci was a master of art, biology, and engineering. The study of philosophy has had a major impact on videographer Bill Viola and installation artist Robert Irwin. Performer Laurie Anderson is equally an artist and a musician and derives many of her ideas from literature. Whenever the base of knowledge expands, the range of potential connections increases. When the islands of knowledge are widely scattered, as with interdisciplinary work, the imaginative leap is especially great.

The message is clear. The more you know, the more you can say. Read a book. Attend a lecture. Take a course in astronomy, archaeology, psychology, or poetry. Art and design require conceptual development as well as perceptual and technical skill. By engaging your heart, your eye, your hand, and your mind, you can fully use your emotional perceptual, technical, and conceptual resources to create your very best work.

Profile:
Heidi Lasher-Oakes, Sculptor

The Infinite Journey: Exploring Ideas in
Art and Science

Heidi Lasher-Oakes is best known for her Biological Abstractions
Series. Her exhibitions include "Seductive Matter, Sensual Form,"
which was installed in the Corcoran Art Gallery, and "In Three
Dimensions: Women Sculptors of the 90's," which was held at the
Snug Harbor Cultural Center. Educated at Reed College, the Pacific
Northwest College of Art, and Syracuse University, Lasher-Oakes was awarded a residency at the
Bemis Art Center in Omaha, Nebraska, and received a Pollock-Krasner Individual Artist Grant in 1997.

MS: What do art and science have in common?

HL: I have always believed that artistic and scientific
methods are closely linked. A scientific experiment is aes-
thetically pleasing when it is simply and elegantly de-
signed and takes into consideration all possible variables.
On the other hand, the full exploration of an artistic idea
requires the same rigor of inquiry and careful documen-
tation as the exploration of a scientific hypothesis. In ei-
ther discipline, if a process is aesthetically successful, it
will lead to a coherent result. An aesthetic process re-
quires that all components be ruthlessly considered and
evaluated individually and as a unit. The aesthetic in-
tegrity of a process does not guarantee that the resulting
artwork or experiment will be successful, but it does
seem to guarantee that the subsequent work will not con-
stitute a waste of time, either for the investigator or for
the audience.

The Shakers have a philosophy of work that expresses
this viewpoint simply: if you are going to do something,
do it as well as you can.

MS: What is the connection between art and science in
your work?

HL: The sculptures in my current Biological Abstraction
Series are inspired by human anatomy and physiology,
by the forms of cell and tissue structures as seen through
an electron microscope, and by the relationships of these
forms to manmade structures and objects. They also in-
corporate plant, animal, and rock forms. Science really
provides the starting point for my artwork.

MS: Why are you a sculptor rather than a scientist?

HL: Art gives me a way to express my ideas and observa-
tions through the creation of physical objects. I am a hap-
tic person, which means that I am as influenced by touch
as I am by sight. I think this ties into a phrase common in
our culture, "Let me see that!" which really means, "Give
that to me: I want to hold it." To know a thing, I have to
hold it, turn it over in my hands, take it apart, then put it
back together.

MS: I'm intrigued by your strong emphasis on research,
both in your own work and in the classes you teach.
What is the value of research?

HL: Research is valuable for two reasons. It provides in-
formation for existing ideas and is a way of generating
new ideas. Personally, I never know where research will
take me. To my mind, the act of researching a subject is
very much like exploring a hypertext site on the Inter-
net—once you start clicking, you soon find that you have
wandered far from your original reference point. While I
understand the value of staying focused, it is the digres-
sions and distractions that give me the best ideas, months
or even years later.

Research is insurance. It provides context and fertilizes
ideas. The more pieces of information you have, the more
connections or associations you will be able to make. And
associations are essential. Associative thinking is the abil-
ity to make original or unexpected connections. It is an
essential part of creativity. Some people start out thinking
this way, while for others it is a learned trait.

A wide range of interests seems to encourage associa-
tive thinking, so I keep my mind open. For example, I am
currently reading a book on grasshoppers, two histories
of military battle dress, a mystery novel by Antonia
Fraser, three collections of American English proverbs, an

introduction to chemistry, and a book by Jorge Luis Borges—and several others waiting in the wings!

MS: How do you get your ideas?
HL: Just about anything in my environment and experience can generate an idea—a book I read, a conversation, a walk in the woods . . .

MS: Your ideas are pretty complex. How do you communicate this information?
HL: Using association, I try to put as many ideas as possible into the forms I construct. For example, Biological Abstraction III, which depicts an ovary and associated seed structures, also embodies references to dandelion seeds, diving bells, and bomb casings. Each reference contains another piece of information which expands on a physical quality of the object and adds another layer of meaning. I'm not interested in making copies of the structures I study. Instead, I try to understand and express their essential forces and overriding themes.

MS: Please describe your working process.
HL: First, I identify a system for study. Since I am especially interested in human anatomy and physiology, I think of a system as an organ or group of organs in the human body. In this series, I have studied the female reproductive tract, the skin, the respiratory tract , and the inner ear.

Once I have chosen a system, I study it at microscopic and macroscopic levels to try to learn something about the relationship between its structure and function. Scale is really important: the microscopic view reveals an astonishing level of complexity in the simplest of structures! During this phase, I also look for materials that share the structural and functional properties of my system's cellular building blocks. I experiment by combining these materials to see how they might work together. At the same time, I begin to make plans and drawings for different aspects of the piece. When I have gathered enough information to give me a solid foundation, I begin construction.

MS: It sounds so orderly! My creative process is much more chaotic.
HL: Actually, my process is definitely *not* as linear as it sounds! The research, while extensive, is never complete: all art-making requires a balance between analysis and intuition. The materials always have something new to teach me if I am willing to learn. This element of unpredictability can be frustrating and uncomfortable, but it is absolutely essential. If I play it safe, if I'm inflexible, too insistent on sticking to a set plan, the resulting piece will be dull and lifeless. For me, learning comes from experimenting and making mistakes. It is the desire to learn about my materials, myself, and the world around me that keeps me actively engaged during many hours of physical work.

MS: I think we can appreciate the function of science in our culture. What is the function of art?
HL: For me, art helps to stimulate thought, encourage contemplation, increase understanding, and express emotion. Like science, it gives us a way to see beyond everyday experience and embrace the complexity and beauty of our world.

Detail.

Heidi Lasher-Oakes, *Biological Abstraction III*, 1996. Wood, fiberglass, foam rubber, canvas, steel, dinghy anchors, rubber gasket material, fabricated and purchased hardware. Primary structure: 4 ft l. × 4 ft w. × 3½ ft h. (1.21 × 1.21 × 1.07 m), entire assembly approx. 15 ft l. (4.5 m).

Summary

- Concept and composition are equally important aspects of art and design.

- Designers usually solve problems presented by clients. Artists usually invent aesthetic problems for themselves. Both explore many alternatives before achieving the desired result.

- Ideas come from many sources, including common objects, nature, mythology, or history.

- Good problems are significant, socially responsible, comprehensible, achievable, and authentic. They provide basic parameters without inhibiting exploration.

- Convergent thinking is highly linear. The word "prose" can help you remember the steps.

- Divergent thinking is nonlinear and more open-ended. It is less predictable and may lead to a creative breakthrough.

- Any idea can be expanded or enriched using brainstorming. List-making, using a thesaurus, mapping, and creating connections are common strategies.

- Visual and verbal research can provide the background information needed to create a truly inventive solution.

- Pursuing an idea through variations on a theme, metaphorical thinking, or interdisciplinary connections can help you realize its full potential.

Keywords

analogy	interdisciplinary	model
brainstorming	thinking	prototype
convergent thinking	maquette	simile
divergent thinking	metaphor	

1. How many meanings can be derived from individual words, such as "water," "hidden," or "parallel"? Use a dictionary, a thesaurus and an encyclopedia to investigate each word thoroughly.

2. How many meanings can be derived from everyday objects, such as keys, rulers, or eyeglasses? Consider every possible association and implication.

3. How many ways can an idea be visualized? Try different forms of balance, variations in emphasis, use of contrast, etc. Most professional designers make dozens of thumbnail sketches or maquettes before starting work on a final piece.

4. How do materials affect meaning? What is the difference between a marker drawing of a given subject, a charcoal drawing of the same subject, a photograph, and a wooden sculpture?

5. How many variations can be invented from a single theme? Any aspect of an image can be changed, including size, color, complexity, style, materials used, and so forth.

James L. Adams, *Conceptual Blockbusting*. Reading, MA, Addison-Wesley, 1986.

Edward de Bono, *Lateral Thinking*. London, England, Ward Educational Limited, 1970.

Malcolm Grear. *Inside/Outside: From the Basics to the Practice of Design*. New York, Van Nostrand Reinhold, 1993.

Mary Frisbee Johnson. *Visual Workouts: A Collection of Art-Making Problems*. Englewood Cliffs, NJ, Prentice-Hall, 1983.

George Lakoff and Mark Johnson. *Metaphors We Live By*. Chicago, University of Chicago Press, 1981.

Ben Shahn. *The Shape of Content*. Cambridge MA, Havard University Press, 1957.

Judith and Richard Wilde. *Visual Literacy: A Conceptual Approach to Graphic Problem Solving*. New York, Watson-Guptill, 1991.

Developing Critical Thinking

Critical thinking combines

- Careful evaluation of all available information.
- The analysis of visual relationships.
- The exploration of alternative solutions.

Critical thinking is motivated by the desire to pursue an idea to the limit. Never complacent, the best artists and designers continually seek to improve each image and expand each idea. Critical thinking is used to determine compositional strengths, expand concepts, and improve visual communication. Knowing what to keep and what to change is essential. By expanding the best aspects of a design and deleting weak areas, we can dramatically strengthen both communication and expression.

Establishing Criteria

Establishing the criteria on which judgments will be made is the first step. For example, if technical skills are being emphasized in an assignment, craftsmanship will be highly valued. Likewise, if the assignment must be done in analogous colors, a black-and-white painting will not meet the criteria, no matter how carefully it is composed. By determining the major questions being raised in each problem, we can understand the basis on which judgments will be reached. Consider:

- What is the purpose of the assignment? Does your teacher want you to learn any specific skills? What compositional and conceptual variables will you need to explore?
- What are the assignment parameters? Are there limitations in the size, style, or materials?
- When is the assignment due and in what form must it be presented?

It is important to distinguish between understanding assignment criteria and seeking the "right answer." In the first case, by determining the bound-

aries, you can fully focus your energy when you begin to work. Just as a magnifying glass can be used to focus sunlight into a powerful beam, so assignment parameters can help you focus creative energy. On the other hand, students who try to determine the "right answer" to a problem often simply want to know the teacher's solution. Such knowledge is rarely helpful. Any problem presented by a teacher simply sets a learning process in motion: you learn through your work. Since learning requires a personal process of investigation, finding your own answer is essential.

Form, Subject, and Content

The most effective compositions present a unified visualization of an idea or emotion. As a result, it is often difficult to dissect and analyze a design. Identifying three major aspects of an artwork can provide a beginning point for discussion.

Form may be defined as the physical manifestation of an idea or emotion. Two-dimensional forms are created using line, shape, texture, value, and color. The building blocks of three-dimensional forms are line, plane, volume, mass, space, texture, and color. Duration, tempo, intensity, scope, setting, and chronology are combined to create time-based art forms. For example, film is the form in which *Star Wars* was first presented.

The **subject,** or topic, of an artwork is most apparent when a person, object, event, or setting is clearly represented. For example, the conflict between the rebels and the Empire provides the subject for *Star Wars.*

The emotional or intellectual message of an artwork provides its **content,** or underlying theme. The theme of the *Star Wars* trilogy is the journey into the self. Luke Skywalker's gradual understanding of himself and acceptance of Darth Vader as his father adds an emotional undercurrent to all the events in the the entire *Star War* series.

Critique Basics:
Stop, Look, Listen, Learn

Any of these aspects of design can be discussed critically. A **critique** is the most common structure used. During the critique, the entire class analyzes the work completed at the end of an assignment. Many solutions are presented, demonstrating a wide range of possibilities. The strengths and weaknesses in each design are determined, and areas needing revision are revealed. These insights can be used to improve the current design or to generate possibilities for the next assignment.

Critiques can be extremely helpful, extremely destructive, or just plain boring, largely depending on the amount and type of student involvement. The main purpose of the critique is to determine which designs are most effective, and why. Specific recommendations are most helpful: be sure to substantiate each judgment so that your rationale is clear. Whether you are giving or

receiving advice, come with your mind open, rather than your fists closed. A critique is not a combat zone! Listen carefully to any explanations offered, and generously offer your insights to others. Likewise, receive their suggestions gracefully rather than defensively. You will make the final decision on any further actions needed to strengthen your design; if someone gives you bad advice, quietly discard it. An open, substantial, and supportive critique is the best way to determine the effect your design has on an audience, so speak thoughtfully, listen carefully, and weigh seriously every suggestion you receive.

When beginning a critique, it is useful to distinguish between objective and subjective criticism. **Objective criticism** is used to assess how well a work of art or design utilizes the elements and principles of design. Discussion generally focuses on formal concerns, such as

- The type of balance used in the composition and how it was created.
- The spatial depth of a design and its compositional effect.
- The degree of unity in a design and how it was achieved.

Objective criticism is based on direct observation and a shared understanding of assignment parameters. Discussion is usually clear and straightforward. Alternative solutions to a problem may be discussed in depth.

Subjective criticism is used to describe the personal impact of an image, the narrative implications of an idea, or the cultural ramifications of an action. Discussion generally focuses on the subject and content of the design, including

- The meaning of the artwork.
- The feelings it evokes.
- Its relationships to other cultural events.
- The artist's intent.

Because subjective criticism is not based on simple observation, it is more difficult for most groups to remain focused on the artwork itself or to reach any clear conclusions regarding possible improvements. The discussion may become more general and wide-ranging, as political or social questions raised by the works of art and design are analyzed. While these are important topics, because of the potential lack of clarity, subjective criticism may be used sparingly during the foundation year.

Types of Critiques
Description

The first step is to look carefully and report clearly. Without evaluating, telling stories, drawing conclusions, or making recommendations, simply describe the visual organization of the work presented. A **descriptive critique** can help you see details and heighten your understanding of the design. The student whose work you describe learns which aspects of the design are most eye-catching and readable and which areas are muddled and need work.

This is a particularly useful exercise when analyzing a complex piece, such as Figure 6.1. In an art history class you might write:

> *Place de l'Europe on a Rainy Day* is a rectangular painting depicting a street in Paris. A vertical lamppost and its shadow extend from the top edge to the bottom edge, neatly dividing the painting in half. A horizon line, extending from the left side and three-quarters of the way to the right, further divides the painting, creating four major quadrants. Because this horizon line is positioned above center, the bottom half of the composition is larger than the top half.
>
> A dozen pedestrians with umbrellas occupy the bottom half of the painting. At the right edge, a man strides into the painting, while next to him a couple moves out of the painting, toward the viewer. To the left of the lamppost, most of the movement is horizontal, as people cross the cobblestone streets.

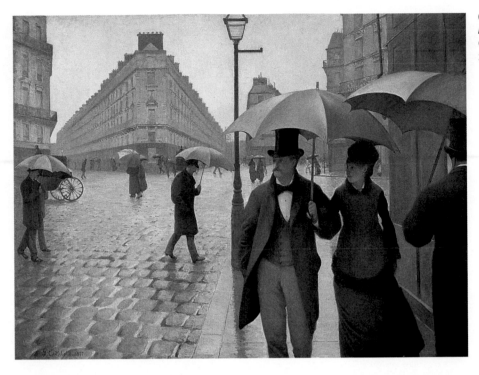

6.1 Gustave Caillebotte, *Place de l'Europe on a Rainy Day*, Paris Street, 1877. Oil on canvas, 83½ × 108¾ in. (212.2 × 276.2 cm).

When using description in a spoken critique, it is useful to consider the following compositional characteristics:

- What is the format or boundary for the design? A circle or sphere presents a very different compositional playing field than a cube or a square.

- What range of colors has been used? A black-and-white design is very different from a design in full color.

- What is the size of the project? Extremes are especially notable. A sculpture that is 10 feet tall or a painting that is one-inch square will immediately attract attention.

- Is the visual information tightly packed, creating a very dense design, or is the design more spacious, with a lot of space between shapes or volumes?

Cause and Effect

A descriptive critique helps us analyze the compositional choices made by the artist. A **cause-and-effect critique** builds on this description. In a simple description, you might say that the design is primarily composed of diagonals. Using cause and effect, you might conclude that *because* of the many diagonals, the design is very dynamic. In a cause-and-effect critique, you discuss consequences as well as choices. Analyzing the same painting, you might write:

Place de l'Europe on a Rainy Day depicts a city street in Paris near the end of the nineteenth century. A vertical lamppost, positioned near the center, compositionally dissects the painting in half. A dozen pedestrians in dark clothing cross the cobblestone streets from left to right, creating a flowing movement. To the right of the post, the pedestrians move in and out of the painting, from background to foreground. Two men and one woman are the most prominent figures. The man at the far right edge pulls us into the painting, while the couple to his immediate left moves toward us, pushing out of their world and into our world. The movement that dominates each side of the painting is arrested by the lamppost. It is almost like we are getting two paintings on one canvas.

6.2 Raphael, *The School of Athens*, 1509–11. Fresco, 26 × 18 ft (7.92 × 5.49 m). Stanza della Segnatura, Vatican, Rome.

Compare and Contrast

In a **compare/contrast critique,** similarities and differences between two images are noted. We will use the Caillebotte painting one more time, now comparing the perspective used with the perspective in Raphael's *The School of Athens* (6.2).

The city streets depicted in *The School of Athens* and *Place de l'Europe* demonstrate many differences between Renaissance and Impressionist perspective.

The one-point perspective used in Raphael's painting leads our eyes to Plato and Aristotle, positioned just below the center of the composition. The other figures in the painting are massed in a horizontal band from the far right to the far left side and in two lower groups, to the right and left of the central figures. Our eyes are led back to the philosophers by a man sprawled on the steps to the right and by the scribes' tables on the left. Like a proscenium arch in a theater, a broad arch in the foreground frames the scene. Overlapping arches add to the depth of the painting. This composition combines the stability of one-point perspective with a powerful illusion of space.

In the Caillebotte painting, a lamppost occupies center stage, rather than a philosopher. The one-point perspective in the cobblestone street and in the buildings on the right is complicated by the two-point perspective used for a large background building on the left. This unusual illusion of space, combined with the movement of the pedestrians, creates a feeling of instability.

All these approaches are often used in art history classes. The same strategies, however, may be used in the studio, for either spoken or written critiques. Here is an example, written by two students in a basic design class. The assignment was to complete an 18 × 24 in. design, transforming the music building (Crouse College) into a labyrinth.

Looking at Cally's design (6.3), Trish wrote:

> Cally's piece uses strong black-and-white contrast, with both negative and positive space clearly developed. On the other hand, my design is brightly colored, representing a kaleidoscope based on the stained glass windows in the building.
>
> We both use the staircase as a major element. Cally's stair leads you in and around the building, creating a way to explore the space. My stair becomes part of the overall pattern.
>
> I thought of the labyrinth as an abstract puzzle, a design you could draw your pencil through to find the ending. I wanted my design to be playful. Cally's design focuses on the psychological, creating an entry into the human mind. Cally's design is mysterious. Her staircases seem to lead nowhere.
>
> We both use lines very deliberately. Where one line ends, another begins. Without lines in a labyrinth, it wouldn't be as puzzling or mysterious. It would just be another design, rather than a puzzle to solve or a fun house to explore.

Looking at Trish's design (6.4), Cally wrote:

> The first difference I notice is that my labyrinth uses black and white to form a high-contrast composition whereas Trish uses color to transform the building into a complex pattern. My vertical format helps suggest the height of the building, which is dominated by two amazing staircases. Trish's horizontal format contains a design that is as abstract as a computer circuit board.
>
> Next, I notice conceptual differences between our solutions. My drawing is representational, depicting a psychological labyrinth, whereas Trish's turns this labyrinth into a puzzle. She took several architectural elements of Crouse College and juxtaposed them as motifs within the drawing. The pipework, in particular, was abstracted and expanded

6.3 Cally Iden, *Transforming Crouse College into a Labyrinth.* Student work. 18 × 24 in.

6.4 Tricia Tripp, *Transforming Crouse College into a Labyrinth.* Student work. 24 × 18 in.

into an elaborate maze. It creates a definite boundary between the background and the foreground. The space is essentially flat in Trish's design: color is used to create a balanced composition rather than being used to create any illusion of space. On the other hand, because my design is representational, I used the illusion of space to create a convincing interior space.

One similarity between our drawings is in the inclusion of the staircase. Trish used the stairs as a *background* shape that adds dynamism to the composition. I used the stair as a primary motif, a means by which people using the building can explore their own minds.

For me, Trish's design creates a sense of alienation. There is no evidence of human experience here—it is a purely visual world, made up of complex shapes. It produces no strong emotion for me, no sense of mystery. It is purely visual.

On the other hand, there are hints of "the human" in my composition, but it is lost within the maze of repetitive stairs: only traces remain. This stark contrast helps communicate the confusion and mystery of my psychological labyrinth. I want to convey the feeling of being caught in a labyrinth, solving mysteries, and finding one's self.

Both critiques are honest without being abusive and offer a discussion of both concept and composition. While they are very different, each of the students clearly respects the approach taken by the other.

Greatest Strength/Greatest Potential

Many projects have one notable strength and one glaring weakness. To create a positive atmosphere, start by pointing out the strength in the work. Begin by looking for:

- The level of unity in the design and how was it achieved.

- The amount of variety in the design, and how much energy it generates.

6.5A

6.5B

- The visual rhythms used and their emotional effect.

- The attention to detail. This could include craftsmanship, conceptual nuance, or compositional economy.

- A conceptual spark. We all love to see an unexpected solution that redefines the imaginative potential of a project.

Using Figure 6.5A as an example, you could say:

> The primary strength of this project is unity. Use of black marker throughout gives the design a simple, clean, and consistent look. The repetition of the arches helps tie it all together. Vertical and horizontal lines dominate, creating a type of grid.

Next, consider ways to improve the project. Mentally arm yourself with a magic wand. If you could instantly transform the design, what single aspect would you change? How can the potential of the project be more fully realized? Some basic questions follow.

- Is it big enough? Is it small enough?

- Is it bold enough? Is it subtle enough?

- How rich is the concept? Can it be expanded?

- How can the concept be communicated more clearly? How can the concept be communicated more fully?

The assignment was to create a labyrinth. Figure 6.5A is spatially shallow. To create 6.5B you might suggest:

> When I think about a labyrinth, I think of it as a mysterious place that I can enter and explore. As it now stands, this design is spatially flat: it gives me no place to go. For further work, you might try increasing the illusion of space. Greater size variation in the arches, with larger ones in the front and smaller ones in the back could help. Overlapping some of the arches could increase the space and add a rhythmic quality to the work. And, have you considered using gray marker for the background shapes? This would reduce the contrast and push them back in space.

Developing a Long-Term Project

Critical thinking is useful at many points in a project, not just at the end. When working on a project for 10 hours or more, it is useful to assess progress at the beginning or the end of each work period. This may be done in a large-group critique, in small teams, in discussion with your teacher, or on your own. Several effective strategies follow.

Week One Assessment

Determine Essential Concept

As a project begins to evolve from brainstorming, to thumbnails, to rough drafts, the concept may also evolve. Your initial idea may expand or shift during the translation from the mind to the hand to the page. Stopping to reconsider your central concept and refine your image can bring great clarity and purpose to the work. What is the design really about? You can speak more forcefully when you know what you want to say.

Explore Polarities

Sometimes, the best way to strengthen an idea is to present the exact opposite. For example, if you want to show the *joy* a political prisoner feels on being released from jail, you may need to show the *despair* she felt before release. To increase the *dynamism* in a design, add some emphatically *static* elements. The contrast created by polarities can heighten communication.

Move from General to Specific

"Be specific!" demands your writing teacher. Just as vague generalities weaken your writing, so vague generalities can weaken your designs. Details are important. "A bird watched people walk down the street" is far less compelling than "Two vultures hovered over University Avenue, hungrily watching the two hapless freshmen stagger from bar to bar." Specifying the kind of bird, type of people, and exact location makes the image come alive.

Move from Personal to Universal

Autobiography is a particularly rich source for images and ideas. The authenticity of personal experience is extremely powerful. However, if you focus too tightly on your own family, friends, and experience, the viewer must know you personally in order to appreciate your design. Try expanding your field of vision. Use a story about your high school graduation to say something about *all* rites of passage from childhood to adulthood.

Week Two Assessment

A well-developed rough or a full-scale model may be presented at this stage. The purpose of this critique is to help the artist or designer determine ways to increase the visual and conceptual impact of an existing idea. Here are three major strategies.

Develop Alternatives

By helping someone else solve a problem, we can often solve our own problem. Organize a team of four or five classmates. Working individually, design 5 to 10 possible solutions to a visual problem using 3 × 4 in. thumbnail sketches. Then, have one person present his or her ideas verbally and visually. Each team member must then propose an alternative way to solve the problem. This can be done verbally; however, once you get going, it is more effective and stimulating if everyone (including the artist) draws alternative solutions. This process helps the artist see the unrealized potential in his or her idea. And, because of the number of alternatives presented, the artist rarely adopts any single suggestion. Instead, the exercise simply becomes a means of demonstrating ways to clarify, expand, and strengthen intentions already formed. Continue until everyone has made a presentation.

Edit Out Nonessentials

Have you ever found it difficult to determine the real point of a lengthy lecture and thus lost interest? In our zeal to communicate, teachers sometimes provide so many examples and side issues that students get lost. Likewise, if your design is overloaded with peripheral detail or if a secondary

visual element is given the starring role, the result will be cluttered and impact will be lost. Look carefully at your design, focusing on visual relationships. Are there any extra shapes or volumes that can be deleted?

Amplify Essentials

Just as it is necessary to delete extraneous information, it is equally important to strengthen the essential information. Review the section on emphasis in Chapter 3 and consider ways to increase your compositional power. Try "going too far," wildly exaggerating the size, color, or texture of an important visual element. The only way to get an extraordinary image is to make extraordinary choices.

Student Response: Developing a Self-Assignment

In the following two pages, Jason Chin describes the development of a month-long self-assignment he completed near the end of his freshman year. The original project proposal is given at the top of the first page. The rest of the text is devoted to Jason's analysis of his actual work process. This type of personal assessment can bring an extended project to a deliberate conclusion.

Self-Assignment:
Jason Chin

The Mythological Alphabet

Original Proposal:

Description: I plan to make an illustrated alphabet book with 32 pages and a cover. The theme of the book will be myths and heroes. I am interested in illustrating the essence of each hero's story. Specifically, how can I visually communicate the story of a tragic hero versus a triumphant one? Further concerns with the book will be making it work as a whole. That means keeping it balanced and making it flow: I don't want the images to become disjointed.

Primary Concerns:

1. How do I communicate the individual nature of the characters?

2. How do I connect each hero to all the others?

3. How will the book affect the reader? I want to get the reader fully involved in the book.

4. How can I best use the unique characteristics of the book format?

Time Management:

Week 1: Research myths and heroes. Identify possible characters for the book.

Week 2: Bring at least 20 thumbnail sketches to the first team meeting.

Week 3: Bring finalized design/layout for book. Each page must have a final design in the form of thumbnails.

Week 4: Complete half of the pages.

Week 5: Finish remaining pages and present at the critique.

Commentary:

The independent project was both a blessing and a curse. Given the freedom to do what I chose was liberating, but the burden of what to do with that freedom was great. Ultimately, it became one of the best learning experiences of my freshman year.

I had decided to pursue illustration as my major, because of my interest in storytelling. This interest in stories led me to choose to make a book for my self-assignment project. The next step was to find a story to tell. To limit my workload, I looked for a story that had already been told, one that I could reinterpret, as opposed to writing my own story. At this point, I came across two books, one of Greek myths, and an alphabet book illustrated by Norman Rockwell, and my initial concept was born.

Once the idea was initiated, I set to work researching Greek myths. The idea was to find one character for each letter of the alphabet. It proved more difficult than I had

first thought. I found about 20 names with no problem, but I soon realized that several letters in our alphabet did not exist in the Greek alphabet. To overcome this hurdle, I took some liberties on the original problem and did not limit myself strictly to characters from myths (for example, I included the White Island for the letter *W*). Once the subject of each illustration was chosen, I set about the task of doing the images and designing the format of the book.

Doing the illustrations and designing the format of the book all came together at about the same time. As I was working out the drawings I made several key decisions that heavily influenced the outcome of the project. First, I decided that each picture would have to be black and white if I was going to pull this whole thing off. Second, I knew that they would have to be relatively small. Through my art history class, I gained a strong interest in Japanese woodblock prints and was especially attracted to their strong compositional sensibility. This became the focus of my

attention while working out the illustrations. Finally, the decision to make the illustrations small helped determine the way I used text in the book, because it all but eliminated the possibility of overlaying text on image.

I designed each image in my sketchbook, doing thumbnails and comp sketches of all sizes and shapes, until I found the image that I felt best represented the character. For example, Zeus has the biggest and busiest frame in the book because he is the king of the gods, while the image of the White Island is quite serene because it is a burial ground. When I had each individual image worked out, I redrew them in order in the pages of my sketch book as if they were in the real book. I could now see how each image would work as a double-page spread, as well as how well the book could flow visually. With this mockup of the book in front of me it was very easy to see obvious mistakes and correct them before going to final art.

I did the final illustrations in pen and ink, on illustration board, and when they were finished, it was time to drop in the text. My first concept for the text was to be very minimal; each page would read, "A is for," "B is for," and so on. The more I thought about it, however, the more I realized that making each page rhyme would drastically increase the reader's interest in the book. So I wrote a more extensive text and put the rhyming parts on opposite pages in order to give the reader one more incentive to turn the page.

The final touch for the book was putting the colored paper down. The decision to do this came when I went to place the type. The only means I had to get good type was to print it out on the computer, but I had no way to print it on the illustration board. So I had to put it on printer paper and cut and paste it. No matter how carefully I cut the paper and pasted it on, it just didn't look right. I came up with two solutions: one, print the words on colored paper and paste it on, or two, cut frames of colored paper to cover over the entire page except for the image and the text. I chose the latter and was pleased to discover that the local art store had a vast selection of handmade and colored papers.

Today I look back on this project as a pivotal experience in my art education, because I had free range to pursue storytelling, something that has since become an essential aspect of my art. In the professional world, bookmaking is rarely an individual process. It is a collaborative process, involving editors, artists, and writers, so for me to be able to pursue it on my own was in fact a blessing. I got to make a book the way that I thought it should be done, and pursue my own personal vision of what a Mythological Alphabet should be. By making this book, I discovered something that I love to do, and want to make a career of doing, and to me the vision that I have gained from this experience is invaluable.

Jason Chin, *A Is for Apollo.* Student work.

Jason Chin, *U Is for Urania.* Student work.

Turn Up the Heat: Pushing Your Project's Potential

6.6A

6.6B

6.7A

6.7B

Some compositions are so bold that they seem to explode off the page. Other compositions have all the right ingredients, but never really take off. By asking the following questions, you can more fully realize the potential of any assignment.

Basic Arithmetic

1. Should anything be *added* to the design? If your composition lacks energy, consider adding another layer of information. Notice how texture changes the energy level in Figures 6.6A and 6.6B.

2. Should anything be *subtracted*? If the composition is cluttered, try discarding 25 percent of the visual information. Then, use the remaining shapes more deliberately (6.7 A–B). Get as much as possible from every visual element.

3. What happens when any component is *multiplied*? As shown in Figures 6.8A and 6.8B, repetition can unify a design, add rhythm, and increase the illusion of space.

4. Can this design be *divided* into two or more separate compositions? When a design is too complicated, it may become impossible to resolve.

6.8A

6.8B

6.9A

6.9B

Packing 20 ideas into a single design can
become a cure for sanity. In Figure 6.9A and
6.9B, a complicated source image has been sep-
arated into several different designs, creating a
whole series of excellent images.

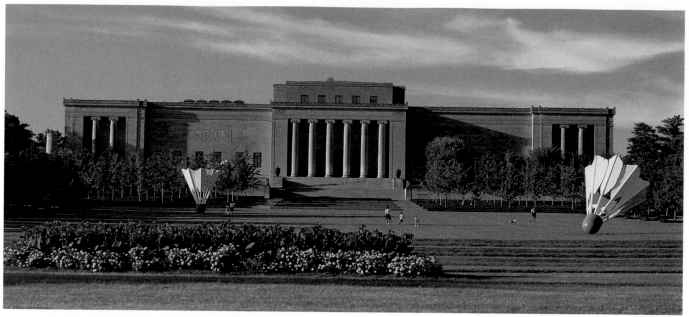

6.10 Claes Oldenburg and Coosje van Bruggen, *Shuttlecocks,*
1994. South facade of the Nelson-Atkins Museum of Art and the
Kansas City Sculpture Park. Aluminum, fiberglass-reinforced plastic,
urethane paint, approx. 19 ft 2⅜ in. h. × 16 ft diameter (5.9 × 4.9 m).

Transformation

Works of art and design present ideas in physical
form. Each composition is strongly influenced by
the materials used, the relationships created, and
the viewing context chosen. Consider these
alternatives:

1. What happens when the medium is changed?
 Even when the shapes stay the same, a silver
 teapot is very different from a glass, steel, or
 ceramic teapot. Sculptor Claes Oldenburg has
 used transformations in material extensively,
 often changing hard, reflective materials into
 soft vinyl. This form of transformation is espe-
 cially effective when the new material brings
 structural qualities and conceptual connota-
 tions that challenge our expectations.

2. What is the relationship of the piece to the
 viewer? What is the relationship between the
 artwork and its surroundings? What happens
 when a chair is reduced to the size of a salt
 shaker? Or when a 20-foot-tall badminton shut-
 tlecock (6.10) is placed in front of a museum?
 How does any image change, both visually and
 conceptually, when size is dramatically reduced
 or increased?

3. Can a change in proportion increase impact?
 Working with the same basic information, a

seemingly endless number of solutions can be produced through variations in proportion (6.11).

4. Is a physical object compelling from all points of view? Does the composition of the piece encourage the viewer to view it from other angles?

6.11

5. Can a change in viewing context increase meaning? The context in which a composition is seen can dramatically alter its meaning. For example, a side of beef has a very different meaning when it is hung in a gallery rather than staying in a slaughterhouse. Likewise, pop artists such as Andy Warhol and Roy Lichtenstein brought new meaning to soup cans and comic books by using them as subject matter in their paintings.

Reorganization

Time-based work, such as visual books, comic books, film, and video, is generally constructed from multiple images. Changing the organization of the parts of the puzzle can completely alter the meaning of the piece. For example, Angela contemplates entering the building in the sequence shown in Figure 6.12. Using a different organization of the same three images, Angela now wonders what will happen when she opens the door at the top of the stairs (6.13). By repeating the image of Angela, we can present a dilemma: she is now in a labyrinth—which route should she take (6.14)?

6.12

6.13

6.14

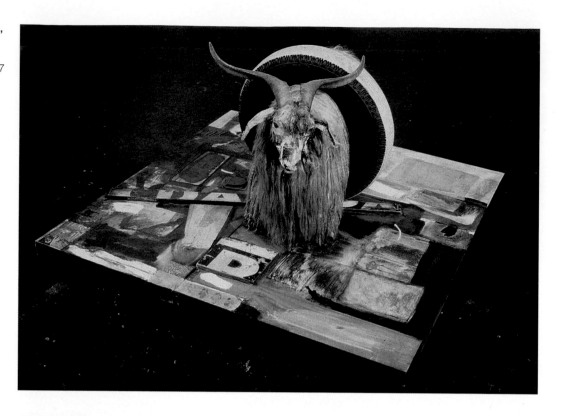

Concept and Composition

Any compositional change affects the conceptual impact of an artwork. Henry M. Sayre provides a striking example in *A World of Art.*[1] A distilled version of his ideas follows.

Robert Rauschenberg's *Monogram* (6.15) is constructed from a stuffed goat, an automobile tire, and a painted plywood base. Seeking to combine painting and sculpture, Rauschenberg created three different versions of this piece. In the first version (6.16), he placed the goat on a shelf that extended from the center of a six-foot-tall painting. This created a connection between the painting and the goat, but diminished its sculptural impact. In the second version, Rauschenberg placed a tire around the goat's midsection and moved the animal in front of the painting (6.17). This enhanced its three-dimensionality but created too much of a

6.16 Robert Rauschenberg, *Monogram, 1st State,* c. 1955. Combine painting: oil, paper, fabric, wood on canvas, plus stuffed Angora goat and three electric light fixtures, approximately 75 × 46 × 12 in. (190.5 × 114.3 × 30.5 cm). No longer in existence.

separation between the animal and the painting. He finally hit on the right combination when he placed the painting on the floor and positioned the goat in the center. The painting retained its integrity as a two-dimensional surface, the goat retained its physical presence, and a highly unified combination of the two elements was achieved. The addition of the tire enhanced the goat's sculptural form and gave the artwork a humorous twist.

Accepting Responsibility

We have explored only a few of the many approaches to critical thinking in this chapter. Every assignment presents new possibilities for critiques, and each teacher continually invents new approaches to address the needs of a specific class.

Regardless of the specifics, however, two facts are inescapable. First, you will learn only what you want to learn. If you reject out-of-hand the alternatives suggested, or if you avoid responsibility for your conceptual and compositional choices, you will gain nothing from the critique, no matter what strategy is used. Second, there are no free rides. Everyone in the class is responsible for the success of the session. It is often difficult to sustain your attention or honestly assess your work or the work of others. When you get a superficial response to a project, insisting on further clarification is not easy. Every critique demands sincere and sustained attention from each participant. And when the responses are supportive and substantial, remarkable improvements in works of art and design can be made.

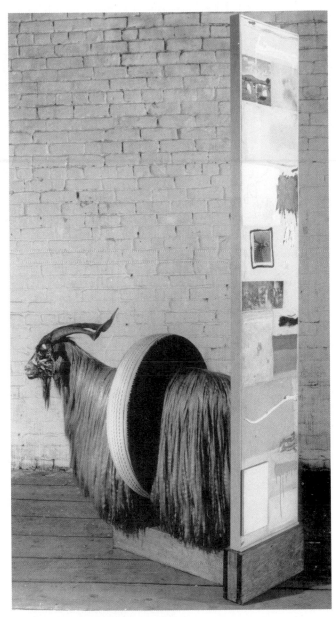

6.17 Robert Rauschenberg, *Monogram, 2nd State*, c. 1956. Combine: oil, paper, fabric, wood, plus rubber tire and stuffed Angora goat on wood, 115 × 32 × 44 in. (292 × 81.3 × 111.8 cm).

Profile:
Bob Dacey, Illustrator

Tell Me a Story: Illustrating *Miriam's Cup*

Bob Dacey is an internationally renowned artist whose drawings and paintings have been published as limited- and multiple-edition prints as well as in a wide range of books and periodicals, including *McCall's,* Ballantine Books, Book-of-the-Month Club, *Playboy*, and Scholastic Publications. His commercial clients include The White House, ABC, CBS, NBC, PBS, Mobil Oil, Sony, the U.S. Post Office, Air Japan, and many others.

Dacey has recently received a Silver Medal from the Society of Illustrators in New York for 1 of the 16 paintings he produced for Scholastic Publications illustrating a 32-page book, *Miriam's Cup,* which is themed on the Exodus of the Israelites from Egypt. The book tells the story of Miriam, the older sister of the prophet Moses. Dacey collected an extensive library of books on Egypt and spent almost a year on research. From costumes to musical instruments, Dacey insisted on getting all the details just right.

MS: Give me a bit of background on *Miriam's Cup*. What was the significance of this project, and what aspects of the story did you want to emphasize in the illustrations?
BD: *Miriam's Cup* gave me a chance to expand on my single-image work. I've always approached each illustration as a moment in time, as if it had a "before" and an "after." This book gave me a chance to push that much further. I started every painting by focusing on the emotion in the moment being depicted. I always ask myself: "What is the essence of this moment?" The composition follows. Shapes and values serve the emotional content, while movement is used to unify the composition.

MS: You have said that 75 percent of your work on this project was devoted to research. Can you describe your research, and tell me why it was so important?
BD: For *Miriam's Cup* I had to understand the culture of Egypt and the Jewish culture of the time. Fortunately, I've always had an extensive interest in both. My personal library contains more books on Egypt than the local library system. Research helped open new ideas, leading in some unexpected directions. Those bullrushes are one example. I looked up the word in three dictionaries and two encyclopedias. One of these sources mentioned that the bullrushes of ancient Egypt are papyrus, those beautiful fan-shaped reeds that can be fashioned into a kind of paper. Without that knowledge, the image I arrived at would have been impossible.

MS: I understand that you have a seven-step process by which you refine and expand your ideas. Can you describe this process as it applies to the cover image for *Miriam's Cup*?
BD: I first consider the intent of each painting: what must this piece communicate? In this painting I focused on Miriam's exuberance as she celebrates her escape from Egypt. Second, the composition must support my intent. The circular movement of the tambourine and flowers dominates this painting. The movement from the raised hand holding the tambourine, to Miriam's hair, to her face, and on to her cupped hand provides a secondary pattern. And, that cupped hand repeats the curve of the flowers. Third, the shapes depend on both the intent and the composition. If I am painting a very stoic character, I use a lot of verticals. Diagonals are used when the character or event is very dynamic. Value is fourth on my checklist. I assign value according to the mood of the painting. Lighter values are used for celebratory images, like this one; darker values dominate when the mood is somber. A mix of light and dark value is best. I base my compositions on the Golden Section [a classic use of proportion], and I often use a 60/40 proportion between light and dark values. Texture, step five, often results from the placement of shape and value—but it really deserves a place of its own, due to its importance as a constructive or destructive factor. When everything else works but the image

still suffers, textural discord is usually the culprit! Color comes next. I really have to have the other questions resolved first. Color without composition, value, or intent just doesn't cut it. This painting is dominated by rich pastel colors, which help convey the exuberant emotion.

All of this contributes to the overall image, the final step. If all of the preceding factors serve my intent, the image can emerge naturally and effectively.

MS: In addition to the extensive research you did for *Miriam's Cup,* it seems that you have a very wide range of interests in general.
BD: Well, everything feeds into my work—and I've always been interested in everything! My undergraduate majors included theater and anthropology before I settled on ad design as the field in which I finally got my degree. Now, my readings range from archaeology to philosophy to psychology to paleontology, and more. I'm also developing my interest in writing and plan to pursue a Masters in writing in order to increase my understanding of narrative.

MS: One of the questions my students often have is this: How do I get from where I am as a student to where you are as a professional?
BD: Focus on your goals, and research the field. Talk to professionals you admire. Set high standards for yourself, and be realistic about the level of professionalism and quality required.

MS: Any final bits of advice?
DB: Don't limit yourself. We all have great potential that serves the higher purpose of society. Pursue your goals with the knowledge that you can succeed. And, remain flexible and open-minded, so that you can redirect your efforts as opportunities present themselves. Read everything! Draw everything!

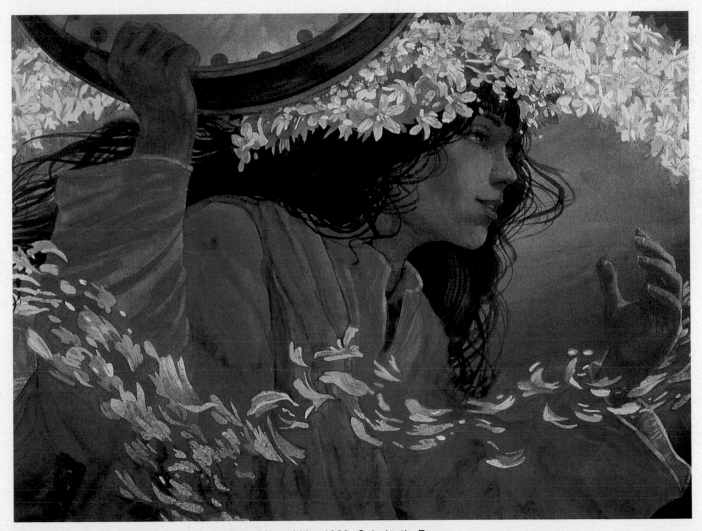

Bob Dacey, Cover of *Miriam's Cup* by Fran Manushkin, 1988. Scholastic Press.

Summary

- Through the use of critical thinking, an artist or designer can identify strengths and weaknesses in a project and determine the improvements that need to be made.

- Understanding the criteria on which a project will be judged helps focus critical thinking.

- Many artworks can be analyzed in terms of three basic aspects: form, subject, and content.

- Objective critiques focus on observable facts. Subjective critiques focus on feelings, intentions, and implications.

- Four common critique methods are description, cause and effect, compare and contrast, and greatest strength/greatest potential.

- Many critique methods may be used when you are working on a long-term project. In every case, there are three primary objectives: explore alternatives, delete nonessentials, and strengthen essentials.

- It is only by pushing a project to the limit that its potential will be fulfilled. Basic arithmetic, transformation, and reorganization can be used to increase compositional power.

- Responsibility for the success of a critique rests with each participant. Come with your mind open rather than your fists closed.

Keywords

cause-and-effect
 critique
compare/contrast
 critique
content
critique

descriptive
 critique
form
objective
 criticism
subject

subjective
criticism

1. What is the subject matter of the artwork? What is the artist trying to say about the subject?

2. To what extent and by what means have the compositional choices supported this intent?

3. Is the artwork contained or does it seem to expand into the viewer's space?

4. What is the spatial depth of the artwork? How does space contribute to the meaning of the work?

5. How have each of the principles of design been used in this artwork?

6. By what means is the artwork unified? What adds variety?

7. What will you remember about this artwork two weeks from now?

8. If you were to make a second version of this project, what changes would you make? Why?

Sylvia Barnet, *A Short Guide to Writing about Art*, 3rd edition. Scott, Foresman, 1989.

Terry Barrett, *Criticizing Photographs: An Introduction to Understanding Images*, 2nd edition. Mountain View, CA, Mayfield, 1996.

Otto G. Ocvirk, Robert E. Stinson, Philip R. Wigg, Robert O. Bone, and David L. Cayton, *Art Fundamentals: Theory and Practice*, 9th edition. Burr Ridge, IL, McGraw-Hill, 2002.

Henry M. Sayre, *A World of Art*, 3rd edition. Upper Saddle River, NJ, Prentice-Hall, Inc., 2000.

Henry M. Sayre, *Writing about Art*, 3rd edition. Upper Saddle River, NJ, Prentice-Hall, Inc., 1999.

Amy Tucker, *Visual Literacy: Writing about Art*. Burr Ridge, IL, McGraw-Hill, 2002.

Katherine Wetzel (photograph), Elizabeth King (sculpture), *Pupil* **from** *Attention's Loop* **(detail), 1987–90.** Installation at the Bunting Institute, Radcliffe College, 1997. Porcelain, glass eyes, carved wood, brass. One-half life size.

Three-Dimensional Design

As we begin our investigation of three-dimensional design, it is useful to consider both the similarities and differences between flat compositions and physical constructions. In both cases, basic design elements are organized to communicate ideas, express emotions, and create functional objects. The basic principles of design are used to create images and objects that offer an effective balance between unity and variety. And, in both two- and three-dimensional design, concept development and critical thinking are essential aspects of the creative process.

However, in two-dimensional design, we use our technical, perceptual, and conceptual skills to create flat visual patterns and convincing illusions. It is the viewer's *mental* response that gives the artwork meaning. By contrast, our experience in the three-dimensional world is physical and direct. As we traverse an architectural space, we alter our perception with each step we take. When we circle a sculpture, we encounter new information on each side. The materials used in the construction of a three-dimensional object determine its structural strength as well as its aesthetic appeal.

This physical connection gives three-dimensional design an inherent power. When we shift from an illusory world to a tangible world, a substantial shift in communication occurs. Confronted by the physical presence of a three-dimensional object, the viewer responds viscerally as well as visually.

This section is devoted to the elements, organization, and implications of three-dimensional design. The basic building blocks of three-dimensional design are discussed in Chapter Seven. In Chapter Eight, the principles of three-dimensional design are described, and the unique characteristics of various materials are considered. Chapter Nine is devoted to the ways in which artists have transformed their ideas into physical objects and to a discussion of differences between traditional and contemporary sculpture.

Three-Dimensional Design:
Aspects and Elements

Thinking in Three Dimensions

When we paint a realistic seascape, we use our technical, perceptual, and conceptual skills to create a convincing illusion. Like the letters in an alphabet, the lines, shapes, colors, and textures in the painting are combined to represent a three-dimensional world. Based on these clues, each viewer mentally reconstructs the setting. Those who have walked on a beach can create a detailed mental image of sea, sand, and sky. Others, who have never seen the ocean, may create a more fanciful world. For both viewers, however, it is the imagination that constructs the cosmos.

Our experience in the three-dimensional world is more direct. As we traverse an architectural space, we alter our perception with each step we take. When we circle a sculpture, we encounter new information on each side. Tangible evidence of three-dimensional design surrounds us. We can judge the strength of materials and the quality of construction by simply sitting in a chair. This physical connection gives three-dimensional design an inherent power.

Form and Function

To harness this power, we must first determine the purpose of a given design.

Sculpture is primarily designed to express ideas and evoke emotions. The sculptor explores an idea, chooses materials, and develops a composition based on his or her aesthetic intention. Public art projects, such as Maya Ying Lin's *Vietnam Memorial* (7.1), and ritual objects, such as Beau Dick's *Mugamtl Mask* (7.2), often commemorate historical events or express social values.

A designer uses the same mastery of composition and materials to create an object that is functional as well as beautiful. For example, when designing the aquatic gear shown in Figure 7.3, Oceanic had to create a product that was strong, flexible, durable, and relatively inexpensive to produce. For the designer, the **form,** or physical manifestation of the design, must fulfill its specific **function,** or purpose.

However, the basic elements and principles of design are the same for the artist and the designer. Both must organize line, plane, volume, mass, and

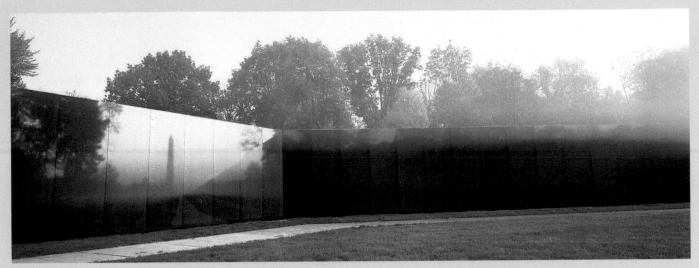

7.1 Maya Ying Lin, Vietnam Veterans Memorial, The Mall, Washington, DC, 1981–83. Polished black granite.

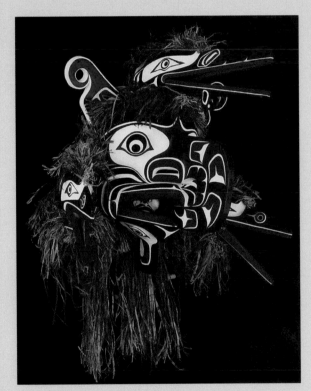

7.2 Beau Dick, Mugamtl Mask (Crooked Beak), 1993. Red cedar, cedar bark, paint, 24 × 26 × 16 in. (61 × 66 × 40.6 cm).

7.3 Aquatic gear used for snorkeling and scuba diving. Oceanic USA, San Leandro, CA.

space into coherent form. The structural integrity of a sculpture is just as important as the structural integrity of a wheelchair, and a teapot that is both beautiful and functional is ideal. By thoroughly exploring the elements of three-dimensional design and understanding their uses, both the artist and designer can create compelling work.

z axis

x axis

7.4 The three dimensions are defined through height, width, and depth.

A

B

C

7.5 Variations on a cube.

The Three Dimensions

Height, width, and depth are the three dimensions in three-dimensional design. In computer-aided design, these three dimensions are defined using the x, y, and z axes used in geometry (7.4). Using the cube as a basic building block, we can create many variations, working from the outside in or the inside out (7.5 A–C).

Drafting for Designers

As demonstrated by these five views of Jens-Rüdiger Lorenzen's *Ring* (7.6), a physical object looks quite different from the top, bottom, and side. **Orthographic projection** can be used to describe these views accurately. The word "orthographic" means "true picture." Lines are used to provide an indication of height, width, and depth. Unlike perspective drawing, which is designed to create the illusion of space, orthographic projection accurately delineates structural details.

An orthographic projection represents six views of a three-dimensional form. Imagine that your project is enclosed in a glass box (7.7A). As you look through the top, bottom, front, back and right and left sides, you can see six distinctive views. In effect, an orthographic drawing is created when you unfold and flatten this imaginary box (7.7B).

Orthographic projection is widely used in manufacturing because it offers a specific vocabulary and is based on shared conventions. Architects use orthographic projection to plan three-dimensional forms in large scale. The basic layouts shown in

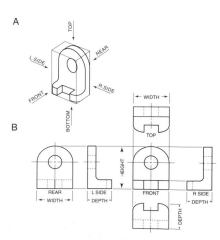

7.6 Jens-Rüdiger Lorenzen, *Ring*, 1992. Steel, argentan, 2⅕ × 2 in. (5.5 × 5 cm).

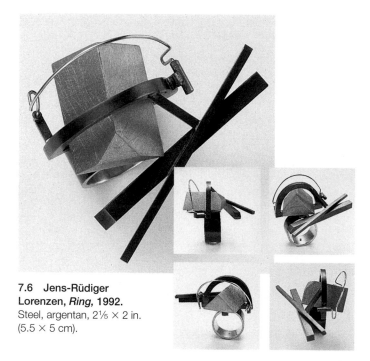

A

TOP

REAR

L SIDE

FRONT

R SIDE

BOTTOM

B

WIDTH

TOP

TOP

HEIGHT

REAR L SIDE FRONT R SIDE

WIDTH DEPTH DEPTH

DEPTH

7.7 Orthographic projection.

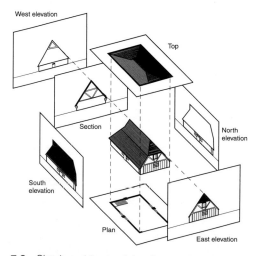

West elevation

Top

Section

North elevation

South elevation

Plan

East elevation

7.8 Simple architectural drawing.

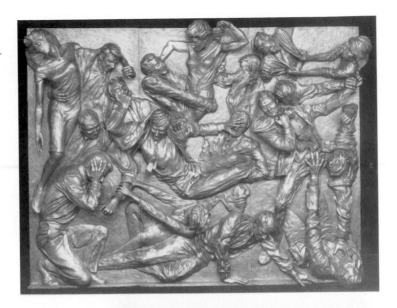

7.9　Robert Longo, *Corporate Wars* (detail), **1982.** Cast aluminum, lacquer on wood relief, 7 × 9 × 3 ft (2.1 × 2.7 × .9 m).

Figure 7.8 are standard. In architecture, the top view is called the **top** view, the bottom view is called the **plan** view, and the sides are designated as **elevations.** A **section** is used when a slice of the object must be shown. Dashed lines are used to indicate the outlines of shapes that are invisible from a given viewpoint.

Degrees of Dimensionality

The degree of dimensionality in sculpture and design varies widely. When developing a three-dimensional object, it is wise to consider at least four approaches to the third dimension.

Relief

When working in **relief,** the artist uses a flat backing (such as a wall or ceiling) as a base for three-dimensional forms. For example, Robert Longo's *Corporate Wars* (7.9) is like a sculptural painting. Using the boundaries created by the supporting wall and the four outer edges, it presents a group of white-collar warriors engaged in hand-to-hand combat. The figures are trapped, bound both to the backing and by their struggle for money.

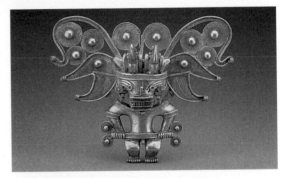

7.10　**Bat-Man Pendant, Columbia, Tairona, 1200–1600.** Gold.

Three-Quarter Works

A **three-quarter work** is designed to be viewed from the front and sides only. The Tairona pendant in Figure 7.10 is one example. Designed to be worn on the chief's chest during festive occasions, it is vigorously defined on the front and relatively plain on the back.

Freestanding Works

Freestanding works, or works **in the round,** are designed to be seen from all sides. When we circle August Rodin's *The Kiss* (7.11), we capture every nuance in the movement of the two figures. Details, such as the man's stroking hand and the woman's raised foot, give life to the inanimate stone.

7.11　**Auguste Rodin, *The Kiss*, 1886–98.** Marble, over life size.

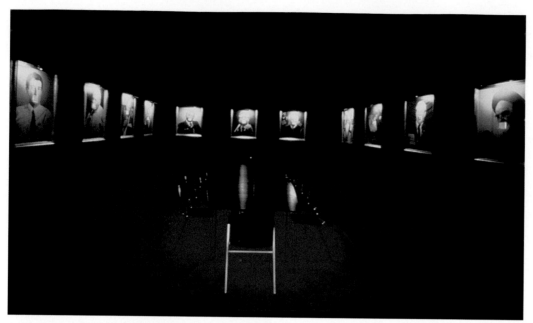

An **installation,** or **walk-through** work, may expand to fill an entire room. On entering Antoni Muntada's *The Board Room* (7.12), the viewer confronts 13 chairs facing a long table. In a reference to the Last Supper described in the Bible, these chairs are accompanied by photographs of contemporary religious leaders, from the Ayatollah Khomeini to Billy Graham. A small video monitor, inserted in the mouth of each man, plays a film clip showing him in action. In an installation of this kind, the viewer must enter the work physically as well as mentally.

The viewer plays an even more active role in Christian Marclay's *Amplification* (7.13). This installation consists of six photographic enlargements plus six additional images that were printed on translucent cotton scrim. Installed in the Swiss Pavilion at the 1995 Venice Bienniale, the images shift, merge, and divide, depending on the viewer's position.

7.12 Antoni Muntadas, *The Board Room*, 1987. Installation at North Hall Gallery at Massachusetts College of Art, Boston. Thirteen chairs placed around a boardroom table. Behind each chair is a photo of a religious leader, in whose mouth a small video monitor shows the leader speaking. Subjects include Ayatolla Khomeini, Billy Graham, Sun Myung Moon, and Pope John Paul II.

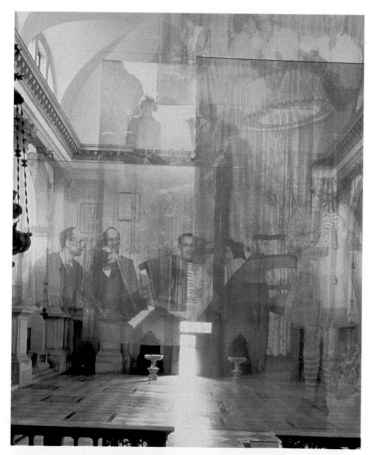

7.13 Christian Marclay, *Amplification*, 1995. Mixed media with six found prints and six photographic enlargements on cotton scrim. Dimensions variable. Installation at the Chiesa di San Stae, Venice, Italy.

Design Elements

Line

In three-dimensional design, **line** can be created through

- *A connection between points.* Two kinds of line are used in *Free Ride Home,* by Kenneth Snelson (7.14). The aluminum tubes provide a skeleton that becomes elevated when the connecting cables are attached. The resulting sculpture is dominated by diagonal lines that

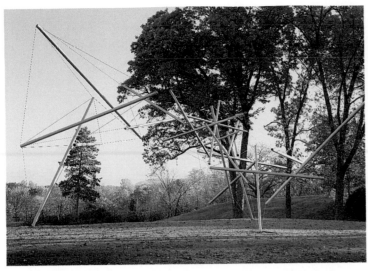

7.14 **Kenneth Snelson,** *Free Ride Home,* **1974.** Aluminum and stainless steel, 30 × 30 × 60 ft. (9.1 × 9.1 × 18.2 m). Storm King Art Center, Mountainville, NY.

7.15. **Ant Farm (Chip Lord, Hudson Marquez, Doug Michels),** *Cadillac Ranch,* **1974.** 10 Cadillacs. Amarillo, TX.

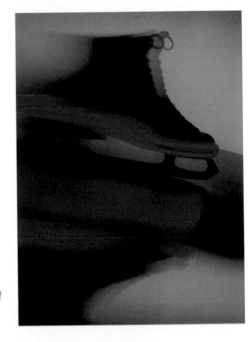

7.16 **Moira North and Rudi Stern,** *Neon Skates,* **1986.** Battery-operated neon skates for performance by The Ice Theater of New York, Moira North, director.

seem to defy gravity as they dance through the air.

- *A series of adjacent points.* The cars that make up Ant Farm's *Cadillac Ranch* (7.15) are distinct objects in themselves as well as the points that create a line of cars. Commissioned by a rancher in Texas, this sculpture has been described as a requiem for the gas-guzzling American automobile.[1]

- *A point in motion.* When a skater wears the *Neon Skates* by Moira North and Rudi Stern, she can literally create lines from a moving point of light (7.16). To create *A Line in the Himalayas* (7.17), Richard Long became the point in motion. As he walked, he paused to rearrange the stones on the trail to create a line. Because few of us will ever visit this remote site, the journey and the sculpture now exist as a line in a photograph.

Types of Line

Straight lines can slice through space with the speed and energy of an arrow in flight. Vertical lines tend to exaggerate height and add elegance to a design. Horizontal lines tend to increase visual and physical stability. Diagonal lines can add dynamism.

7.17 **Richard Long,** *A Line in the Himalayas.* Black-and-white photograph.

7.18 Mark di Suvero, *Ik Ook Eindhoven*, **1971–72** . Painted steel, 24 × 24 × 33 ft (7.3 × 7.3 × 10 m). In the background: ***Are Years What? (For Marianne Moore)*, 1967.** Painted steel, 40 × 40 ft × 30 ft (12.2 × 12.2 × 9.1 m).

7.19 Peter Pierobon, *Ladderback Chair.* Firm & Manufacturer: Snyderman Gallery.

7.20 José de Riviera, *Brussels Construction,* **1958.** Stainless steel, 46½ × 79 in. (118.1 × 200.6 cm).

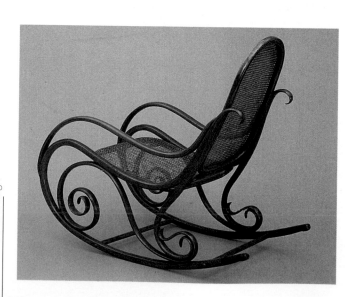

All three types of line are used in Mark di Suvero's *Ik Ook Eindhoven* (7.18) and Peter Pierobon's *Ladderback Chair* (7.19). The di Suvero sculpture is dominated by two horizontal I beams suspended from a vertical support. The diagonal lines that are connected to this primary structure emphasize the gravity of the artwork and add energy. On the other hand, it is the tall vertical back that transforms Pierobon's chair into a whimsical sculpture. Its exaggerated height pulls our eyes upward and provides a support for the jagged lines that create the rungs of the ladder.

Curved lines tend to flow though space more slowly, often encompassing all sides of an object to create a harmonious whole. In José de Riviera's *Brussels Construction* (7.20), a single line of steel activates a sculptural space. As the sculpture slowly rotates on its motorized base, the movement suggested by the line is accentuated by its physical rotation.

Curved lines can also suggest natural forms and forces. Gebrüder Thonet's *Rocking Chair* (7.21) was especially popular near the end of the nineteenth century, as interest in nature and natural forces blossomed both in Europe and America.

7.21 Gebrüder Thonet, Rocking Chair, c. 1860. Beech wood, cane, 37⅝ in. h. × 22¾ in. w. × 42½ in. d. (95.6 × 57.8 × 107.9 cm). Manufacturer: Gebrüder Thonet, Vienna, Austria.

7.22 Claire Zeisler, *Red Forest*, 1968. Dyed jute, 8 ft 2 in. h. × 7 ft 4 in. w. × 2 ft d. (249 × 224 × 61 cm).

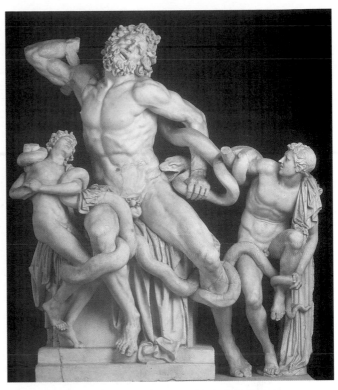

7.23 Laocoön and His Two Sons. Marble, 7 ft (2.13 cm).

Single lines, such as the steel rod in *Brussels Construction*, can bring a simple eloquence to an artwork. On the other hand, multiple lines can be used to create new sculptural forms. As shown in Claire Zeisler's *Red Forest* (7.22), many fiber works are created through the organization of multiple lines of thread, yarn, or other materials.

Uses of Line

Through their physical presence, **actual lines** can connect, define, or divide a design. The ancient Greek sculpture *Laocoön and His Two Sons* (7.23) depicts a scene from the Trojan War. When the Greeks offer a large, hollow, wooden horse to the Trojans, Laocoön warns against accepting the gift. The Greek goddess Athena then sends two serpents to attack and kill the seer, thus gaining entry into Troy for the Greeks hidden in the horse. In this sculpture, the writhing serpent compositionally connects the three terrified men while adding emotional power to this tale of Athena's wrath.

In Figure 7.24, dancers from the Nikolais Dance Theatre push against the elastic lines that define their space. It is the interaction between these boundaries and the dancers that gives this performance power.

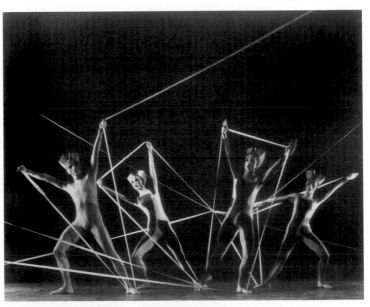

7.24 **The Nikolais Dance Theatre Performing *Sanctum.*** With Amy Broussard, Phyllis Lambat, and Murray Louis.

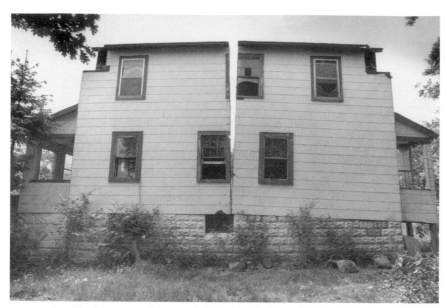

7.25 Gordon Matta–Clark, *Splitting: Exterior*, 1974. Black-and-white photograph.

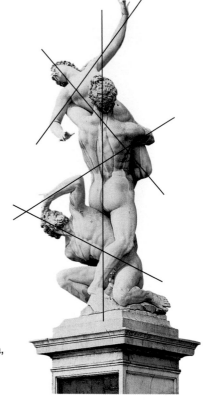

7.26 Giovanni da Bologna, *The Rape of the Sabine Women*, completed 1583. Marble. 13 ft 6 in. (4.1 m).

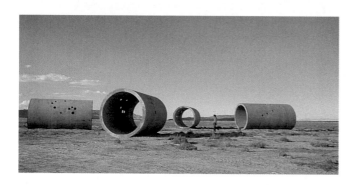

7.27 Nancy Holt, *Sun Tunnels*, 1973–76. Great Basin Desert, Utah. Four tunnels, each 18 ft long × 9 ft 4 in. diameter (5.5 × 2.8 m), each axis 86 ft long (26.2 m). Aligned with sunrises and sunsets on the solstices.

The line dividing Gordon Matta-Clark's *Splitting: Exterior* (7.25) changes an abandoned house into an evocative sculpture. Combining his background in architecture with a propensity for anarchy, Matta-Clark often seeks to "undo" a building and the social conditions that led to its construction.[2]

Implied lines can play an equally important role in a design. Such lines are created through mental rather than physical connections. *The Rape of the Sabine Women*, by Giovanni da Bologna (7.26), relies on a series of implied lines for its impact. Starting at the bottom and exploding upward, the repeated diagonals in the sculpture create a vortex as powerful as a whirlpool. At the bottom is the husband of the captured woman. In the center, a standing Roman soldier is intent on securing a wife for himself. The agitated movement culminates at the top with the extended arm of the embattled woman.

A **sight line** gives Nancy Holt's *Sun Tunnels* (7.27) its power. At first glance, the four 22-ton concrete tunnels seem static. Upon entering each tunnel, the viewer discovers a series of holes that duplicate the size and position of the stars in four

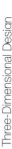

major constellations. The light pouring in through these holes shifts as the sun rises, travels across the sky, then sets. During the winter and summer solstices, the sculpture is further transformed as light from the rising and setting sun is framed by an alignment in the repeated circular shapes. Like a telescope, the massive cylinders are more important for the visions they create than as objects in themselves.

Shapes and Planes

A two-dimensional **shape** is created when any area is clearly separated from its surroundings (7.28). A shape can be created when a line connects to enclose or outline an area; when an area of color or texture is defined by a clear boundary; or when an area is surrounded by contrasting values, colors, or textures. For example, Jonathan Borofsky's *Man with Briefcase* (7.29) was created when a shape was removed from a steel plate. Raised to frame the sky, the static panel is constantly activated by the surrounding sky. Such a cutout is often called a **negative shape.**

Shapes that have been combined to create three-dimensional structures are called **planes.** For example, the linear skeleton of Gerrit Rietveld's *Red and Blue Chair* (7.30) clearly defines three-dimensional space. To support a human body, a structure with height, width, and depth had to be created. As intersecting elements in a cohesive structure, the plywood panels that form the seat and back are called planes, rather than shapes.

In his famous mobiles (7.31), Alexander Calder put simple planes in motion. Inspired by the delicate weights and balances he saw in the paintings of Piet Mondrian (see 3.35, page 3-12), Calder used these structures to represent the movement of heavenly bodies within the universe. The flat shapes and curving lines continually move, creating a variety of configurations.

7.28

7.29 Jonathan Borofsky, *Man with Briefcase*, 1987. Corten steel, 30 ft × 13 ft 6 in. × 2 in. (9.1 m × 4.1 m × 5 cm).

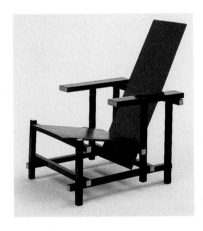

7.30 Gerrit Rietveld, *Red and Blue Chair*, c. 1918. Painted wood, 34⅛ in. h. × 26 in. w. × 33 in. d. Seat 13 in. h. (86.7 × 66 × 83.8 cm).

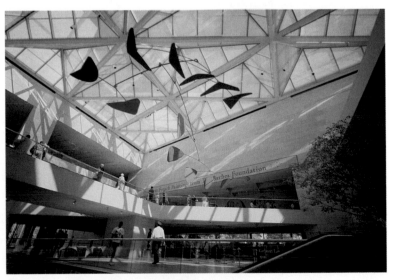

7.31 Alexander Calder, *Untitled*, 1976. Painted aluminum and tempered steel, 29 ft 10½ in. × 76 ft (9.1 × 23.2 m). National Gallery of Art, Washington, DC.

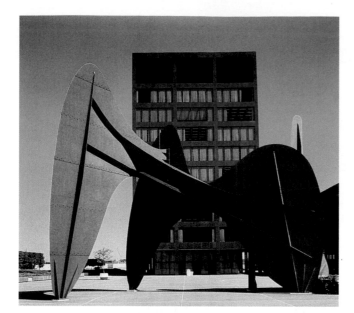

7.32 Alexander Calder, *La Grande Vitesse*, 1969. Painted steel plate, 43 × 55 ft (13.1 × 16.8 m). Calder Plaza, Vandenberg Center, Grand Rapids, MI.

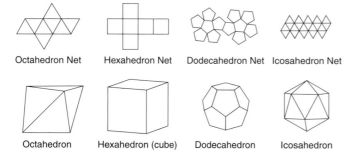

Octahedron Net Hexahedron Net Dodecahedron Net Icosahedron Net

Octahedron Hexahedron (cube) Dodecahedron Icosahedron

7.33 A variety of polyhedra

When slotted together, planes can create large-scale structures that are remarkably strong. With outdoor sculptures, such as Alexander Calder's *La Grande Vitesse* (7.32), structural integrity is essential. Located in a public plaza, the sculpture must withstand wind, rain, and snow while presenting minimal risk to pedestrians. Intersecting planes, combined with a ribbed reinforcement at stress points, have been used to create a durable structure.

Volume

A **volume** is an enclosed area of three-dimensional space. Cubes, cones, cylinders, and spheres are the most familiar volumes. Industrial designers often use a variety of **polyhedra,** or multifaceted volumes (7.33). Such volumes can be surprisingly strong. In an assignment at Ohio State University (7.34), students used polyhedra to construct their bristol board helmets.

While the size and shape of an interior volume is important in all three-dimensional work, the specific amount of enclosed space is essential to all containers, from architecture to glassware. *The Ginevra Carafe*, by Ettore Sottsass (7.35), easily holds a liter of wine. This narrow cylinder requires little table space and an extra disk of glass at the base provides weight and stability. An additional glass cylinder at the top ensures that the lid will remain firmly in place. For an industrial designer, a simple cylinder is rarely simple. The most elegant design will fail unless it fulfills its basic function.

The sphere Bill Parker used for *Jewel of Enlightenment (Hashi-no Toma)* (7.36) combines the aesthetic requirements of sculpture with the functional requirements of industrial design. Measuring 40 inches in diameter, the transparent globe is both a container for electricity and a compelling volume

7.34 OSU students used a variety of polyhedra to construct bristol board helmets. Charles Wallschlaeger, Professor Emeritus, The Ohio State University, Department of Industrial, Interior, and Visual Communication Design.

7.35 Ettore Sottsass, *Ginevra Carafe*, 1997. Manufactured by Alessi, Crusinallo, Italy.

7.36 Bill Parker, *Jewel of Enlightenment (Hashi-no Toma)*, 1989. 40 in. (101.6 cm) diameter sphere standing 5 ft (1.5 m) from the floor, glass sphere, gas mixture, high voltage at high frequency.

in itself. Positioned five feet from the floor, the sphere is slightly above ordinary eye level, making it even more awe-inspiring.

Mass

A **mass** is an enclosed area of three-dimensional substance.

The most massive sculptures are usually carved from a solid block of plaster, wood, clay, or stone. Just as Alexander Calder took advantage of the buoyancy of a thin plane to create the mobile, so Henry Moore took advantage of the imposing power of mass when he created *Locking Piece* (7.37A). In such structures, the **primary contours** (or outer edges) are complemented by the **secondary contours** created by internal edges (7.37B). As the viewer circles the form, these contours visually alternate, as the primary contours become the secondary contours, and the secondary contours become the primary contours.

Secondary Contours

Primary Contour

7.37A and B Henry Moore, *Locking Piece*, 1963–64. Bronze, 115 × 110¼ × 90½ in. (292 × 280 × 230 cm).

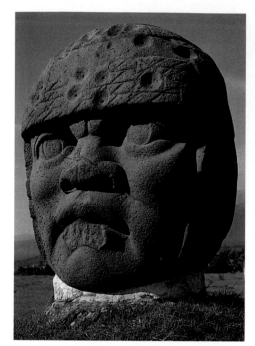

7.38 Colossal Head, 1300–800 B.C. Stone. Mexico, Olmec culture, Jalapa, Veracruz, Mexico.

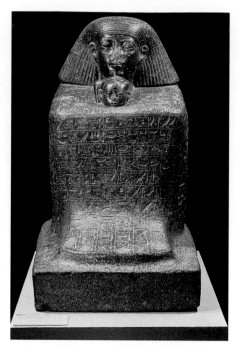

7.39 Senenmut with Princess Nefrua, The Deceased Moves on to the Other World, c. 1480 B.C. Thebes. Black granite, approximately 39½ in. (100.5 cm).

A massive form is often chosen when stability, permanence, and power are needed. A series of colossal heads produced by the Olmec people of ancient Mexico combines the abstract power of a sphere with the specific power of a portrait (7.38). The cubic block of stone that dominates *Senenmut with Princess Nefrua* (7.39) provides a surface for extensive hieroglyphic writing as well as an impressive support for the two heads. The pyramids at Giza offer a more extreme example. Built almost 5,000 years ago to memorialize and protect a deceased pharaoh, they remain solid and imposing.

Space

Space extends in all directions and has no boundary. A dialog between a structure and its surroundings is created as soon as an artist positions an object in space. An opening in a mass can increase our awareness of its solidity while the addition of a physical object can heighten our awareness of an architectural space. Space is the partner to substance. Without it, line, plane, volume, and mass lose both visual impact and conceptual purpose.

Presence and Absence

This interrelationship between space and substance is demonstrated in every area of three-dimensional design. David Smith's *Cubi XXVII* (7.40), constructed from nine solid cubic volumes and one cylinder, is dominated by a central void. The stainless steel construction activates and is activated by the empty space.

Space plays an equally important role in representational work. It is the open mouth in *Model of a Trophy Head* (7.41) that animates the mask. No facial

7.40 David Smith, *Cubi XXVII*, March 1965. Stainless steel, 111³/₈ × 87³/₄ × 34 in. (282.9 × 222.9 cm).

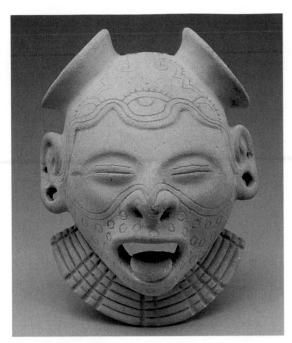

7.41　Model of a Trophy Head, Ecuador, La Tolita, 600
B.C.–400 A.D. Ceramic.

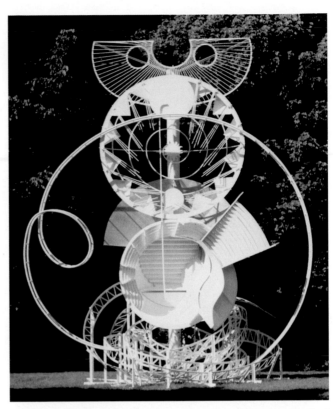

7.42　Alice Aycock, *Tree of Life Fantasy*, Synopsis of the Book of
Questions concerning the world order and/or the order of
worlds, 1990–92. Painted steel, fiberglass and wood, 20 × 15 × 8 ft
(6.1 × 4.6 × 2.4 m).

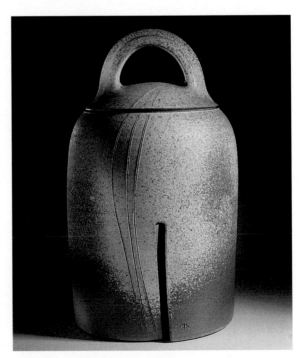

7.43　Karen Karnes, *Vessel*, 1987. Stoneware, wheel-
thrown, glazed, and wood-fired, 16½ in. h. × 10½ in. d.
(41.9 × 26.7 cm).

expression, however extreme, would be as lively if
the mouth were closed.

Open and Closed Space

Every three-dimensional object combines space,
volume, and mass. The proportion of open space
relative to solid substance is critical. The space in
Alice Aycock's *Tree of Life Fantasy* (7.42) is defined
by a filigree of delicate lines and planes. Inspired
by the double-helix structure of DNA and by
medieval illustrations showing people entering
paradise through a spinning hole in the sky, sculp-
tor Alice Aycock has combined a linear structure
with a series of circular planes. The resulting sculp-
ture is as open and playful as a roller coaster.

Karen Karnes's *Vessel* (7.43) is a closed structure,
consisting of a cylindrical form capped by a simple
lid. It is a functional pot, with the actual bottom of
the container placed just above the vertical slit.
Thus, the bottom third of the piece is like a
pedestal for the functional container. In its own
way, this pot is just as animated as the Aycock
sculpture. The surprise and contrast created by the
narrow channel of space completely redefine the
familiar vessel form.

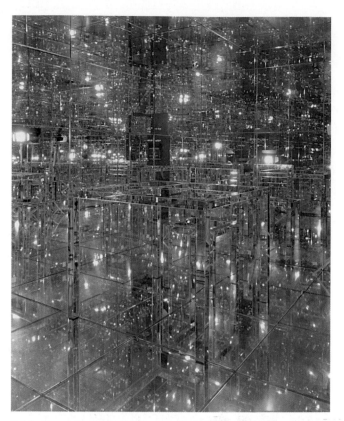

7.44 Lucas Samaras, *Mirrored Room*, 1966. Mirrors on wooden frame, 8 × 8 × 10 ft (2.44 × 2.44 × 3 m).

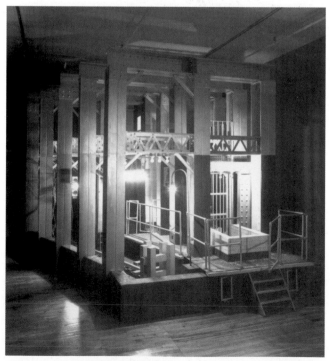

7.45 Donna Dennis, *Subway with Silver Girders*, 1981–82. Wood, masonite, acrylic, enamel, cellulose compound, glass, electrical fixtures, and metal, 12 ft 2½ in. w. × 14 ft 3½ in. d. (31 × 36 cm).

Physical Entry, Conceptual Entry

Some sculptures are designed to be entered physically. Lucas Samaras's *Mirrored Room* (7.44) multiplies and divides the reflection of each visitor who enters. Other sculptures can only be entered mentally. *Subway with Silver Girders* (7.45), by Donna Dennis, recreates in great detail the architecture and lighting we find in a subway station. Constructed at two-thirds the scale of an actual station, the sculpture presents a magical entry into a prosaic place. This subway station provides transportation for the mind, rather than the body.

Kinetic Form

Early examples of **kinetic form** include puppets, fountains, and clocks. Medieval clockmakers delighted in creating moving figures to accentuate the passage of time. The jousting knights at the top of the Wells Cathedral clock (7.46) were designed to be seen in motion.

When time is combined with space, a sculpture can become as lively as a theatrical stage. Beautifully engineered, Calder's large mobiles continually rotate with ponderous grace. Placed beneath the skylights in the National Gallery, *Untitled* (see 7.31) is further activated by changes in light and shadow.

Another celestial force activates Walter De Maria's *The Lightning Field* (7.47). Arranged in a

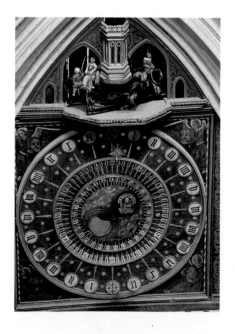

7.46 Wells Cathedral Clock, 1392–c. 1500. Double-twelve astronomical clock dial, with jousting knights. Wells, UK.

grid over nearly one square mile of desert, 400 steel poles act as a collection of lightning rods. Impressive even in daylight, the site becomes awe-inspiring during a thunderstorm. Lightning jumps from pole to pole and from sky to earth, creating a remarkable display of pyrotechnics.

Texture

Texture refers to the visual or tactile quality of a form. The increased surface area of a volume, combined with the physical immediacy of sculpture, heightens the impact of texture in all types of three-dimensional design. The surface area shifts and turns, enclosing the physical volume.

Degrees of Texture

Variations in the surface of a volume may be subtle. In *Blackware Storage Jar*, by Maria Montoya Martinez and Julian Martinez (7.48), a polished, reflective surface is combined with a smooth, matte surface. The tactile and visual contrast between the two surfaces is minimal. Visible yet unobtrusive, the geometric and organic patterns enhance the jar but never compete with the purity of the graceful form.

Gertrud and Otto Natzler used a very different approach for *Pilgrim Bottle* (7.49). The volume as well as the textural surface is exaggerated. Between the narrow neck and compressed base, the jar bulges out in a circular shape, as magical and as pockmarked as the surface of the moon. The unusual union between volume and surface, combined with the intriguing title, invite intellectual speculation. Who is the pilgrim, and what might this bottle contain?

Uses of Texture

Texture can enhance or deny our understanding of a physical form. In Figure 7.50, the lines carved into the surface of the vessel increase its dimensionality. Concentric circles surrounding the knobs at the base of each handle create a series of visual targets that

7.47 Walter De Maria, *The Lightning Field*, 1977. Near Quemado, NM. Stainless steel poles, average height 20 ft 7½ in. (6.1 m), overall 5,280 × 3,300 ft (1,609.34 × 1,005.84 m).

7.48 Maria Montoya Martinez and Julian Martinez, *Blackware Storage Jar*, 1942. Hopi, from San Ildefonso Pueblo, NM. Ceramic, 18¾ in. h. × 22½ in. d. (47.6 × 57.1 cm).

7.49 Gertrud Natzler and Otto Natzler, *Pilgrim Bottle*, 1956. Earthenware, wheel-thrown, and glazed, 17 × 13 × 5 in. (43.2 × 33 × 12.7 cm).

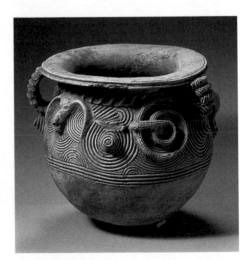

7.50 Globular Vessel with Inverted Rim, tenth century, Igbo, Nigeria. Terracotta, 16 in. (40.6 cm).

7.51 Detail of Maya Carvings on the "Nunnery," at Uxmal, Mexico. Stone.

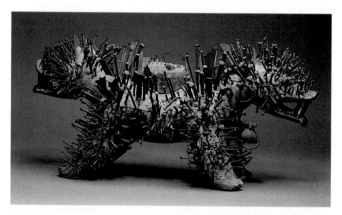

7.52 *Two-Headed Dog,* **Vili, Zaire.** Wood, resinous mass, metal, 13¾ in. (34.9 cm).

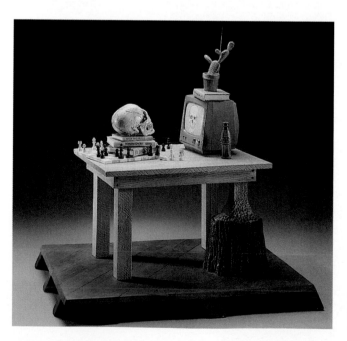

circle the globe, while additional grooves accentuate the surface of the sturdy handles.

By contrast, the patches of green and brown paint on the sides of a battleship are designed as camouflage. By mimicking visual information from the surrounding environment, the sailors seek to *minimize* the solidity of the ship. An invisible ship creates an elusive target.

Textural Animation

Many textures animate the surface of the "Nunnery," a Mayan building that adjoins the Pyramid of the Magician in Uxmal, Mexico (7.51). Human and animal figures in high relief are surrounded by bricks arranged in diagonal, vertical, and horizontal patterns. Curving lines have also been carved into the stone walls. The highly ornamented building seems alive with energy.

Two-Headed Dog (7.52), constructed by the Vili people in Zaire, generates even more energy. This simple wooden figure bristles with blades of iron and nails of various sizes. The embodiment of a powerful spirit, this guardian figure is provoked to attack wrongdoers through the use of verbal commands as well as the embedded nails.

Characteristic and Contradictory Textures

Every material has its own native textural properties. Fluid materials such as clay, glass, or metal can easily be formed into a wide variety of textures. Gold, which may occur in nature as dust, in nuggets, in veins, or in branching form, can be cast, hammered, or soldered. Despite the adaptability of most materials, however, we are accustomed to their use in specific ways. The gleaming reflective surface of a steel teapot, the transparent and reflective qualities of glass, and the earthy functionality of clay fulfill our expectations.

When a material is used in an uncharacteristic way, or when strange textures are added to familiar forms, we must reappraise both the material and the object it represents. Except for the wooden platform

7.53 Robert Notkin, *Vain Imaginings,* 1978. White earthenware, glaze, brass, redwood, white cedarwood, 16 × 13½ × 16½ in. (40.6 × 34.3 × 41.9 cm).

and brass screws, Robert Notkin's *Vain Imaginings* (7.53) is made of clay. The textures of wood, plastic, glass, and bone have been skillfully imitated. Clay is very unlike any of these materials, and a purist may argue that such mimicry violates its inherent nature. On closer examination, however, we can see a perfect match between the image and the idea. The table, which symbolizes the world, supports a chess set, suggesting risk, and a television set, which presents an illusion. The ceramic skull is placed on top of four books titled *The Shallow Life, Moth and Rust, Vain Imaginings,* and *By Bread Alone*. The image on the screen repeats the skull. The clay itself suggests impermanence (as in "he has feet of clay") and mortality (as in "earth to earth, dust to dust, " which is said during many funerals). In this masterwork of imitation, ceramicist Robert Notkin has created a "fake" sculpture for a false world.

Doormat by Mona Hatoum (7.54) offers an even more disorienting reinterpretation of a familiar object. Constructed from steel pins, this mat is part of a series of political art projects by Palestinian artist Mona Hatoum. Commenting on the realities of racism, Hatoum suggests that for African Americans, the opportunities offered by the Civil Rights movement may seem as illusory as a welcome mat made of pins.

Textural Elaboration

Given the versatility of materials, it is hardly surprising that artists rarely accept a surface at face value. Modifications in the surface can enhance the power of a sculpture or create very different effects from the same basic material. In *Rock Bible* (7.55), Takako Araki used three kinds of texture to animate an artwork and expand its meaning. The words on the pages of the *Bible* provide one texture, the rough surface of the disintegrating book provides a second, and the characteristic texture of the clay provides a third.

In Seiji Kunishima's *Suspended Pool '86–9* (7.56), a highly polished top surface becomes a pool of visual water while the pitted bottom surface reconfirms the solidity of the black granite. Through variations in the surface, the sculptor has created very different effects from a single block of stone.

7.54 Mona Hatoum, *Doormat,* **1996.** Stainless steel and nickel-plated pins, glue and canvas, 1 × 28 × 16 in. (2.5 × 71 × 40.6 cm).

7.55 Takako Araki, *Rock Bible,* **1995.** Ceramic, silkscreen, 8¼ × 23⅝ × 16½ in. (21 × 60 × 42 cm).

7.56 Seiji Kunishima, *Suspended Pool '86–9,* **1986.** Black granite, 12⅝ × 34⅝ × 26⅜ in. (32 × 88 × 67 cm.)

7.57A Hue

7.57B Value

7.57C Intensity

7.57D Temperature

Color and Light

Many color definitions and applications remain the same whether we are creating a three-dimensional or a two-dimensional form. Each color has a specific **hue** (7.57A), which is determined by its wavelength. **Value** (7.57B), the lightness or darkness of a color, helps determine legibility. **Intensity,** or **saturation** (7.57C), refers to the purity of a color. **Temperature** (7.57D) refers to the psychological heat attributed to a color.

Artists and designers use harmony and contrast to create unity and to evoke an appropriate emotion. These aspects of color and light are of particular importance to interior and exhibition designers. A restaurant that is beautifully designed and attractively lit will invite diners to enter. Color and light inform as well as invite visitors to an exhibition, encouraging the audience to follow a specific traffic pattern or to explore a hidden space. Color clues can also delineate the boundaries between various sections in an exhibition, thus dividing it into manageable parts.

Harmony and Discord

Selecting the right colors for a product and determining the degree of color **harmony** can make or break a design. The triadic harmony used in *Smartronics Learning System* by Fisher-Price (7.58) creates an attractive educational toy for young children. The large red and blue buttons are easy to push and invite even the most skeptical child to play. A very different type of harmony is offered in *Kita Collection*, by Toshiyuki Kita (7.59). These simple chairs with their removable seats can be color-customized to fit into any interior. By contrast, the green, blue, ochre, and black used by George Sowden in Figure 7.60 push this chair beyond any traditional system of color harmony. The combination of pastels and black is both distinctive and unconventional.

7.58 *Smartronics Learning System* **by Fisher-Price.**

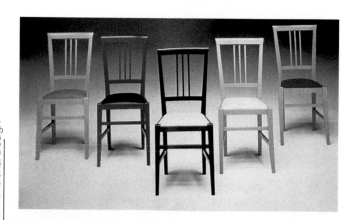

7.59 Toshiyuki Kita, *Kita Collection* of Chairs with Removable Seats for Stendig International Inc. Beech wood frame and upholstered seat.

7.60 **George J. Sowden,** *Palace Chair,* **1983.** Designed for Memphis. Lacquered beech wood and stained beech wood.

7.61 **Michael Graves, Alessi Coffee Set.** Glass, silver, mock ivory, and Bakelite.

7.62 **iMacs in 5 Colors.** To illustrate the contrast between opacity and transparency, and to show how iMacs are distinguished from monochromatic competitors. Chiat/Day Advertising.

Contrast

Designers often use **contrasting colors** to accentuate the function of a product or to create a distinctive image. Contrasting colors and materials distinguish Michael Graves' Alessi coffee set (7.61). The fragile, transparent glass is protected by metallic armor. These bands of metal accentuate the cylindrical forms, while the blue handles and bright red accents further animate the set. A similar **contrast** between opacity and transparency combined with a surprising use of color helped distinguish the iMac computer (7.62) from its monochromatic competitors. As with the Fisher-Price toy, color helped to personalize the iMac, inviting new users to play.

Color and Emotion

The emotional implications of color can be demonstrated by a visit to any car dealership. Bright red, black, or silver sports cars become oversized toys for single drivers, while more subdued colors are often used for the minivans and station wagons favored by families. In Figure 7.63, color is used to add a sporty look to quite a different vehicle. This manual wheelchair, designed by Adele Linarducci for children ages 6 to 11, gives the user a psychological boost while encouraging the development of physical strength and dexterity.

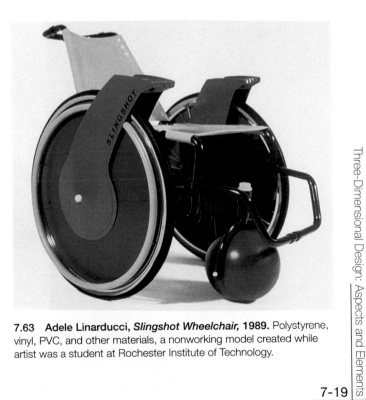

7.63 **Adele Linarducci,** *Slingshot Wheelchair,* **1989.** Polystyrene, vinyl, PVC, and other materials, a nonworking model created while artist was a student at Rochester Institute of Technology.

7.64 George Segal, *Walk, Don't Walk*, 1976. Museum Installation, with viewer. Plaster, cement, metal, painted wood, and electric light, 104 × 72 × 72 in. (264.2 × 182.9 × 182.9 cm).

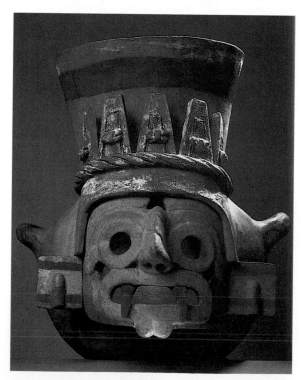

7.65 Ritual Vessel Depicting Mask of Tlaloc, Aztec, Mexico, Tenochtitlan, 1400–1521. Ceramic.

On the other hand, it is the absence of color that brings power to the life-sized figures in George Segal's installations. Despite their proximity to the viewer and their large scale, the white figures in *Walk, Don't Walk* (7.64) are drained of individuality and are emotionally distant. Here, an antiseptic white is used to suggest alienation.

Symbolic Color

All cultures use color symbolically. Ritual vessels, masks, banners, or regal costumes are rarely muted. On the contrary, the visual and psychological impact of color is used very deliberately, especially by political and religious leaders. The scarlet-and-gold feather cloak used by a Hawaiian king symbolized his power and was highly visible during ceremonies. In Europe, purple has long been associated with royalty, and scarlet red is a color associated with the British monarchy.

Symbolic color is culturally based and color associations vary. For example, the color yellow signifies the direction north in Tibet but the qualities of light, life, truth, and immortality to the Hindu.[3] Blue represents mourning in Borneo, while in New Mexico it is painted on window frames to block entrance by evil spirits. In ancient times, blue represented faith and truth to the Egyptians yet was the color worn by slaves in Gaul.[4]

The blue face that dominates the mask of the Aztec god Tlaloc in Figure 7.65 is both symbolically and visually appropriate. Symbolically, the blue represents sky and the rain that Tlaloc calls forth to nourish the crops. Visually, the contrast between the warm, reddish clay and the sky-blue paint increases the impact of the ferocious face.

7.66

7.67 Maria Lugossy, *Amphitheatrum*, **1983.** Laminated plate glass, cut, ground, and polished, 3½ in. h. × 30⅞ in. d. (8.7 × 78.5 cm).

7.68

Color of, on, and within an Object

Color and light also have many unique qualities when used three-dimensionally. As shown in Figure 7.66, a designer can use the existing color *of* the object, apply color *on* the object, and use color *within* the object.

Depending on the material used, these simple variables can be used to compress or visually expand a design and to invite or deny entry into a piece. In Maria Lugossy's *Amphitheatrum* (7.67), clear and green glass has been laminated to create an elegant, stratified structure. A network of parallel lines radiates from the center, accentuating the circular form. As we walk around the sculpture, we can explore the structural and coloristic nuances of each layer as well as the overall form. In Figure 7.68, simple volumes and parallel lines create a series of containers for 12 pieces of chocolate. Starting with a simple black outer box, moving to the beautifully striped, pink-and-black inner box and ending with the individually wrapped treats, the user gradually reveals a hidden treasure. The packaging provides an aesthetic experience as well as a functional container. Hidden in this box, even mediocre chocolate would seem special.

A very different combination of parallel lines and surface color animates *Eagle Transforming into Human* by Terry Starr (7.69). The beautiful wood grain that flows through the image suggests a metamorphosis. Bold, black and red accents at the eyebrows, mouth, and eyes arrest this movement and suggest the piercing gaze of the fierce bird.

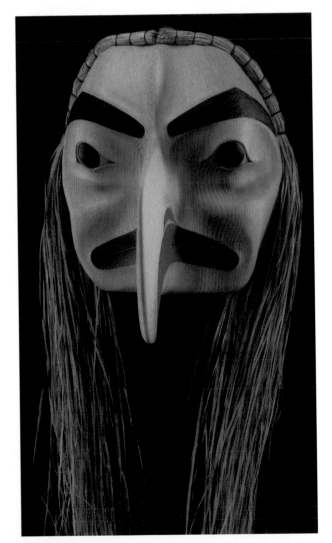

7.69 Terry Starr (Tsimshian), Eagle Transforming into Human, **1989.** Red cedar, cedar bark, paint, 15 × 11 × 15 in. (38.1 × 27.9 × 38.1 cm).

7.70 Andy Goldsworthy, *Maple Leaves Pinned with Thorns*, Plano, IL, 1992.

7.71 Daniel Chester French, Abraham Lincoln (Detail of Seated Figure), 1911–22. Full-size plaster model of head of marble statue, Lincoln Memorial, Washington, DC, 1917–18. Head 50½ in. h. (128.3 cm), total figure 19 ft h. (5.8 m).

7.72 NASA Exhibit at the 1989 Paris Air Show. Designers: Bill Cannan, Tony Ortiz, H. Kurt Heinz. Design Firm: Bill Cannan & Co.

Finally, the shredded cedar-bark hair that frames the mask increases the human quality of the bird-like face.

Color is equally important in the work of Andy Goldsworthy. Using natural materials in natural settings, he often creates intense areas of red, green, or gold to alert the viewer to junctions, boundaries, or unusual configurations between objects in the landscape. These accents of color are especially powerful when the surrounding colors are subdued. The scarlet maple leaves in Figure 7.70 create a flaming arrow shape that activates the negative space between two tree trunks. If we are alert, after seeing this sculpture we will become more aware of the negative spaces throughout the landscape and begin to see all tree trunks differently.

Light of, on, and inside an Object

Light can heighten a sense of volume, define or obscure an interior, attract an audience, or create a mystery. A three-dimensional object can gain or lose power depending on the lighting used. Daniel Chester French's *Head of Abraham Lincoln* (7.71) loses dimensionality when lit from below but gains a quality of animation. When lit from above, the same figure seems more formidable and commanding. Theatrical set designers and installation artists are masters of light. To suggest the mystery of space travel and highlight individual displays, the designers of a 1989 NASA exhibition used bright pools of light within an otherwise dark display (7.72).

Indeed, light can create a composition. In Larry Bell's *The Iceberg and Its Shadow* (7.73), multiple plates of glass create reflections that continually shift, separate, and surround the viewer. This combination of volume, space, and light creates a world that is both physical and illusory. Like a house of mirrors, the sculpture is both tangible and transient.

The relationship between color and light is further demonstrated by Suzanne Harris's *Won for the One* (7.74). A plate glass cube has been suspended from the ceiling using piano wire. Lit by beams of red, yellow, and green light on three sides, the glass transmits a circle of radiant white light below the cube, illuminating the floor.

7.73 Larry Bell, *The Iceberg and Its Shadow,* 1977. Clear and gray glass coated with inconel, 60 in. w. (152.4 cm), 57 in. to 100 in. h. (144.8 to 254 cm). Busch Lobby, MIT Permanent Collection.

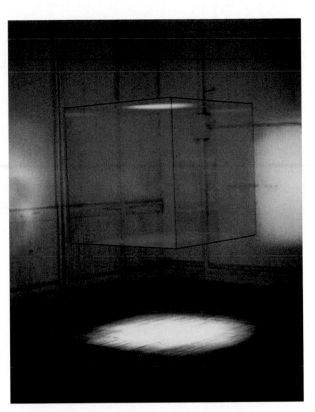

7.74 Suzanne Harris, *Won for the One,* 1974. ¼ in. plate glass cube, 4 ft (1.22 m), 300 lb, piano wire, lit three sides, red, yellow, green, casting a white "shadow" floating effect.

Light can even become a sculpture. James Turrell's *Afrum-Proto* in Figure 7.75 was created when a powerful beam of light struck the corner of an empty room.

The Complexity of Three-Dimensional Design

Completing a new project every week or so is quite common in a basic two-dimensional-design class. On the other hand, a month of work may be devoted to a major project in a three-dimensional-design class. The materials may be less familiar, the construction methods are more time-consuming, and most important, the multiple surfaces of a physical object present a particular challenge. Used poorly, the various elements may clash, resulting in a disjointed composition. Used well, each element contributes to a complex and cohesive design. Awareness of the interrelationship of all design elements, attention to detail, and a willingness to experiment with many possibilities are essential qualities of a good designer.

7.75 James Turrell, *Afrum-Proto,* 1966. Quartz-halogen projection, as installed at the Whitney Museum of American Art, New York, 1980.

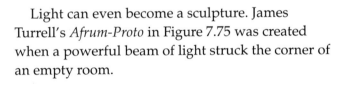

Profile:
Rodger Mack, Sculptor

The Oracle's Tears: Conception, Composition, and Construction

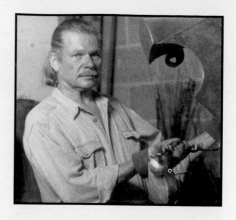

Rodger Mack is an internationally renowned sculptor best known for his work in bronze and steel. His work, which is equally divided between commissions and self-initiated projects, is included in the collections of the Museum of Modern Art in Barcelona, Spain, the Grand Hotel in Guayaquil, Ecuador, the Arkansas Arts Center Museum, Little Rock; the Albrecht-Kemper Museum of Art in St. Joseph, Missouri, the Munson-Williams-Proctor Institute in Utica, New York, and the Everson Museum in Syracuse, New York. Mack, who has always used travel as a major inspiration for his imagery, is the recipient of a Fulbright grant for study in Italy, grants from the National Endowment for the Arts and the New York State Council on the Arts; and workshop grants for projects in England, Barcelona, and South Africa.

My meeting with Mack was delayed for almost a year due to his many commissions and elaborate projects. Finally, with the departure date for his yearlong trip to Italy fast approaching, we got together over lunch. I had always admired Mack's abstract sculptures that so elegantly combine power and grace. Indeed, I expected our conversation to focus on the elements and principles of design. As you will see, the conversation that actually developed was equally devoted to concepts and composition.

MS: One of the biggest questions my students have is this: How do I get from where I am, as a beginner to where you are, as a professional? Could you describe that path briefly?

RM: I always knew that I wanted to study art, and I began my undergraduate work at the Cleveland Institute of Art, planning to become an automotive designer. In the fourth year of the five-year BFA program, I had the good fortune of being picked by General Motors to participate in an experimental summer internship. It was an exciting time: I was well paid, and directly involved in my intended career.

I realized, though, that automotive design limited my possibilities as an artist, and I turned instead to a major in sculpture, with a minor in ceramics. At Cleveland, ceramicist Toshiko Takaezu was a great influence. She taught me a level of professionalism and an understanding of a new level of quality, both in concept and in craft. I was further influenced by Toshiko's teacher, Maija Grotell, who had developed the ceramics program at Cranbrook, where I did my graduate work. At the age of 70, she was continuing to do pioneering work with ceramic glazes.

Finally, as an apprentice to William McBey, I learned about working on commissions and the realities of day-to-day work in the studio. With sculpture, cleaning up is important: if you don't control your work space, it will control you!

MS: How do you get started on a sculpture?

RM: I don't have to get started, because I never stop! I'm always watching, listening, and thinking. When I do stop the merry-go-round long enough, I record my ideas in a notebook. I always carry this notebook on the plane: while others read, I draw. I always have many more ideas than I can handle: I wish I could build them as fast as I can think them up.

Whenever I stop generating new material, I just visualize the inventory of sculptural parts I already have in the studio. Putting them together in new ways provides even more possibilities: an idea gets me working with the metal, which then generates more ideas. I always try to have something ready for casting each month, if only to add to this inventory of parts.

I only make maquettes when they are required for a commission. The small scale of a maquette is so different from the actual scale of the piece, especially for a major project. I remember one maquette I made for a commission in North Little Rock, Arkansas. It was made of bronze, and I charged them $200 for the maquette. Before

the meeting to review the project, one of the city councilors put a box of multicolored sticks of plasticine in front of me and said, "Next time, make it out of this." He was annoyed that I had made the maquette in bronze. In fact, the city council was against the project—they just didn't want to spend the money—but a grassroots civic group saw the importance of the work, and the commission was approved.

MS: How do you choose which of the drawings to make into sculptures?
RM: I might choose a drawing because I can't see the other side. I get curious. There is something in the drawn side that compels me to spend the time and money on the sculpture, so that I can see the other side. Drawings that I really finish are the sculptures that I never make.

MS: It seems that you actually "draw" with the metal; that is, you approach it with the same openness with which I approach a sheet of paper. How malleable is it?

RM: Just malleable enough! I like it because it is NOT easy. It is hard, and you have to really commit yourself to the piece. I am most intuitive when I am working with existing fragments from my inventory, essentially collaging parts together. Starting with a collection of parts, I create connections, often heating a bar of bronze to just the right temperature and bending it to form a bridge or activate a space. I see the space around each volume as much as I see the volume itself.

MS: Please describe your latest piece, *The Oracle's Tears*.
RM: I've always been drawn to ancient cities and architectural forms, and have been working with mythological themes for the past six years, with a series of maidens, a minotaur, a Trojan horse, and several oracles completed so far. When I visit these ancient civilizations, it saddens me that they are gone, destroyed to make way for new civilizations.

This sculpture is made from six major parts. The column is the dominant feature, structurally and conceptually. Just above it, I have placed a form which has reappeared in my work for 30 years, the Oracle. It is like an image on a tarot card, the hanging man, perhaps. A smaller piece, based on a shape I found in a market in Athens, connects the oracle and the column. On the top, the "capitol" repeats the triangular spaces seen throughout the sculpture. The tears are created by the three descending lines. The base is the final element. It provides a stable support and adds a sense of completion.

MS: How was the sculpture made?
RM: I used a combination of fabrication and casting. The oracle form was made by cutting out shapes from a sheet of ⅛ inch bronze and welding them together. The tears and the column were cast in sections, then welded. A potassium dichloride patina, applied using a blowtorch, gives the piece its golden color.

MS: This is an especially important piece for you, I think.
RM: You always hope your latest piece is the best! But yes, it combines ideas I've been working on for three years, with an overall theme which first appeared in my work when I was in undergraduate school.

MS: What advice do you have for a beginning student?
RM: Well, there's the old cliché: Learn the rules before you break them. Always worked for me!

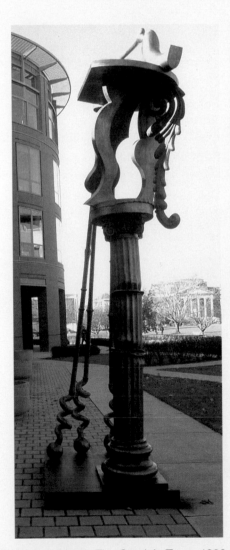
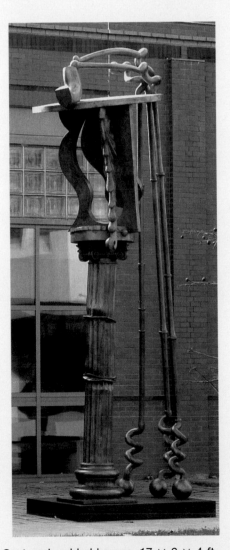

Rodger Mack, *The Oracle's Tears*, 1999. Cast and welded bronze, 17 × 6 × 4 ft (5.18 × 1.83 × 1.22 m)

Summary

- The first step in creating a design is to understand its purpose. A sculptor seeks to convey ideas and express emotions. A craftsperson or designer is equally concerned with the function and the beauty of an object. Form and function must match.

- The elements of three-dimensional design are line, plane, volume, mass, space, texture, and color and light.

- By accurately describing six views of an object, orthographic projection provides a way to develop accurate plans for three-dimensional designs.

- Artworks can vary in dimensionality—from relief, which uses a flat backing to support dimensional forms, to freestanding sculptures, which must be viewed from all sides. Exhibitions and installations push this effect even further, as the viewer must enter and physically explore the artwork.

- A line can connect, define, or divide a design. It can be static or dynamic, increasing or decreasing the stability of the form.

- A shape is created when a line connects to enclose an area; when an area of color or texture is defined by a clear boundary; or when an area is surrounded by a contrasting color, value, or texture. A plane is a shape that has been modified or combined to create a three-dimensional structure.

- A volume is an area of enclosed three-dimensional space. Volume is often created when planes are connected or multiplied to create an enclosure. A mass is an enclosed area of three-dimensional substance. Both volume and mass can be perceived through primary contours and secondary contours.

- Space is the partner to substance. Without it, line, plane, volume, and mass lose meaning.

- Texture refers to the visual or tactile surface of an object. It can be used to increase, decrease, or add complexity to our understanding of a physical object.

- Like texture, the color of, on, and within an object can increase or decrease our understanding of the form. Light can enhance our perception of a three-dimensional form, attract an audience, or be used as a material in itself.

Keywords

actual lines	function	negative shape	section
characteristic texture	harmony	orthographic projection	shape
contradictory texture	hue	plane	sight line
contrast	implied lines	plan view	space
contrasting colors	installation	polyhedra	symbolic color
elevation	intensity	primary contour	temperature
form	in the round	relief	texture
freestanding	kinetic form	saturation	three-quarter work
	light	secondary contour	value
	line		volume
	mass		walk-through

As you begin your studio work, consider:

1. What are the unique characteristics of each of the elements of three-dimensional design? How does a line contribute to the composition, compared to the contribution of a plane, volume, or mass?

2. Specifically, what role does each element play in your project?

3. What is the relationship between substance and space? Are they equally balanced, or does one dominate? What would happen if this relationship was substantially exaggerated—if the composition was 90 percent space and 10 percent mass, for example?

4. To what extent can texture, color, or light enhance, conceal, or add complexity to the form?

5. Is your object equally interesting on all sides? Are there any surprises?

Gaston Bachelard, *The Poetics of Space*, Maria Jolas, translator. Boston, Beacon Press, 1969.

Frank Ching, *Architecture: Form, Space, and Order*, 2nd edition. New York, Van Nostrand Reinhold, 1996.

John Lidstone, *Building with Wire*. New York, Van Nostrand Reinhold, 1972.

Charles Wallschlaeger and Cynthia Busic-Snyder, *Basic Visual Concepts and Principles for Artists, Architects and Designers*. Dubuque, William C. Brown, 1992.

Howard Hibbard, *Masterpieces of Western Sculpture from Medieval to Modern*. New York, Harper and Row, 1980.

Three-Dimensional Design:
Organization

The power of each element of design can be amplified through careful composition. In Alice Aycock's *Tree of Life Fantasy* (see 7.42, page 7-13), line, plane, and space have been combined to create an exuberant dance. Every element is both dependent on and supportive of every other element. Martin Puryear's *Seer* (8.1) consists of a closed volume at the top and an open volume at the bottom. The horn-shaped top piece is powerful and imposing, while the open construction at the bottom invites us to enter and visually explore the structure. Here, the contrast between open and closed volumes adds both power and mystery to the piece. And graceful metal lines have been combined with a series of contoured volumes to create the elegant and utilitarian form of Niels Diffrient's *Freedom Chair* (8.3).

Artists and designers use each element very deliberately. Extensive exploration and experimentation are used to determine the best means of integrating disparate parts into a cohesive whole. Dozens of drawings or three-dimensional models may be produced before an idea is finalized. As shown in Stan Rickel's *Teapot Sketches* (8.2), a physical object can be made manifest through an almost endless variety of forms.

8.1 Martin Puryear, *Seer,* 1984. Water-based paint on wood and wire, 78 × 52¼ × 45 in. (198.2 × 132.6 × 114.3 cm).

8.3 Niels Diffrient, *Freedom Chair,* 1999. Die-cast aluminum frame with fused plastic coating; four-way stretch black fabric.

8.2 Stan Rickel, *Teapot Sketches,* 1991. Mixed medium, 12 × 12 in. (30.5 × 30.5 cm).

8.4 Michel-Ange Slodtz, *St. Bruno*, 1744. Marble.

8.5 Jean-Antoine Houdon, *St. Bruno of Cologne*, 1766. Stucco.

Principles of Three-Dimensional Design

Balance

For the architect, sculptor, and industrial designer, physical balance is a structural necessity, while visual balance is an aesthetic necessity. As with physical balance, **visual balance** requires equilibrium, or equality in size, weight, and force. Especially in three-dimensional design, visual balance can be created through absence as well as presence. Space is always the partner to structure.

The expressive power of **balance** can be seen in two contrasting interpretations of a single subject. Figures 8.4 and 8.5 both represent St. Bruno, an eleventh-century Catholic saint who founded an austere, contemplative religious group known as the Carthusian Order. Members lived in caves and devoted their time to transcribing manuscripts, to meditation, and to prayer.

The first statue, completed by Michel-Ange Slodtz in 1744, dramatizes a pivotal moment in Bruno's life. Preferring his contemplative existence to the power and prestige of a more public life, Bruno rejects promotion to the office of bishop. Slodtz used **asymmetrical balance** to express this dramatic moment. Asymmetrical balance creates equilibrium between visual elements that differ in size, number, weight, color, or texture. In this case, the small bishop's hat, proffered by the angel in the lower right corner, is the focal point of the entire sculpture. The much larger figure of St. Bruno recoils when confronted by this symbol of authority. As a result, the small hat matches the power of the saint.

A very different interpretation of the life of St. Bruno is given in the second sculpture. Completed by Jean-Antoine Houdon in 1766, Figure 8.5 emphasizes the contemplative nature of the Carthusian Order and its founder. Using **symmetrical balance,** Houdon presents a dignified, introspective man. If we divide the figure in half from top to bottom, the two sides basically mirror each other. This saint is a philosopher, very much at peace with the choices he has made. Just as asymmetrical balance is appropriate for the dramatic moment represented by Slodtz, so symmetrical balance is ideal for the serenity shown by Houdon.

A third common approach to balance is shown in this mask of the Native American Bella Coola tribe (8.6). With **radial balance,** all visual elements in a composition are connected at a central point. Here,

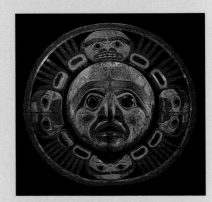

8.6 Bella Coola Mask Representing the Sun, from British Columbia, before 1897. Wood, diameter 24¾ in. (63 cm).

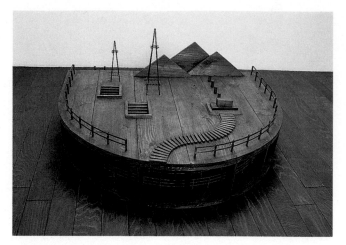

8.9 Akira Kamiyama, *This Is My Place, I Suspect*, 1984. Japanese cedar, yarn, oil stain, 19⅞ × 39⅜ × 32¼ in. (50.5 × 100 × 82 cm).

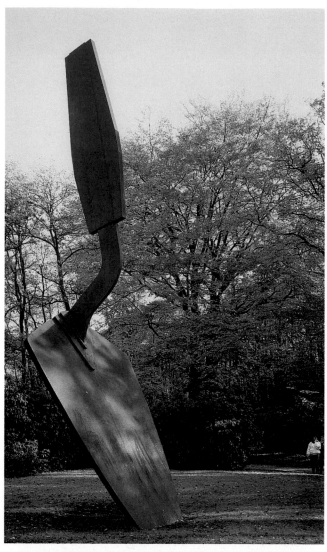

8.7 Claes Oldenburg, *Trowel*, 1971. Steel, painted blue, 38 ft 4⅔ in. × 11 ft 11⅔ in. (11.7 × 3.7 m).

8.8 Home Pro Garden Tool Line. Designers: James E. Grove, John Cook, Jim Holtorf, Fernando Pardo, Mike Botich. Design Firm: Designworks/USA.

the center of the face creates the pivot point. Radiating outward in all directions, the composition is an effective representation of the sun.

Scale and Proportion

Scale is determined by the size of an object relative to its surroundings. Almost 40 feet tall, Claes Oldenburg's *Trowel* (8.7) is both witty and imposing. What manic gardener has left this giant tool in the park? We are familiar with gardening tools which can be handheld (8.8). Any change in the "normal" size of an object immediately attracts our attention.

A very different approach to scale transforms *This Is My Place, I Suspect* (8.9) by Akira Kamiyama. The small brown structure looks like an architectural model for an antiquated factory. When combined with the industrial site, this very personal title suggests a mystery. What can possibly occur in this place? Connecting the small scale with the evocative title, we may conclude that this is the place for almost anything, from meditation to murder. Unable to enter this miniature piece physically, we must explore the site conceptually, using the clues presented as a springboard for our imagination.

Proportion refers to the relative height, width, and length of visual or physical elements *within* a composition. Any change in proportion substantially affects all aspects of a three-dimensional form. Three variations of Constantin Brancusi's *Bird in Space* are shown in Figures 8.10 to 8.12. In *Maiastra* (8.10), the

abstract bird form is dominated by the egg-shaped torso that tapers into the folded wings at the bottom and the raised head at the top. This bird is approximately 3 times taller than it is wide. Brancusi further abstracted *Golden Bird* (8.11) and elongated the body. The bird is now 7 times taller than it is wide and an elaborate base adds even more height to the sculpture. With *Bird in Space* (8.12), Brancusi elongated the form even more and added an expanding "foot" below the folded wings. This bird is almost 10 times taller than it is wide. By lengthening the columnar structure in this final version and carefully tapering the sculpture near the base, Brancusi made this simple sculpture fly.

In industrial design, changes in proportion can enhance or diminish function. The five gardening tools in Figure 8.8 are all based on the same basic combination of handle, blades, and simple pivot. Variations in proportion determine their use. The short-handled pruner in the lower-left corner is used to trim twigs and small branches from shrubs. It must fit comfortably in a single hand. The proportions of the lopper in the opposite corner are much different. Its 20-inch-long handle provides the leverage needed to cut heavier branches from small trees. For the industrial designer, function often determines proportion.

As with all design decisions, choosing the right scale and proportion greatly increases expressive power. Giovanni Bologna's *Apennine* (8.13) is scaled to overwhelm the viewer with a sense of the mountain spirit's presence. His human frame far exceeds human scale, and the surrounding trees and cliff appear to diminish in proportion to him.

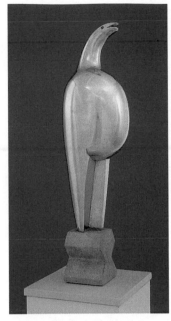

8.10 Constantin Brancusi, *Maiastra,* 1912. Polished brass, 29⅞ × 7¼ × 7½ in. (75.7 × 18.5 × 19 cm).

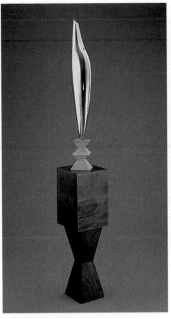

8.11 Constantin Brancusi, *Golden Bird,* 1919, pedestal c. 1922. Bronze, stone, and wood, 37¾ in. h. (95.9 cm), base 48 in. h. (121.9 cm).

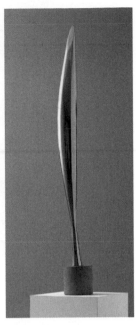

8.12 Constantin Brancusi, *Bird in Space,* 1928. Bronze (unique cast), 54 × 8½ × 6½ in. (137.2 × 21.6 × 16.5 cm).

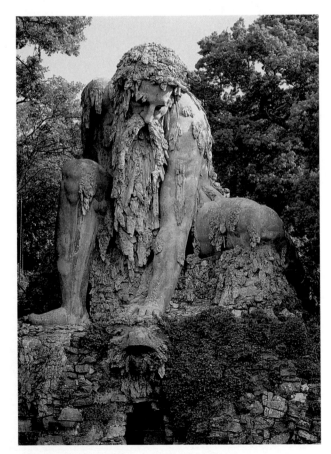

8.13 Giovanni Bologna, *Apennine,* 1580–82. Stone, bricks, mortar. Villa di Pratolino, Florence region, Italy.

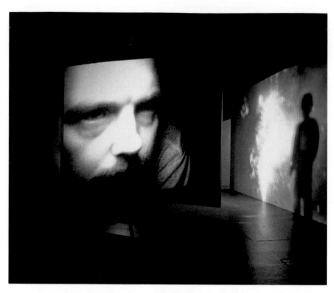

8.15 Bill Viola, *Slowly Turning Narrative*, 1992. Video/sound installation.

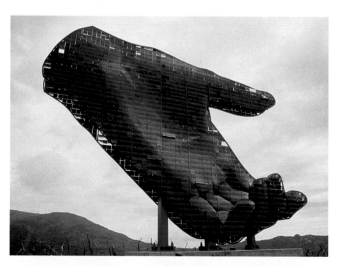

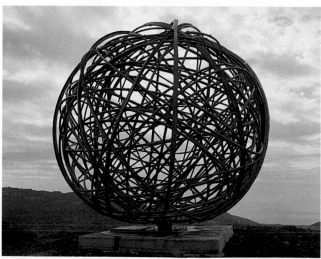

8.16 Todd Slaughter, *Mano y Balo* (details), 1997. Aluminum and steel, hand 27 × 40 × 4 ft (8.2 × 12.2 × 1.2 m), ball 20 ft (6 m) diameter. Overlooking the Straits of Gibraltar.

Proportional extremes can be equally expressive. Standing just over five feet tall, Alberto Giacometti's *Chariot* (8.14) offers a somber analysis of the human condition. The solitary figure is delicately balanced on gigantic wheels, which then rest on two small pedestals. The entire form is linear, as if distilled down to the barest essentials. Both the chariot and the figure it transports are precariously balanced and seem very vulnerable.

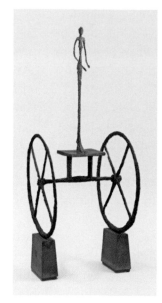

8.14 Alberto Giacometti, *Chariot,* 1950. Bronze, 57 × 26 × 26⅛ in. (144.8 × 65.8 × 66.2 cm).

Proximity

Physical impact and conceptual complexity can also be strengthened through **proximity,** the distance between the parts of a structure or between an object and the audience. While *This Is My Place, I Suspect* (8.9) conceptually pulls the viewer into a miniature world, the various components of Bill Viola's *Slowly Turning Narrative* (8.15) physically surround the viewer. This installation consists of a 9 × 12 ft screen, which slowly rotates on its central axis in a darkened room. Black-and-white projections of a man's face can be seen on one side; on the other, color images of children, people at a carnival, and other playful images are shown. One side of the screen is a mirror, which reflects distorted images back into the room. The combination of the moving images and moving screen is hypnotic. In close proximity to the viewer, the enormous faces have an overwhelming impact.

A combination of scale, proximity, and wind animates Todd Slaughter's *Mano y Balo* (8.16). Commissioned by the port city of Algeciras in Spain, the monumental sculpture rests on a bluff overlooking the Strait of Gibraltar. The 40-foot-long hand may be catching or throwing the 20-foot-tall ball which is positioned 50 feet away. Slaughter notes that, "The implied action of the hand . . . metaphorically

alludes to the history of exchange of religion, art, power and conflict between the European and African continents." To heighten the metaphor, the hand has been designed to disappear when the wind blows. On the front and back, one-thousand movable panels that are attached to the armature have been covered with the photographic image of a hand. A strong wind shifts the panels from their vertical position to a horizontal position, causing the hand to dissolve visually into the surrounding sky.

Contrast

Just as similarity in line, space, texture, volume, and color can be used to unify a sculpture, so **contrast,** or difference, can be used to create **variety.**

Contrast can appear in many forms and in varying degree. Two strongly opposing systems dominate Arnaldo Pomodoro's *Sphere* (8.17). The imposing spherical volume seems to have been eaten away by some external force, leaving a pattern of rectilinear teeth across its equator. This creates a strong contrast between the massive structure and the invading space, and adds rhythm and texture to the spherical form.

Loops (8.18), by Mary Ann Scherr, presents a contrast between movement and constraint. A curving plane encircles the user's throat, providing protection but restricting motion. Below, the suspended rings sway with every movement of the body, creating a dynamic counterpoint to the constraining collar.

Water animates Pol Bury's *Fountains at Palais Royal* (8.19). The design relies on three major elements. The site itself is dominated by the regularly spaced columns that are so characteristic of neo-classical architecture. The polished steel spheres, poised within the bowl of each foundation, reflect these columns and the shimmering water, which provides the third element in the design. In a sense, the spheres serve as mediators between the rigid columns and the silvery water. Like the columns, they are simple volumes, arranged in a group. Like the water, they seem fluid as they reflect the moving water and the passing clouds. In this project, unity and variety have been combined to create an elegant and intriguing sculpture.

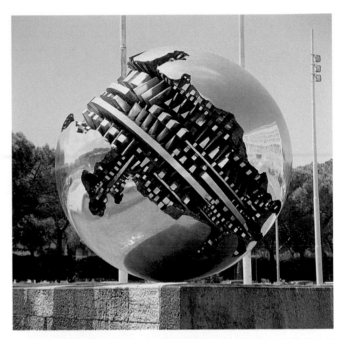

8.17 Arnaldo Pomodoro, *Sphere,* **1965.** Bronze, 47 in. (119.4 cm) diameter. Ministero degli Esteri, Rome.

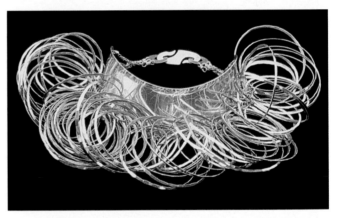

8.18 Mary Ann Scherr, *Loops,* **1988.** Sterling silver neckpiece, 8½ × 4¾ × 5 in. (21.6 × 12.1 × 12.7).

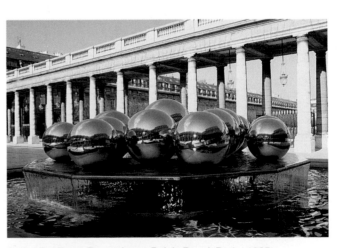

8.19 Pol Bury, *Fountains at Palais Royal,* Paris, 1985.

8.20 Le Corbusier, *Interior, Chapelle de Ronchamp*, Notre-Dame-du-Haut, Ronchamp, France, 1950–55.

8.21 Magdalena Abakanowicz, *Standing Figures* (Thirty), **1994–99.** Bronze, overall 54 ft 3 in. × 19 ft 8 in. (16.55 × 6 m).

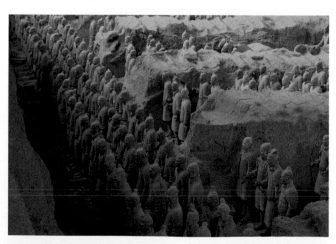

8.22 Tomb of Emperor Shih Huang Ti, 221–206 B.C.
Painted ceramic figures, life size.

Finally, strong contrast between light and dark adds both visual and emotional impact to architect Le Corbusier's *Interior, Chapelle de Ronchamp* (8.20). Light enters the darkened church through the narrow, stained-glass windows. Expanding into broad beams as it passes through the thick walls, it pours into the spaces, as liberated as the spirit.

Repetition

Repeated use of any aspect of design is called **repetition.** Repetition is often used to unify elements within an artwork or to quantify an elusive idea. For example, the 30 statues in Magdalena Abakanowicz's *Standing Figures* (8.21) are unified by their similarity in size, shape, and solemnity. Variations in each cast bronze surface provide a degree of individuality. Often interpreted as victims of war, the hollow, headless figures seem frozen in time, offering a silent testimony to a tragic past.

The 6,000 clay soldiers filling the tomb of Emperor Shih Huang Ti (8.22) demonstrate a different use of repetition. The emperor, best known for unifying China and building the Great Wall, may have sought companionship as he faced his death, or wanted a memorial to his accomplishments. His large army of ceramic soldiers could serve either purpose.

Sherrie Levine's *La Fortune* (8.23) demonstrates a third use of repetition. Our sense of reality is challenged when we encounter these six billiard tables. The identical arrangement of the balls seems impossible: the balls would be randomly distributed in six actual games. Here, a very ordinary scene becomes mysterious, even nightmarish, due to relentless repetition.

Grids

Highly repetitive artworks can be mind-numbing or mind-expanding, depending on the intention and execution of the work and on the response of the audience. Let's start with a simple **grid.** It offers a matrix for thought, nothing more. The most patient viewer may begin to see subtle variations in space or imagine a game of tic-tac-toe. Less patient viewers will find the work meaningless.

To reach a broader audience, most artists add information to this basic structure.

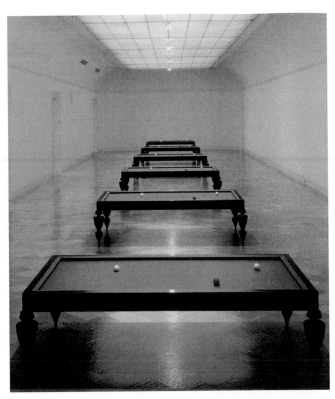

8.23 Sherrie Levine, *La Fortune* (After Man Ray) 1–6, 1990. Felt, mahogany, resin, 33 × 110 × 60 in. (84 × 280 × 153 cm).

8.24 Leonardo Drew, *Number 56,* 1996. Rust, plastic, wood, 113 × 113 in. (287 × 287 cm).

8.25 Mona Hatoum, *Current Disturbance,* 1996. Wood, wire mesh, lightbulbs, timed dimmer unit, amplifier, four speakers, 9 ft 2 in. × 18 ft × 16 ft 6 in. (279 × 550.5 × 504 cm).

In *Number 56* (8.24), Leonardo Drew poured rust into hundreds of plastic bags that were then connected to a wooden support. The rust, so suggestive of decay, and the relentlessly numbered plastic specimen bags present a dialog between order and chaos. On a purely visual level, the resulting order and disorder offer a hypnotic combination of monotony and mystery.

In *Current Disturbance* (8.25), Mona Hatoum used a grid for unity and a sequence of lights for variety. A single, clear lightbulb has been placed in each compartment within the structure. Controlled by a computer, these lights flicker in various patterns, from near darkness to a crescendo of illumination when all are lit. A single lit bulb in the center of the piece and the grid structure itself are the only constants.

Daniel Buren's *The Two Plateaus* (8.26) offers another variant on the grid. This public art project, located in the Palais Royal in Paris, covers a 1,000-square-foot plaza. The striped cylinders range in height from about two to six feet. Mimicking the columns in the building and organized on the pavement like players on a checkerboard, they bring both energy and humor to the site.

8.26 Daniel Buren, *The Two Plateaus,* 1985–86. 1,000-square-foot sculpture for the Cour d'Honneur, Palais Royal, Paris. Black marble, granite, iron, cement, electricity, water.

8.27 David Watkins, *Torus 280 (B2)*, 1989. Neckpiece, gilded brass, 11 in. (28 cm).

8.28 David Watkins, *Torus 280 (B1)*, 1989. Neckpiece, gilded brass, 11 in. (28 cm).

8.29

Rhythm

Repetition with variation creates rhythm. Most of us first encounter rhythm through music or dance. Musically, rhythm is defined as the organization of sound in time. Through a combination of sound and silence, rhythm can become amazingly complex. Meter (the basic pattern), accents (which emphasize specific notes), and tempo (the speed with which the music is played) can be combined to create a dazzling array of songs.

Just as a musician creates a deliberate pattern connecting sound and silence, so the artist can create rhythm using space and form. For a sculptor, **rhythm** can be defined as the sequential organization of multiple forms in space. Variations in the basic pattern and the rate of change combined with the use of accents can enhance or detract from the concept being communicated. As with music, the number and distribution of beats create the rhythm. In David Watkins's *Torus 280 (B2)* (8.27), the consistent order of the circular shapes creates a slow, regular pattern. When the number of circles multiplies in *Torus 280 (B1)* (8.28), the **tempo,** or pace, increases. As the neckpiece expands outward, the space between the circular openings also expands, creating greater variety in form. Variations in the size and location of the circles create a very different effect in Figure 8.29. With fewer openings in the circle and greater variety in the shapes, the rhythm becomes quiet and graceful.

The multiple views offered by physical objects accentuate the importance of rhythm. The fluid movement of the four women circling an exuberant musician creates a joyous dance in Jean-Baptiste Carpeaux's *The Dance* (8.30). Our eyes follow the turning heads, clasped hands, and swirling arms as they move in, out, and around in space. A similar rhythm animates Steve Woodward's *Model of Proposal for Concourse Commission* (8.31). The plywood vortex seems to rise out of the floor to collect in a spinning disk at the top, then descend again, in an endless pattern. When combined with the spinning effect, this up-and-down movement gives the design great vitality.

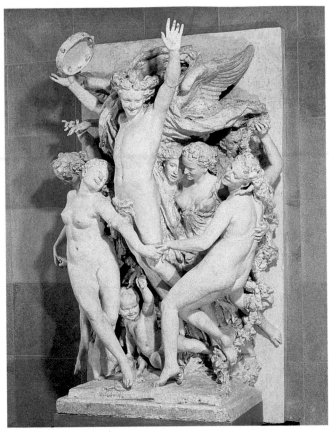

8.30 Jean-Baptiste Carpeaux, *The Dance* **(after restoration), 1868–69.** Marble, 7 ft 6½ in. (2.3 m).

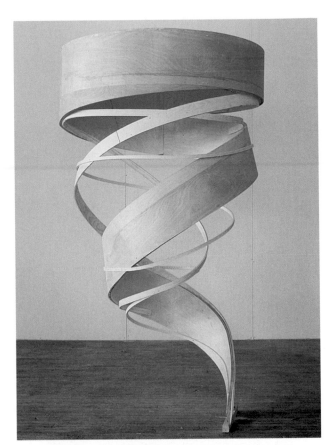

8.31 Steve Woodward, Model of Proposal for Concourse Commission, 1987. Wood, 13¾ × 8 × 7½ in. (34.9 × 20.3 × 19 cm).

In contrast, the rhythm in Louise Nevelson's *Luminous Zag: Night* (8.32) is relentless and percussive. Within the grid, each box contains a highly agitated mix of diagonal and horizontal forms that open and close as decisively as pistons in an engine. Each rhythmic "beat" in this sculpture is sharp and distinct.

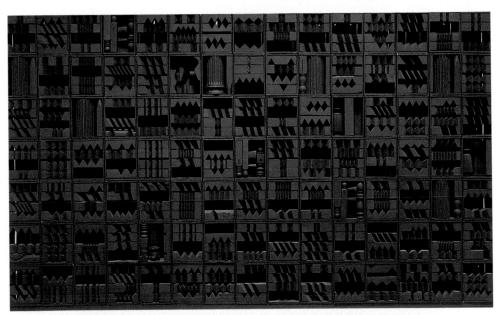

8.32 Louise Nevelson. *Luminous Zag: Night,* **1971.** Painted wood, 105 boxes, total 10 ft × 16 ft 1 in. × 10¾ in. (304.8 × 490.3 × 27.3 cm).

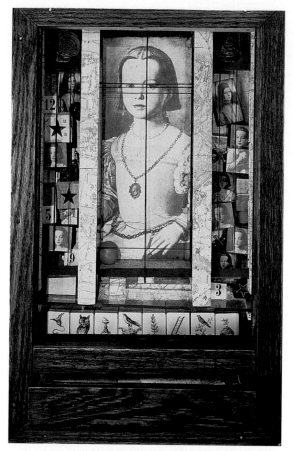

8.33 Joseph Cornell, *Untitled (Medici Princess)*, c. 1948.
Construction, 17⅝ × 11⅛ × 4⅜ in. (44.8 × 28.3 × 11.1 cm).

8.34 Portrait Vessel of a Ruler, Moche, 250–500 A.D.
Ceramic.

Composition and Construction

Choice of Materials

The materials used in a project may affect the range of possible solutions. In selecting a material, consider these qualitites in relationship to your intended design.

- *Strength*. How much weight can a given material support? What is its breaking point when stressed?

- *Workability*. How difficult is it to alter the shape of a material? Does it cut and bend easily?

- *Durability*. How long must an object last? In what context will a sculpture be shown? The hard basalt used for many Egyptian sculptures has endured for millennia, while the flexible fabric used in a temporary installation may last less than a year.

- *Weight*. A material that is too light for a given purpose can be as problematic as a material that is too heavy. What is the function of the design, and how can weight serve that function?

- *Cost*. Can the material chosen be obtained easily and at a reasonable cost? If your budget is limited, expensive materials will have to be removed from consideration.

- *Toxicity*. Many plastics produce toxic gases when cut, etched, or burned. Paints and solvent may require the use of masks and gloves and often present significant disposal problems. Is the ventilation of your workplace appropriate for your work process? Are less toxic materials available?

- *Function*. Most important, how appropriate is a given material for a particular purpose? A teapot will be useless if the material used is porous, and a chair that is too difficult to construct can never be mass-produced. Any material chosen must serve both the structural and aesthetic needs of the physical object.

Construction Methods

Compositional choices are strongly influenced by the construction method used. The two most common methods of construction are addition and subtraction.

In an **additive** process, the artwork is constructed from separate parts that have been connected using glues, joints, stitching, or welds. **Assemblage** is one additive method. Using objects and images that were originally created for another purpose, Joseph Cornell created a whole series of evocative box structures, such as Figure 8.33. Many of these assemblages were designed to honor specific people, past or present. **Modeling** is an additive process often used by ceramicists. Pinching and pushing this pliable material, skillful potters and ceramicists can make both functional and sculptural objects (8.34)

In a **subtractive** process, the artist removes materials from a larger mass, gradually revealing the sculpture within the stone or other material. **Carving** is the most common subtractive method. Traditional carvers, such as the Tlingit man shown in Figure 8.35, follow a methodical process, beginning with a drawing on the cedar pole, making a rough cut, then refining and finishing the totem pole.

Connections

Physical and visual **connections** are equally important in three-dimensional design. Visual connections can compositionally unify multiple surfaces, while physical connections can increase strength, flexibility, functionality, and stability.

Connections can be created

- Through **contact** (8.36A)
- Through **junctions** (8.36B)
- Through **joints** (8.36C)

Physical connections are critically important to woodworkers. Through years of experimentation, carpenters have developed dozens of specific joints and splices. Mary Miss' *Staged Gates*, shown

8.35 Tlingit Totem Carver, 1996. Southeast Alaska.

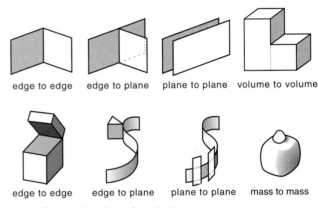

edge to edge edge to plane plane to plane volume to volume

edge to edge edge to plane plane to plane mass to mass

8.36A Connections through contact.

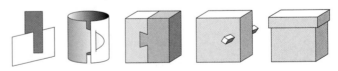

8.36B Connections through junctions.

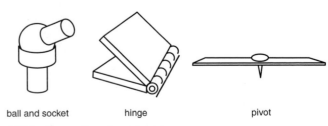

ball and socket hinge pivot

8.36C Connections through joints.

8.37A Mary Miss, *Staged Gates*, 1979. Wood, 12 × 50 × 120 ft (3.6 × 15.2 × 36.6 m).

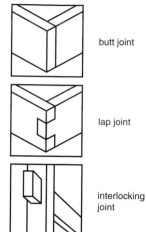

butt joint

lap joint

interlocking joint

8.37B Three types of joints.

in Figure 8.37A, was largely constructed using three types of joints (8.37B). Nails, screws, or bolts are required when lap or butt joints are used. Interlocking joints can be strengthened using nails or can create a simple connection without such additional reinforcement.

Employed to create functional objects, industrial designers pay particular attention to all types of connections. The junction between two flexible planes and a cylindrical volume creates a simple and elegant squeegee in Figure 8.38. The joints used in the *Tizio Table Lamp* (8.39) give it both versatility and grace. And, Robert Brunner and Ken Wood used a variety of hinges and pivots in *Sportscope*, a simple periscope for children (8.40).

Visual connections are just as important as physical connections. In Figure 8.41, a split yellow-orange circle dominates the center of the piece. Proximity between the two halves creates a visual connection despite the physical separation. A second split circle echoes the interior circle and creates a dynamic container for the composition as a whole. The two gold spheres at the upper left and

8.38 Ziba Design, Squeegee. Designers: Schrab Vossoughi, Christopher Alviar, Paul Furner. Design Firm: Ziba Design.

8.39 Artemide (R. Sapper), *Tizio Table Lamp.*

8.40 Lunar Design (Robert Brunner and Ken Wood), *Sportscope.* Pentagram Design.

lower right seem poised for movement. Every component is connected to at least one other component, either through contact or penetration.

Transitions

When the multiple surfaces of an object are varied, many types of **transitions** can be created. The various angles and joints in Eduardo Chillida's *Asbesti Gogora III* (8.43) create an abrupt transition from surface to surface, while a fluid transition helps to unify the various sections of Liv Blåvarp's neckpiece *Bird* (8.42). When a sculpture is composed of separate parts, an even wider range of transitions can occur. Mark di Suvero's *Gorky's Pillow* (8.44) is as complex and as playful as a children's playground. With a perimeter exceeding 64 feet in circumference, the sculpture presents a variety of transitions between the interior and exterior, from the top to the bottom, and from side to side.

Such transitions are often based on **gradation.** Gradation creates sequential change within a consistent system. Here are a few of the many options available.

8.41 John Okulick, *Wind Wizard*, 1987. Painted wood, gold leaf, oil stick, 22 × 25 × 6 in. (55.9 × 63.5 × 15.2 cm).

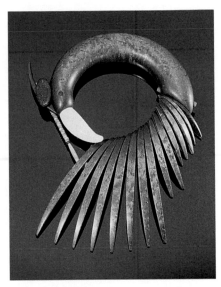

8.42 Liv Blåvarp, *Bird*, 1991. Neckpiece, birdseye maple, satinwood, whaletooth, 12½ × 10¼ in. (32 × 26 cm).

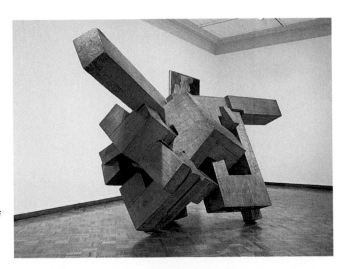

8.43 Eduardo Chillida, *Asbesti Gogora III,* 1962–64. Oak, 81½ in. × 136⅜ in. × 73⅛ in. (207.3 × 346.4 × 184.2 cm).

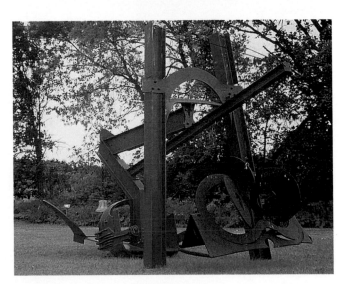

8.44 Mark di Suvero, *Gorky's Pillow,* 1969–80. Steel, painted steel, brass bell, 15 ft × 23 ft 1 in. × 9 ft 7 in. (457 × 703 × 292 cm).

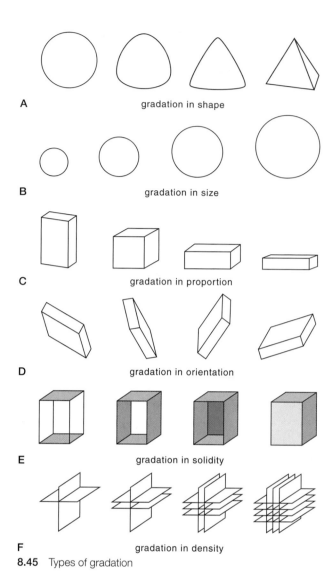

A — gradation in shape

B — gradation in size

C — gradation in proportion

D — gradation in orientation

E — gradation in solidity

F — gradation in density

8.45 Types of gradation

- Gradation in shape (8.45A)
- Gradation in size (8.45B)
- Gradation in proportion (8.45C)
- Gradation in orientation (8.45D)
- Gradation in solidity (8.45E)
- Gradation in density (8.45F)

Unity and Variety

Regardless of the design principles used, creating a design that is functional, cohesive, and structurally sound is a major challenge. Offering both interior and exterior surfaces and with multiple views, any three-dimensional object tends to be complex.

Finding the right balance between **unity** and **variety** is crucial. Too much unity can be monotonous, while too much variety becomes chaotic. Some designs require a high level of unity while other designs require more variety. Based on a grid, Sol LeWitt's *Wall/Floor Piece #4* (8.46) provides a methodical transition from the horizontal floor to the vertical wall. At the other extreme, the lines, shapes, volumes, and masses in Judy Pfaff's *Rock/Paper/Scissor* (8.47) ricochet off the floor, walls, and ceiling with exuberant energy. Just as extreme unity is right for the LeWitt piece, so extreme variety is right for Pfaff's installation.

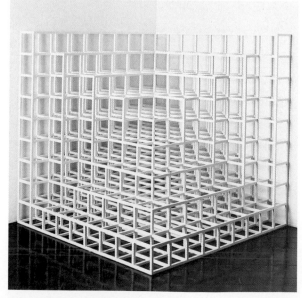

8.46 **Sol LeWitt,** *Wall/Floor Piece #4,* **1976.** White painted wood, 43¼ × 43¼ × 43¼ in. (109.9 × 109.9 × 109.9 cm).

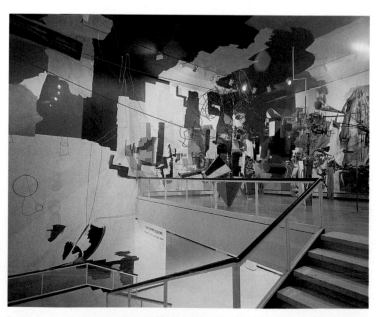

8.47 **Judy Pfaff,** *Rock/Paper/Scissor,* **1982.** Mixed media installation at the Albright-Knox Art Gallery, Buffalo, NY, September 1982.

8.48 Raymond Loewy, Coca-Cola Contour Bottle. Coke, Coca-Cola, and the Dynamic Ribbon device and the design of the Coca-Cola Contour Bottle are registered trademarks of the Coca-Cola Company.

Similarity in any aspect of the design increases unity. Difference in any aspect of the design increases variety. Both are essential. The "feathers" in Liv Blåvarp's *Bird* (see 8.42, page 8-13) unify the design while gradation adds variety. Raymond Loewy's Coca-Cola bottles (8.48) retain a distinctive contour despite variations in proportion and size. Symmetrical balance unifies the mask from the Pacific island of New Ireland in 8.49. An underlying sense of order freed the artist to experiment with many textures, colors, and figures, resulting in a complex and energetic mask.

Finally, the tower of photographs in the Holocaust museum in Washington, DC (8.50) is unified by a dominant structure and its repeated contents. Designer James Ingo Freed filled the soaring structure with thousands of photographs of Jews massacred in the Polish town of Ejszyszki. Multiplied over and over, the wedding pictures, photographs of groups of school children, and family snapshots personalize the massacre and make the Holocaust more meaningful.

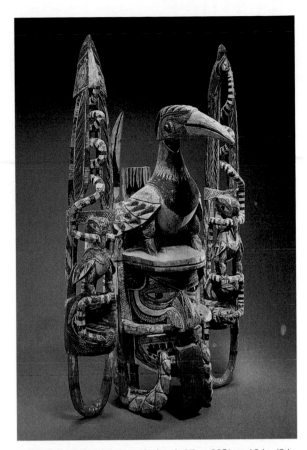

8.49 Mask (Wanis), New Ireland. 37 × 20⅞ × 19 in. (94 × 53 × 48.3 cm).

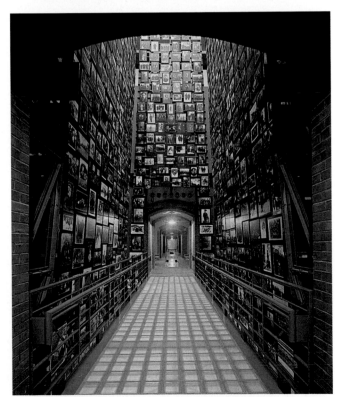

8.50 Tower of Photos from Ejszyszki, completed in 1993, United States Holocaust Memorial Museum, Washington, DC.

Profile:
David MacDonald, Ceramicist

A Passion for Pottery

Internationally renowned ceramicist David MacDonald is best known for his work with utilitarian vessels. His work has been included in over 60 exhibitions, including the Torpedo Factory Art Center in Alexandria, Virginia; The Studio Museum in Harlem; and the Afro-American Historical and Cultural Museum in Philadelphia. He is also renowned as a teacher and community leader, with work in an adult literacy program, a summer ceramics intensive program for high school students, and work with inmates at the Green Haven Maximum Security Correctional Facility in New York State to his credit.

MS: How did you start making art?
DM: Initially, it was a way to create some private space. As the third in a family of nine children, I always shared a bedroom with at least three of my brothers. I would help my parents unpack the groceries, then unfold the paper bags so that I could use the inside as drawing paper. Through hours of drawing, I was able to create my own little world.

MS: In our conversations and in viewing your work, I am struck by your passion for ceramics in general and functional vessels in particular. What is special about clay?
DM: I was introduced to ceramics during my second year in college. I was immediately fascinated by clay: it is responsive to the slightest pressure and can record the finest impression. After my first mug came out of the kiln and I made my first cup of tea, I was hooked. The idea of turning a lump of dirt into a useful object amazed me. Since I grew up with very little material wealth, I loved the idea of transforming nothing into something.

Now, I am drawn to functional ceramics because I like playing with the interaction between the object and the user. Having to produce a functional object makes the creative act much more interesting and challenging for me. When a teapot has just the right weight, balance, and proportions, it makes the act of pouring tea a celebration of the physical world.

MS: What is the source of your ideas?
DM: Anything can become a conscious or unconscious inspiration. I can get lost in the produce section of the supermarket: the shapes and colors of the vegetables give me all sorts of ideas.

On a more scholarly level, I was influenced by Japanese and Chinese ceramics during college, and for the past 20 years, I have been strongly influenced by African art and culture.

MS: Yes, I notice that a dramatic change in your work occurred around 1978. Before that time, your work was sculptural, representational, and highly charged politically; afterward, it became more utilitarian and abstract. What happened?
DM: At the opening for a solo show in Syracuse, I was asked a question by an elderly white woman that dramatically changed my attitude about my work. She innocently asked if there was anything positive about being black in America or was it just one frustration and humiliation after another. The question haunted me for months afterward. I realized that my creative work had been based on anger and a feeling of victimization. As I matured as an individual, I realized that my experiences weren't limited to anger—there is much more to my life than that! I then decided to tap the rich and varied cultural and artistic tradition to which I am heir. Now I am most interested in expressing the magnificence and nobility of the human spirit and in celebrating my African heritage.

MS: What distinguishes a great pot from a mundane pot?
DM: There is no simple answer to this question. We can talk endlessly about form, surface, line, and so forth, and still not gain any real insight into what makes one pot great and another mundane. Yet, we immediately feel it when the mixture of physical elements is just right. Out of the 30 similar bowls a potter produces, two or three always seem to stand apart, as something special.

The search for this elemental quality makes my art magical and compels me to make the next piece. Ironically, if I ever identify exactly what it is that makes

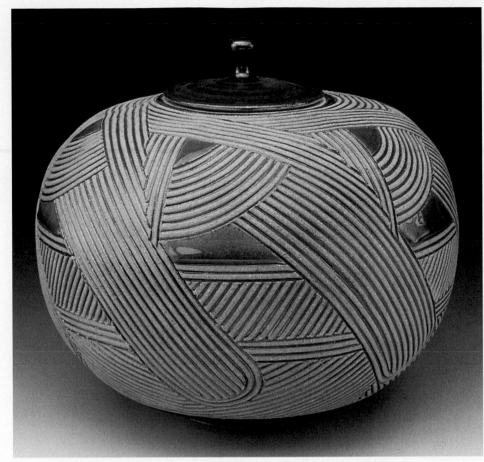

David MacDonald, *Carved Stoneware Storage Jar*, 1997. 15 in. (38.1 cm).

space. The slashing diagonal lines help to unify the design and move the viewer's eye around the form, reinforcing the spherical volume.

MS: What were the most valuable lessons you learned from your teachers?
DM: From Joseph Gilliard at Hampton University, I learned the history and technique of ceramics and gained greater patience and self-control. I developed my self-awareness and passion for communication through my work with Robert Stull at the University of Michigan. From Henry Gernhardt, my Syracuse University colleague for 24 years, I learned that teaching is also an art. In nearly 40 years of teaching, Henry's commitment to his art and his students never faltered.

MS: Is there any advice you would like to give to my students?
DM: An artist has to believe in him or herself. The dedication, courage, and energy my students bring to the classroom are more important than anything I can offer. If you want to stand above the crowd, your passion for your art must be manifest through a willingness to work harder than anyone else. The students who succeed see their art as a way of life and not simply as a way of earning a living. My job as a teacher is to help my students realize their potential and to bring eloquence to their unique voice.

an exceptional piece, the excitement will be sucked out of the creative process. The search is as compelling as the solution.

MS: Tell me about the vessel pictured here.
DM: *Carved Stoneware Jar* was inspired by the bulbous form of a melon or gourd. The body is full and round and the lid handle is suggestive of a stem. I like the sense of an internal force or energy stretching the outer shell almost to the point of bursting.

First, I considered the function of the jar. To a large extent, the function determines the form. A certain size range facilitates everyday use. If the size is increased, the object is more suitable for ceremonial use, or as a decorative object. Certain shapes offer more storage capacity and better accessibility to whatever is being stored. Finally, the base must be big enough to provide stability.

The surface was carved when the jar was leather-hard, a couple of days after being thrown on the potter's wheel. A form this large can "carry" a fairly complex pattern, composed of smaller shapes in combination with larger design areas. By leaving some areas uncarved, I was able to create an overlapping effect and increase the illusion of

Detail.

Summary

- The power of each element of design can be amplified through careful composition. To determine the best way to combine multiple parts into a cohesive whole, designers often produce dozens of drawings or three-dimensional models before finalizing an idea.

- The three major types of balance are asymmetrical, symmetrical, and radial.

- Scale (the size of an object relative to its surroundings) and proportion (the size of one part of an object compared to another part) can enhance both function and communication.

- Proximity (the distance between structural components or between a sculpture and the viewer) can increase the impact of scale.

- Contrast in texture, dynamics, size, materials, or other variables can be used to emphasize a particular area in a design or to create an opposing visual system.

- Repetition increases design unity. Rhythm (repetition with variation) can create a transition from form to form or from surface to surface. Rhythm can be as graceful as a ballet or as percussive as a drumbeat.

- The native, or inherent, qualities of each material substantially affect both the structure and the concept in any design.

- Two primary construction methods are additive and subtractive.

- Connections and transitions can contribute compositional cohesion as well as structural strength.

- Finding the right balance between unity and variety is critical. Too much unity can be monotonous, while too much variety becomes chaotic. Similarity in any aspect of the design increases unity. Difference in any aspect of the design increases variety.

Keywords

additive
assemblage
asymmetrical
 balance
balance
carving
connections
contact
contrast
gradation
grid

joints
junctions
modeling
proportion
proximity
radial balance
repetition
rhythm
scale
symmetrical
 balance

subtractive
tempo
transition
unity
variety
visual balance

As you begin your studio work, consider:

1. How many elements are being used in your design? What elements are being used most successfully?

2. If your design is strictly linear, consider using variations in the density, color, or proportion of the lines to add interest. If your design combines line, plane, and volume, consider using repetition, connections, and gradation to increase unity.

3. What is the most important characteristic of the composition? If it is essentially an exploration of movement in space, what is the rhythm, extent, and type of movement being created? When you understand the essential character of a design, you can more effectively invent ways to heighten its overall impact.

4. Try redesigning the project proportionally. A design that was first developed as a 6-inch cube will read very differently if it is redesigned to be 3 inches wide and 20 inches tall.

5. How do the various surfaces of the design relate to each other? What is the relationship between the interior and the exterior? To what extent can contrast between the various surfaces enhance meaning?

Oliver Andrews, *Living Materials: A Sculptor's Handbook.* Berkeley, CA, University of California Press, 1988.

Arline Fisch, *Textile Techniques in Metal.* Asheville, NC, Lark Books, 1996.

Paul Johnson, *Pop-Up Paper Engineering.* Bristol, Taylor & Francis, Inc., 1992.

Peter Lane, *Ceramic Form: Design and Decoration,* revised edition. New York, Rizzoli International Publications, Inc., 1998.

Susan Grant Lewin, *One of a Kind: American Art Jewelry Today.* New York, Harry N. Abrams, Inc., 1994.

Martha Dreyer Lynn, *Clay Today: Contemporary Ceramists and Their Work.* San Francisco, Chronicle Books, 1990.

Bonnie J. Miller, *Out of the Fire: Contemporary Glass Artists and Their Work.* San Francisco, Chronicle Books, 1991.

Rudi Stern, *Contemporary Neon.* New York, Retail Reporting Corporation, 1990.

Wucius Wong, *Principles of Form and Design.* New York, Van Nostrand Reinhold, 1993.

Physical and Cerebral

Constructed Thought

What is the difference between the pile of wood in Figure 9.1 and the sculpture in Figure 9.2?

The size, orientation, and location of the pile of wood are based on its purpose. It provides the raw material needed for building a house. Positioned at the edge of a construction site, the boards are arranged in a roughly parallel position so that workers can easily grasp and remove individual planks. The pile of wood is purely functional; it exists as an end in itself. Its organization has no aesthetic intention.

At first glance, Figure 9.2 may seem very much like a pile of wood. The rough planks are clustered together, in close proximity to the house and in a parallel position. On closer examination, we see the perpendicular boards that elevate the structure. Balanced on stilts, the mass of wood seems suspended and in transition. It continues around the house and into the windows. Is the house expelling or inhaling the boards? The entire structure seems poised, ready to shift at any moment.

How and why was this sculpture made? Sculptor Tadashi Kawamata begins by collecting scrap wood from demolished buildings. He then constructs temporary installations, which he describes as "cancers," on conventional buildings. With no predetermined end point, the structures grow like weeds, often enveloping the building. At the end of the exhibition, Kawamata continues onward, dismantling the construction to create another sculpture elsewhere. Using scrap material to build temporary structures, his work demonstrates the

9.1 Pile of wood from a construction site.

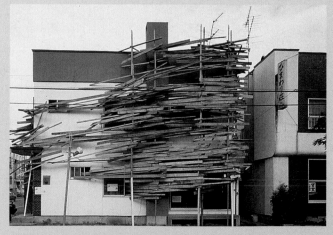

9.2 Tadashi Kawamata, *Tetra House N-3, W26 Project,* Sapporo, Japan, 1983.

fluidity and circulation of urban structures. His design is based on aesthetic rather than functional criteria.

All three-dimensional work gains power from its physical presence. Sculpture, however, is much more than brute force. It is through the transformation of tangible material into ideas and emotions that a sculpture gains significance. The planks in Figure 9.1 begin and end as physical material. A pile of wood is just a pile of wood. By contrast, sculpture such as *Tetra House N-3, W26 Project* uses physical material to explore and express ideas.

From Life to Art: Connection and Separation

Contemporary sculpture is constructed from a wide range of materials, including ice, fire, blood, spools of thread, and crushed automobiles. In her *Ceremonial Arch* (9.3), Mierle Ukeles combined the metal and wood used in traditional sculpture with gloves, lights, metal springs, and asphalt to create an artwork that is both visually exuberant and structurally sound. Sculpture is now shown in parks, subway stations, and public plazas as well as in galleries and museums. Because contemporary sculpture is so reliant on familiar materials and public settings, the relationship between art and life has become especially close.

This can be an advantage or a disadvantage. Connection to life gives art its vitality. For example, when a play expresses actual feelings in a compelling way, it connects to our personal experience. However, if the situations seem improbable and the acting contrived, the play is likely to fail. Authenticity is essential.

Made of tangible material, sculpture is inherently connected to reality. Too direct a connection, however, is deadly. A pile of wood is just a pile of wood. For art to have meaning, commonplace experiences must be distilled, re-examined, or transformed. It has often been said that a play is "life with the boring parts left out." A play that simply replicates everyday experience can never transport an audience beyond the commonplace. Likewise, sculpture requires a heightened experience, *beyond* everyday life. Through a combination of insight and hard work, the sculptor transforms even the most resistant material into compelling communication. When all elements in a sculpture work in harmony, the viewer is simultaneously connected by the reality of the material and transported by the power of the idea.

9.3 Mierle Ukeles, *Ceremonial Arch Honoring Service Workers in the New Service Economy*, 1988. Steel arch with materials donated from New York City agencies, including gloves, lights, grass, straps, springs, and asphalt; overall structure 11 ft × 8 ft × 8 ft 8 in. (3.35 × 2.43 × 2.44 m), plus glove branches ranging from 2 to 4 ft long (61 × 122 cm).

9.4 Michelangelo, *Pietà*, 1498–1500. Marble, 5 ft 8 in. (1.74 m) h.

9.5 Sandra Enterline, *Caged Sphere Bracelet Series*, 1992. Sterling silver, 18-karat gold, hollow-formed, fabricated. Left to right, 5 × 5 × 1⅛ in. (12.7 × 12.7 × 3 cm), 4 × 4 × ¾ in. (10.2 × 10.2 × 1.9 cm), 4 × 4 × ¾ in. (10.2 × 10.2 × 1.9 cm).

9.6 Myra Mimlitsch-Gray, *Timepiece*, 1988. Kinetic brooch, 14-karat gold, lens, diamonds, abrasive disk. Fabricated, 2¼ × 1½ × ¼ in. (6 × 4 × .5 cm).

Degrees of Representation

Representational sculptures often depict persons or objects in such exquisite detail that they seem to come to life. Michelangelo's *Pietà* (9.4) is a good example. In this massive sculpture, Mary grieves as she cradles the dead Jesus. Every crease in the fabric is defined and every nuance of gesture is deliberate. Mary's right hand extends Jesus' flesh as she gently lifts his right shoulder. His head is thrown back and his arms are limp. She tilts her head slightly and her left hand echoes the position of his feet. **Vitalistic** sculptures, such as the *Pietà*, seem to embody life. They engage our thoughts and emotions through their compelling realism and narrative implications.

Nonobjective sculptural objects can be appreciated for their pure physical form. For example, the simple metal rings Sandra Enterline constructed for her *Caged Sphere Bracelet Series* (9.5) work beautifully as ends in themselves. We can appreciate their economy and grace without knowing a story or pursuing any additional ideas they may suggest.

Most sculptural objects fall somewhere between these two extremes. These **abstract** sculptures have been distilled down from a recognizable source. Myra Mimlitsch-Gray's *Timepiece* (9.6) simultaneously suggests the mechanism and movement of a clock, a pendulum, and a musician's metronome. By reducing these familiar timepieces to their essential form, she was able to create an economical design that conveys a universal sense of time.

9.7 Michele Oka Doner, *Terrible Table*. Bronze and glass, 15¾ × 26 × 22 in. (40 × 66 × 56 cm).

9.8 Gianfranco Frattini, *Tria Table.* Design firm: Morphos/Acerbis International. Opaque lacquered wood.

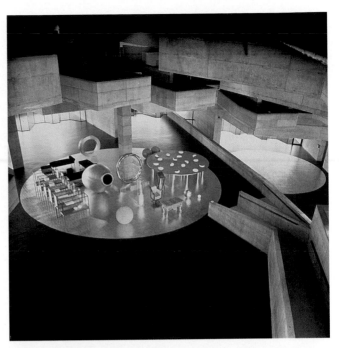

9.9 James Lee Byars, *The Perfect Thought*, 1990. (Installation shot). Various objects covered with gold leaf, composed in one of two circles of gold leaf, large circle 40 ft (12.2 m) diameter, small circle 27 ft (8.2 m) diameter.

Each approach has advantages and disadvantages. The representational approach can stimulate the imagination or provide a fresh interpretation of a familiar object. For example, the thorny branches at the base of Michele Oka Doner's *Terrible Table* (9.7) are sure to change the emotional atmosphere of any room this table occupies. On the other hand, pure form is especially effective in situations in which universality, economy, or versatility is required. In contrast to Doner's table Gianfranco Frattini's *Tria Table* (9.8) is simple, straightforward, and highly adaptable.

Boundaries

Because the art/life connection is so important, sculptors must be especially attentive to the physical and psychological boundaries in each piece. As the dividing line between objects, images, or experiences, the **boundary** is charged with energy. It can serve three major purposes.

Boundaries Can Connect

A simple shape can create a boundary. To define *The Perfect Thought* (9.9), James Lee Byars painted two gold-leaf circles on the floor. The larger circle enclosed 23 separate works from earlier exhibitions while the smaller circle remained empty. This simple device gave cohesion to the existing body of work while leaving a second space open, to be filled by the viewer's imagination.

A physical boundary is used to create a psychological connection in *My Mother 3*, by Cho Duck-Hyun (9.10). The strip of fabric that extends out

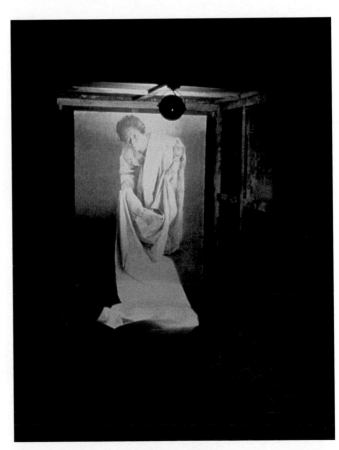

9.10 Cho Duck-Hyun, *My Mother 3* (Memory of the Twentieth Century), 1996. Graphite and charcoal on canvas, Halogen light, 48 × 57 in. (122 × 145 cm).

9.11 Maya Ying Lin, *Topo*, 1991.

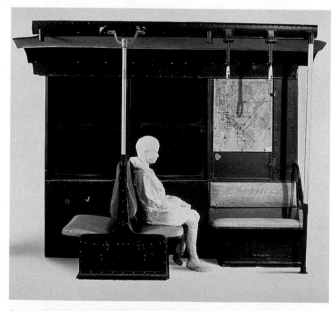

9.12 George Segal, *The Subway*, 1968. Plaster, metal, glass, rattan, electrical parts with lightbubs, and map. 7 ft 4 in. × 9 ft 5 in. × 4 ft 3 in. (2.25 × 2.88 × 1.3 m).

from the drawing and rolls onto the floor enters our space. Combined with the gentle gesture of the woman, the unfurled fabric invites our entry into her world. Here, the tangible world of sculpture and the illusory world of drawing work in perfect harmony.

Boundaries Can Separate

Constructed from nine 12-foot-wide bushes within the median of a busy highway, Maya Ying Lin's *Topo* (9.11) simultaneously relies on separation and connection for its power. Separated from the surrounding landscape, these particular bushes become sculptural objects. Enclosed within the mile-long median, they provide a series of visual stepping stones, inviting us to move down the line diagonally. Shifting circles at either end of the sculpture appear to rotate the last two bushes, directing our attention back down the line. Through this illusion of perpetual motion, the simple design becomes highly energized.

Psychological separation adds power to George Segal's *The Subway* (9.12). Developed as a three-dimensional painting, Segal's construction replicates a familiar setting, using actual subway seats, handrails, and a window, which flashes with the lights of "passing" trains. The ghostly white plaster figure seems familiar but remains distant, the shell of a living, breathing person. Here, a psychological boundary transforms the commonplace into an expression of alienation.

Indeed, physical and psychological boundaries are so important that some sculptures focus on this subject directly. Constructed from a series of translucent rooms, *Single Room Occupancy*, by Susan Schwartzenberg and Ali Sant (9.13), presents an examination of connection and isolation in contemporary life. Clustered together tightly and offering no real privacy, the eight-foot-long rooms suggest a connection among the residents in a budget hotel. On the other hand, a transparent telephone in one room, a sink in another, and a clear Plexiglas dresser in a third, particularize the rooms. As we explore the site more fully, we find that each resident is absorbed by his or her own hopes and fears. Lines of text, sound, and projected images

9.13 Susan Schwartzenberg and Ali Sant, *Single Room Occupancy* (detail), 1997. Video and mixed media installation.

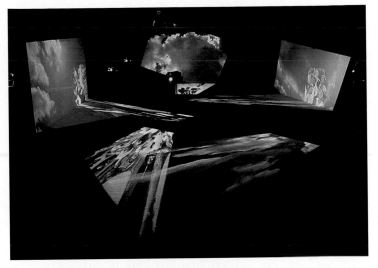

9.14 Susan Trangmar, *Blue Skies*, 1990. Installation view.

add to the ghostly effect. There is no real sense of community among the people caught in this eerie labyrinth. Despite their close proximity, the inmates in the hotel remain isolated.

Boundaries Can Enclose

Increasingly, sculptors use every square inch of gallery space and surface to create complex installations. In *Blue Skies* (9.14), Susan Trangmar used the gallery walls as four large projection surfaces. Surrounded by the projections and by his or her own cast shadow, the viewer becomes a participant in the installation.

The sculpture itself can also envelop the viewer. The boundaries in Hiroshi Teshigahara's *Bamboo Installation* (9.15) create a passage through a bamboo maze. The patterns of light and shadow combined with the graceful arch entice and enchant the visitor. The physical sensation of enclosure brings magic to the delicate structure.

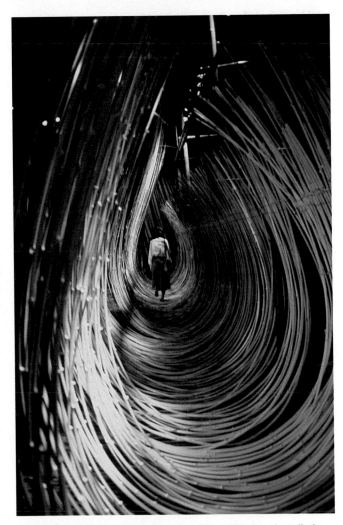

9.15 Hiroshi Teshigahara, One-man Show Bamboo Installation at Metropolitan Plaza in Ikebukuro, Tokyo, June 10–15, 1993.

9.16 Barbara Chase-Riboud, *Malcom X #3*,
1970. Polished bronze and silk.

9.18 Andrea del Verrocchio, *Equestrian Monument of
Colleoni,* c. 1483–88. Bronze, 15 ft (4.6 m). Cast by
Alessandro Leopardi Campo.

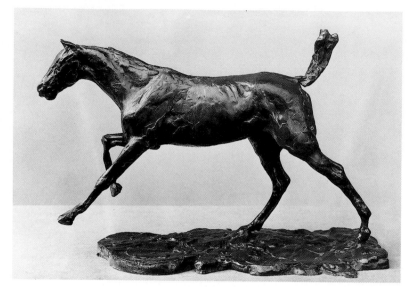

9.17 Edgar Hilaire Germain Degas, *Horse Galloping on Right Foot,* c. 1881.
Bronze cast of wax model, 11⅛ in. (30 cm).

Bases and Places

Traditional sculpture is generally mounted on a
plinth, which provides a horizontal base, or on a
pedestal, which provides a vertical base. Either can
serve three purposes:

- To physically separate the sculpture from the
surrounding space.

- To provide strength and structural stability.

- To elevate an object psychologically, distin-
guishing it from its surroundings and increas-
ing its impact.

Seemingly insignificant, the plinth or pedestal
can actually become an essential component of
three-dimensional design, both physically and aes-
thetically. In Figure 9.16, the marble base adds ele-
vation as well as a marked contrast in material. As
a result, Barbara Chase-Riboud's *Malcolm X #3* now
has a solid platform from which to speak. The
plinth in *Horse Galloping on Right Foot* (9.17), by
Edgar Degas, provides a visual context for the gal-
loping horse as well as physical stability. The sculp-
ture would collapse, physically and aesthetically, if
the base were removed. The pedestal for Andrea
del Verrocchio's *Equestrian Monument* (9.18)

elevates the heroic statue and creates an architectural connection to the surrounding buildings.

The traditional role of the base has been expanded by artists in the twentieth century. For Constantin Brancusi, the base was always an essential element of the artwork rather than a passive support. In *The Fish* (9.19), a circular mirror suggests the reflective quality of water while providing physical stability. Positioned on top of a graceful pedestal, both the fish and the water appear suspended. Seeking dynamism rather than stability, Umberto Boccioni split the base in half when he composed *Unique Forms of Continuity in Space* (9.20). The abstracted figure strides forward in space, too energetic to be contained by conventional boundaries. Pushing this idea even further, the base becomes the sculpture in Jude Lewis' *Family: Pride and Joined*. Constructed in response to a death in the family, the sculpture is dominated by warped and twisted floorboards, the site of an emotional trauma.

Indeed, in contemporary sculpture, the base often extends to include an entire architectural site. Resting directly on the surface of the plaza, the granite boulders in Elyn Zimmerman's *Marabar* (9.21) are intended to suggest continents, while the channel of water suggests the ocean. Combining large scale with a "baseless" design, the artist has dissolved the traditional boundary between the stones and the surroundings. As a result, the entire plaza is transformed into a sculptural site.

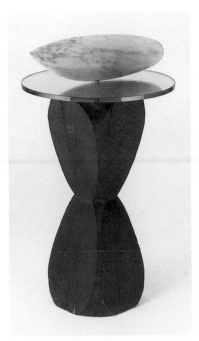

9.19 Constantin Brancusi, *The Fish*, **1922.** Marble, mirror, oak, 5¼ in. h. × 16⅞ in. w. (13.3 × 42.9 cm). Base mirror 17 in. (43.2 cm) dia., base wood 24 in. (61 cm) h.

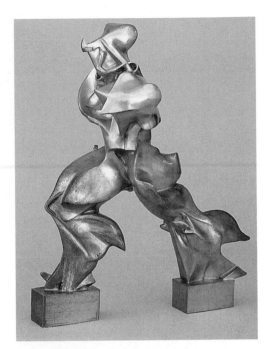

9.20 Umberto Boccioni, *Unique Forms of Continuity in Space*, **1913.** Bronze (cast in 1931), 43⅞ × 34⅞ × 15¾ in. (111.2 × 88.5 × 40 cm).

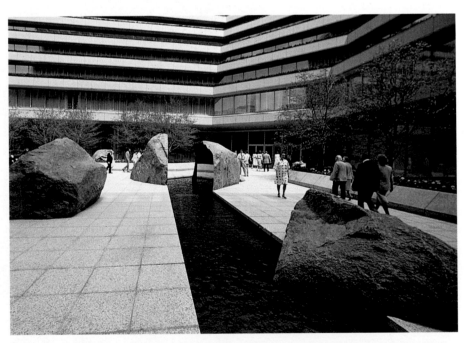

9.21 Elyn Zimmerman, *Marabar*, **1984.** Boulders (natural cleft and polished granite) and water. Plaza: 140 × 60 ft (42.7 × 18.3 m). Pool: 60 ft × 6 ft × 18 in. (18.3 m × 1.8 m × 45.7 cm). Boulders: 2 to 10½ ft. (61 cm to 3.2 m).

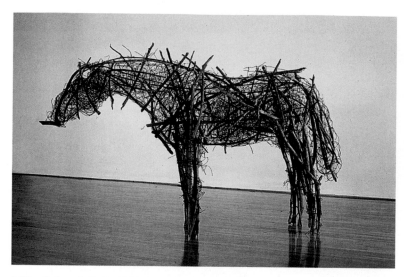

9.22 Deborah Butterfield, *Large Horse #4*, **1979.** Steel, wire, sticks, 77 × 124 × 33 in. (195 × 315 × 84 cm).

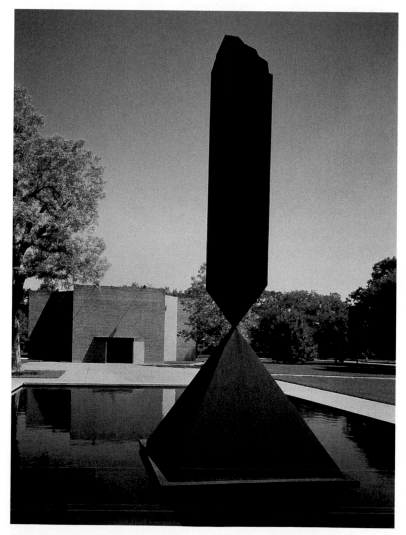

9.23 Barnett Newman, *Broken Obelisk*, **1963–67.** Cor-Ten steel, 26 × 10½ × 10½ in. (66 × 26.7 × 26.7 cm).

Physical Qualities of Sculptural Objects

When we begin to work in three dimensions, physical reality replaces the illusions that dominate two-dimensional work. The movement of waves that is *suggested* in a painted seascape becomes a powerful force on an actual beach. We feel the wind and smell the salty air. Visual textures are replaced by the tangible textures. We can feel the sand and examine each seashell as we walk along the shore. All our senses come to life. The painted world we entered through imagination changes dramatically when physical entry is possible.

To create compelling sculpture, we must fully realize the physical potential of each object and each space. Physical forces, such as gravity, torsion, and tension create conceptual opportunities as well as structural limitations. Materials also affect meaning.

Deborah Butterfield's wood-and-wire *Large Horse #4* (9.22) has a mystery and power that is very different from the speed and grace of Degas' bronze horse. When all of the physical and material forces are fully engaged, the aesthetic impact increases.

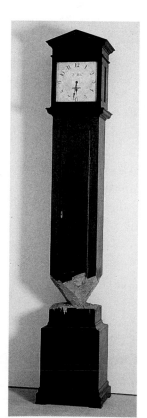

9.24 Walter Martin and Paloma Muñoz, *Of Bodies Born Up by Water*, **1987.** Plaster, oil paint, sheet metal, and wood, 111½ × 20 × 16½ in. (283 × 51 × 42 cm).

Physical Forces
Weight and Gravity

Of the forces of nature, **gravity** is the most immediately noticeable when we begin to construct a three-dimensional structure. Lines, spaces, and volumes must be organized according to the laws of physics while simultaneously meeting our aesthetic objectives. Balance becomes a structural necessity as well as a compositional force. After watching several prototypes collapse, it is easy to conclude that gravity is our enemy, to be conquered at all costs. But is it?

When we begin to analyze the uses of gravity in sculpture, we soon find that it is an asset rather than a liability. Just as a ballet dancer relies on gravity to provide a solid launching pad for each leap and a predictable support for each landing, so the sculptor uses gravity to express ideas and generate emotions.

Barnett Newman's *Broken Obelisk* (9.23) is a monochromatic structure constructed from a simple pyramid and an inverted obelisk. The point of contact between the two sections becomes charged with energy, as the top half seems to balance on the point of the pyramid. Caught in this moment of equilibrium, the sculpture is as carefully balanced as a ballerina on point.

Walter Martin's *Of Bodies Born Up by Water* (9.24) demonstrates how a similar structure can be used for a very different effect. The poised obelisk is now a grandfather clock. When it topples, time, memory, and family history may be erased.

The gravity in Beverly Pepper's *Ventaglio* (9.25) creates another kind of dance. The largest of the open cubic volumes leans to the left, while the three smaller volumes tumble forward. The movement is as energetic and as playful as a cartwheel. And, thanks to gravity, this dynamic activity contrasts sharply with the static base of the sculpture.

An even more forceful use of gravity animates *Device to Root Out Evil* (9.26). The inverted church structure seems to have been propelled aloft, finally driving into the ground upon landing. As noted by sculptor Dennis Oppenheim, this inversion of a familiar structure creates a reversal of content. The steeple is now pointing to hell rather than to

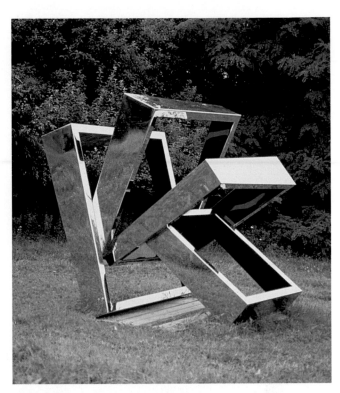

9.25 Beverly Pepper, *Ventaglio*, 1967. Stainless steel with blue enamel, 94¹⁄₂ × 78³⁄₄ in. (240 × 200 cm).

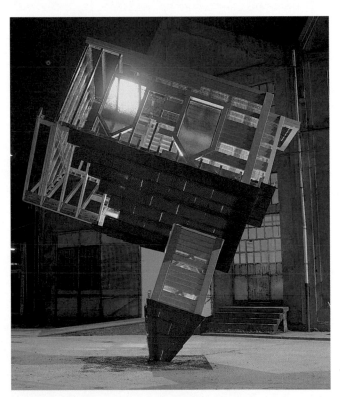

9.26 Dennis Oppenheim, *Device to Root Out Evil*, 1997. Galvanized structural steel, anodized perforated aluminum, transparent red Venetian glass, concrete foundations, 20 × 15 × 8 ft (6.1 × 4.57 × 2.44 m).

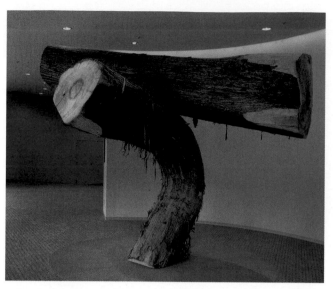

9.27 Chuichi Fujii, *Untitled*, 1987. Japanese cedar, 10 ft 6 in. × 13 ft ½ in. × 11 ft 6 in. (320 × 400 × 350 cm).

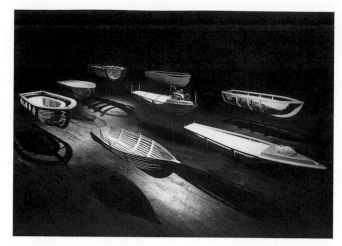

9.28 Patricia A. Renick, *Life Boats/Boats About Life*, 1979–80. 1 to 1½ ft high × 5 to 6½ ft long × 1 to 1½ ft deep (30.5 to 45.7 cm high × 152.4 to 198.1 cm long × 30.5 to 45.7 cm deep).

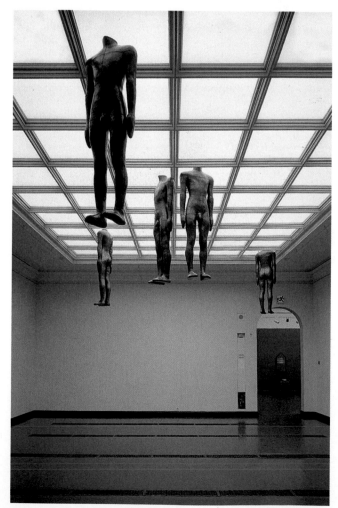

9.29 Antony Gormley, *Learning to Think*, 1991. Lead, fiberglass and air, 5 figures, each 68 × 41¾ × 122 in. (173 × 106 × 310 cm).

heaven. Even without any cultural associations, however, we would still respond to the improbable balance and intense color in this large piece.

Indeed, exaggerated or diminished gravity can change the meaning of any sculpture. In Chuichi Fujii's *Untitled* (9.27), a cedar log seems to have been crushed by the weight of a second log. The combination of the rough logs and the exaggerated weight seems to bring a powerful natural force into the pristine gallery. At the other extreme, Patricia A. Renick's *Life Boats/Boats About Life* (9.28) seems to float on air, as weightless as a dream. Dramatic lighting and elegant cast shadows heighten the magical effect. Here, it is the denial of gravity that gives the sculpture power.

A combination of weight and weightlessness gives Antony Gormley's *Learning to Think* (9.29) its impact. Constructed from a mold made from the artist's own body, the hollow lead figures are basically identical. Hovering 10 feet off the ground, they seem weightless. At the same time, because they are suspended from the ceiling, each figure seems as heavy as a convict at the end of a hangman's noose. This paradox gives the sculpture great physical force and communicates an elusive concept. Clearly, the knowledge embodied in this sculpture is not easy to attain!

Compression and Expansion

Most materials tend to **compress** as weight increases. As shown in Figure 9.27, physical com-

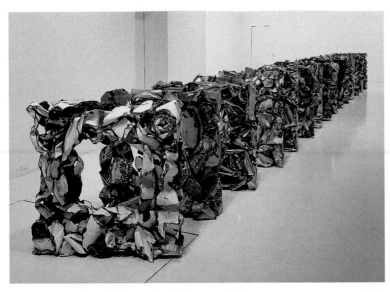

9.30A John Chamberlain, *The Hedge*, 1997. Painted milled steel, chromium-plated steel, and stainless steel, overall installed 44½ in. × 44½ in. × 46 ft 4 in. (113 cm × 113 cm × 14.12 m); 16 units, each 44½ × 44½ × 12 in. (113 × 113 × 30.5 cm).

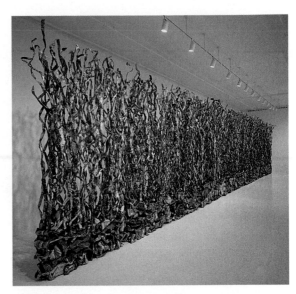

9.30B John Chamberlain, *The Privet*, 1997. Painted milled steel and chromium plated steel, 12 ft 6 in. × 61 ft 6 in. × 30 in. (3.81 m × 18.75 m × 76.2 cm).

pression can be used to evoke a visceral response. We feel the pressure as the top log pushes down on the log below. Compression plays an especially important role in the works of John Chamberlain, who began making sculptures from crushed automobiles in the sixties. In *The Hedge* and *The Privet* (9.30), crushed pieces of metal have been transformed into an improbable garden. This contradiction between the materials and the meaning suggests a new definition of nature.

Expansion is an equally compelling force. Constructed from the charred fragments of a church that had been struck by lightning, Cornelia Parker's *Mass* (9.31) seems to present the event in suspended animation. Supported by fine steel wire and cotton thread, the hovering sculpture appears weightless, caught at the moment of explosion.

Tension and Torsion

Tension can be used to stretch or bend an object, while torsion creates a twisting movement. Either can add physical and cerebral strength to a sculpture. Stretched taut, the steel cables in Kenneth Snelson's *Free Ride Home* (see 7.14, page 7-5) provide the force needed to elevate the aluminum tubes which dominate the sculpture. Tension is equally important for the designer. It is the tension in the bent metal rods that creates the structure in the

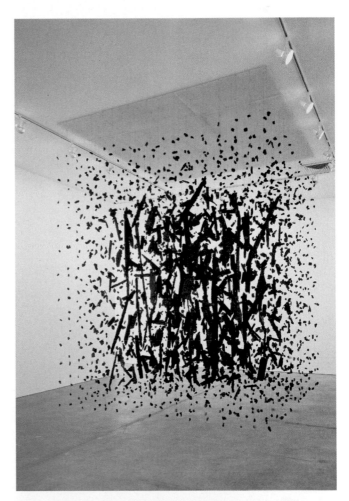

9.31 Cornelia Parker, *Mass (Colder Darker Matter)*, 1997. Charcoal retrieved from a church struck by lightning, suspended from steel wire and cotton thread, 10 × 10 × 10 ft (3.5 × 3.5 × 3.5 m).

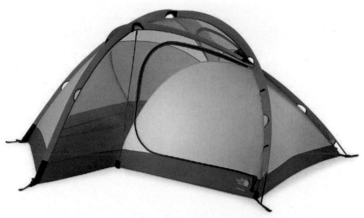

9.32 Peregrine Tent by The North Face, San Leandro, CA.

9.34 Eric Hilton, *Innerland*, 1980. Engraved by Ladislav Havlik, Lubomir Richter, Peter Schelling, and Roger Selander, cut by Mark Witter. Cast, cut, engraved, sandblasted, and polished, $3^7/_8 \times 19^3/_8 \times 19^3/_8$ in. (9.9 × 49.3 × 49.3 cm).

9.35 Human Skull Carved in Rock Crystal, Mexico (Aztec) Culture, 1300–1521 A.D.

9.33 Giovanni Anselmo, *Torsion (Torsione)*, 1967–68. Metal and material, 59 × 63 in. (150 × 160 cm).

Peregrine Tent from The North Face (9.32). In Giovanni Anselmo's *Torsione* (9.33), torsion provides both the form and the content of the artwork. Based on our experience in the physical world, we can feel the power of the twisted fabric and imagine the explosive result were this power released.

Material and Immaterial

Each of these physical forces is influenced by the materials the sculptor uses. Every material has unique physical properties as well as psychological associations. Mirrors are fragile, reflective surfaces commonly used for observation of the self and others. Blood is generally red, sticky, requires refrigeration, and provides evidence of both life and death. Bronze is malleable when heated and solid when cool, decays slowly, and can be colored gold, green, or copper-red, depending on the patina used. Depending on the weave and thread weight, silk can provide a shimmering, translucent veil or a solid, roughly textured barrier.

A love of materials and understanding of their characteristics is an essential aspect of all three-dimensional work. The transparency of glass is emphasized in Eric Hilton's *Innerland* (9.34). Constructed from 25 cubes of clear glass, the sculpture appears to shift with each change in the viewer's position. The transparency of rock crystal

9.36 Maren Hassinger, *12 Trees No 2*, 1979. Galvanized wire rope, 10 × 150 × 5 ft (3.1 × 45.7 × 1.5 m).

9.37 Hans Haacke, *Weather Cube*, 1963–65. Acrylic plastic, water, climate in area of display, 12 in. cube (30.5 cm).

adds both visual and conceptual power to the carved Aztec skull in Figure 9.35. In Maren Hassinger's *Trees No 2* (9.36), the contradiction between the forms of the trees and the wire rope from which they were made provokes a question: Are these mechanical or natural objects?

In the past 50 years, sculptors have expanded their choice of materials to include many physical and chemical processes. These include:

- *Condensation.* Sealed inside the Hans Haacke *Weather Cube* (9.37), water evaporates or condenses based on the ambient temperature inside the gallery.

- *Oxidation.* Ronald Dahl transformed the familiar ladder when he placed his sculpture in the Nevada desert and set it aflame to create *Seven Windows to a Sky on Fire* (9.38).

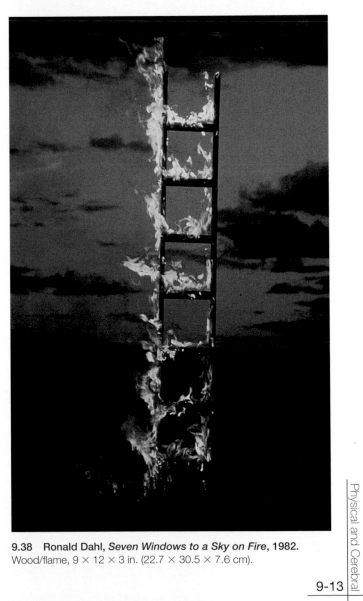

9.38 Ronald Dahl, *Seven Windows to a Sky on Fire*, 1982. Wood/flame, 9 × 12 × 3 in. (22.7 × 30.5 × 7.6 cm).

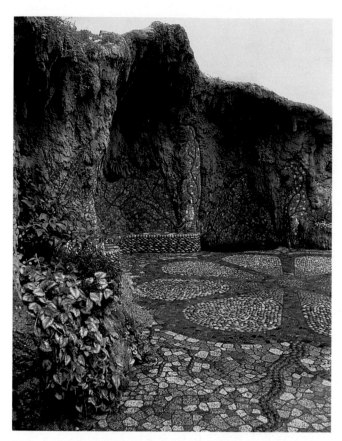

9.39 Lorna Jordan, *Waterworks Gardens: The Grotto*, 1996.
Third of five public garden rooms in the King County East Division
Reclamation Plant, Renton, WA.

- *Filtration*. Located next to a wastewater treatment plant, Lorna Jordan's *Waterworks Gardens: The Grotto* (9.39) purifies up to 2,000 gallons of oil-laced storm water per minute. The eight-acre site includes stone mosaics, natural filtration systems, and colorful bands of sedges, yellow iris, and red-twig dogwoods, which have been divided into five public gardens.

Permanence and Tangibility

The increasing use of diverse materials has also heightened awareness of the variations in permanence and tangibility of physical objects. **Permanence** refers to the durability of an object. **Tangibility,** derived from the Latin word for touch, refers to the substantiality of an object. Traditional sculpture, made of stone, metal, or wood, was intended to last for millennia. And, indeed, the solid black granite used in *Qennefer, Steward of the Palace* (9.40) has changed little since the statue was completed over 3,000 years ago. This sculpture is both tangible and permanent.

9.40 *Qennefer, Steward of the Palace*, c. 1450 B.C.
Black granite.

9.41 Dale Chihuly, *Jerusalem Wall of Ice*, 1999. 54 ft (16.46 m).

Jerusalem Wall of Ice (9.41), by American glass artist Dale Chihuly, was equally massive and tangible when first constructed in October 1999. Ice, however, is an unstable material. Erected outside the walls of the old city of Jerusalem, the 54-foot-long wall quickly melted in the hot, dry air. Designed to symbolize a melting of tensions between Israelis and Palestinians, the wall was tangible but impermanent.

Presence/Absence

Presence is another crucial aspect of physicality. When we actually confront a massive sculpture such as the Olmec portrait (7.38, page 7-12), it exudes a strength that is far beyond anything a small photograph can convey. Equally, the space surrounding a sculpture or the **absence** of an anticipated object can have great impact.

Many sculptors have used this quality of presence and absence to explore the passage of time and the nature of memory. British sculptor Rachel Whiteread explores presence and absence in many of her works. Using hundreds of gallons of cement to create a solid cast from an empty house, she creates a sense of absence by making the space within the house very solidly present (9.42). In his *Writing on the Wall* series, Shimon Attie used slide projections to remind us of shops and families destroyed during the Holocaust. Figure 9.43 shows one of the many slides from the 1930s that he projected onto a wall in Berlin. The actual bookstore depicted disappeared long ago.

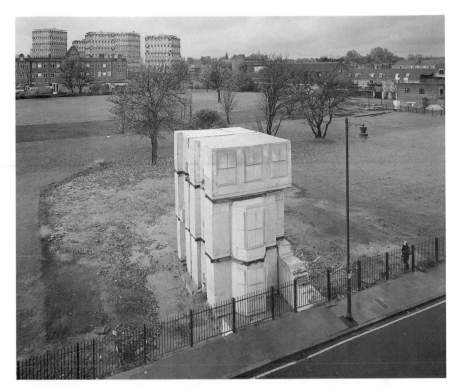

9.42 Rachel Whiteread, *House*, 1993. Commissioned by Artangel Trust and Beck's (corner of Grove Rd. and Roman Rd., London, destroyed 1994).

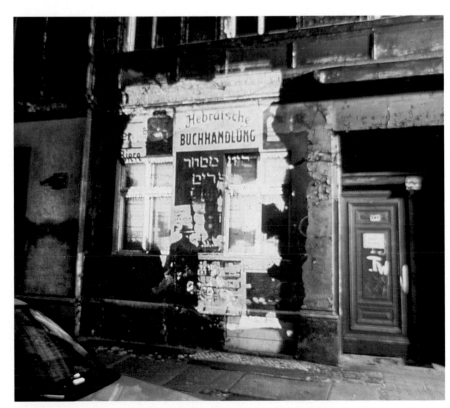

9.43 Shimon Attie, *Almstadtstrasse 43 (formerly Grenandierstrasse 7): Slide projection of former Hebrew bookstore, Berlin*, 1930, from the series *The Writing on the Wall*, **1992.** Ektacolor print of site-specific slide-projection installation, 20 × 24 in. (50.8 × 60.9 cm).

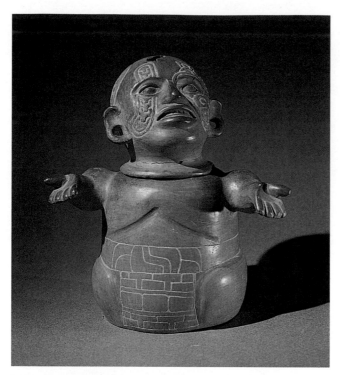

9.44 **Covered Effigy Jar with Removable Head. From Teotihuacan, Mexico.** Ceramic, 10¾ in. (27.3 cm).

9.45 **Antoine Pevsner, *Torso*, 1924–26.** Construction in plastic and copper, 29½ × 11⅝ × 15¼ in. (74.9 × 29.4 × 38.7 cm).

Cerebral Qualities of Sculptural Objects

The combination of tangible material and aesthetic complexity gives sculpture a unique power. Like an alchemist, the sculptor transforms ordinary materials into conceptual gold. Tadashi Kawamata's pile of wood becomes a metaphor for urban change. In Mierle Ukeles' *Ceremonial Arch*, the gloves and lightbulbs used by sanitation workers are transformed into a sculpture. Scraps of metal become a garden in John Chamberlain's *The Hedge* and *The Privet*. Through a miracle of invention, the best sculptures simultaneously embrace and transcend their physical nature.

Building on a Tradition

As we study art history, we find that a remarkable range of ideas has been made manifest in physical form. Traditional sculpture has been characterized by four qualities.

- **Mass,** or solid substance, rather than open space, is the primary concern. Traditional sculptures, such as Michelangelo's *Pietà* (see 9.4, page 9-2), are relatively solid. In this masterpiece, a sense of profound resignation is created through the use of gravity. The mother has fully accepted her grief. The position of the limbs and the folds in the fabric create a dynamic surface on a stable pyramidal mass.

- The human figure is the primary subject. Sculptors have long sought to capture in wood, metal, or stone the vitality of a living person.

- As a means to this end, traditional sculpture is overwhelmingly representational. Indeed, attention to detail and the ability to animate marble has long been one of the hallmarks of Western sculpture, from the Renaissance to Romanticism. Even a less detailed pre-Columbian effigy jar (9.44) gains simple eloquence using a representational approach.

- Traditional sculptures tell stories. Public monuments have often been commissioned by kings or by communities of ordinary people to tell national stories. For example, the Statue of Liberty, designed to embody the democratic ideal shared by France and the United States, was financed through a public lottery, theatrical events, art exhibitions, and even prize fights. The poem describing "huddled masses yearning to breathe free" combined with the heroic figure distills the history of immigration to America into a few words.

Reinventing Sculpture

In Europe these four aspects of traditional sculpture reached their climax during the nineteenth century. Seeking fresh ideas and new approaches, artists in Russia, Italy, and France then began a process that would transform sculpture forever. Four major changes followed.

- Space, rather than mass, became a major concern. As shown in Antoine Pevsner's *Torso* (9.45), sculpture began to be constructed from the inside out rather than being carved from the outside in.

- Abstraction and transformation became more important than description and representation. For example, Raymond Duchamp-Villon's *The Great Horse* (9.46), constructed from a mix of organic and mechanical parts, bears little resemblance to an actual horse.

- While the human figure continued to dominate early twentieth-century sculpture, by midcentury almost any subject matter could be used. Indeed, many significant artworks from this period, including Mark de Suvero's *Ik Ook Eindhoven* (see 7.18, page 7-6), are **nonobjective,** without external subject matter. Weight, balance, and the dynamics of space are the only content such works require.

- Sculptors began to break down the traditional separation between art and life. Commonplace objects, such as Marcel Duchamp's *Bicycle Wheel* (9.47), were placed in galleries and defined as art.

9.46 Raymond Duchamp-Villon, *The Great Horse*, 1957 version of a 1914 work. Bronze, 39¼ × 24 × 36 in. (99.7 × 60.9 × 91.4 cm).

9.47 Marcel Duchamp, *Bicycle Wheel*, 1951. (Third version, after lost original of 1913). Assemblage, metal wheel, 25½ in. (63.8 cm) diameter, mounted on painted wood stool 23¾ in. (60.2 cm); overall 50½ × 25½ × 16⅝ in. (128.3 × 63.8 × 42 cm).

9.48 *Stonehenge* (aerial view), Salisbury Plain, England, c. 2800–1500 B.C.

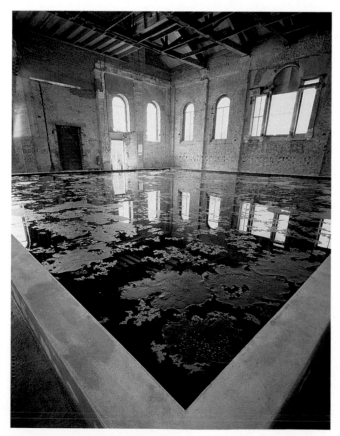

9.49 Glen Onwin, *Nigredo*, 1992. Installation view of exhibition *As Above, So Below,* at the Square Chapel, Halifax, 9 May–15 June, 1992. Exposed timbers of the roof reflected in an artificial concrete pool filled with black brine and wax.

Contemporary Questions, Contemporary Answers

The evolution of sculpture has accelerated in the past 30 years. **Earthworks,** which transform natural sites into sculptural settings, have become a powerful force in both art and ecology. An **installation,** which may combine time, space, and sound, can present both artist and audience with new opportunities for communication and expression. **Performance art** (which is discussed at greater length in Chapter 12), combines art, technology, and theater. The traditional has become the transformative. Four of the manifestations of change are described below.

Sculpture as Place

Traditionally permanent, sculpture has always been placed in a wide variety of significant settings. *Stonehenge* (9.48), constructed from massive limestone blocks weighing up to 50 tons, may have been used as a gigantic sundial by its Neolithic builders. The avenue approaching the stone circle is carefully aligned to the summer solstice while stones within the circle are aligned with the northernmost and southernmost path of the rising moon.

Likewise, contemporary sculptors add meaning to their work by exploring the physical, psychological, and temporal characteristics of each site. Glen Onwin's *Nigredo* (9.49) is one of four works in a series titled *As Above, So Below.* Placed in an abandoned chapel, this concrete pool, filled with water, black brine, and wax, seems especially ominous in the once-sacred site. The personal and the political are combined in Karen Giusti's *White House/ Greenhouse* (9.50). Placed in Battery Park in New York City, the transparent one-quarter scale model of the White House had both Wall Street and the Statue of Liberty in the background. Made of recycled steel beams, clear vinyl, and large paintings on Plexiglas, the structure presented a scathing commentary on American politics while simultaneously providing a greenhouse for 200 rosebushes.

Sculpture as Journey

As sculptures have expanded in size, the manner in which the viewer enters, exits, and explores the site

has become increasingly important. When the audience participates, a sculpture can be transformed from an object into an experience.

Christopher Janney's *Sonic Plaza* (9.51) at Eastern Carolina University is an especially enticing example. Composed of four distinct sculptures, the site offers a wide range of sensory experiences to the viewer. Various melodic sounds greet participants at the *Sonic Gates*. The 64 water jets on the *Percussion Water Wall* spew forth complex patterns of water to a percussive accompaniment. Four additional sculptures emerge from the large doors of the *Media Glockenspiel* each day. And, the cloud of water vapor created by *Ground Cloud* hovers over the plaza, responding to pedestrian movement and wind direction.

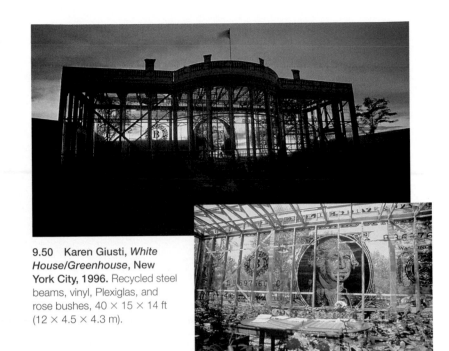

9.50 Karen Giusti, *White House/Greenhouse*, New York City, 1996. Recycled steel beams, vinyl, Plexiglas, and rose bushes, 40 × 15 × 14 ft (12 × 4.5 × 4.3 m).

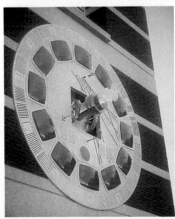

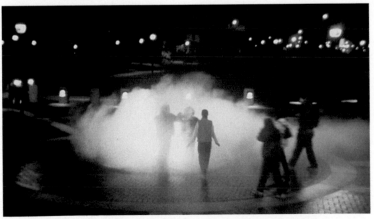

9.51 Christopher Janney, *Sonic Plaza*, Eastern Carolina University, 1998. Sound, light, water, and interactive elements, total length 400 ft (122 m). Top row, left to right: *Sonic Gates* and *Percussion Water Wall*; bottom row, left to right: *Media Glockenspiel* and *Ground Cloud*.

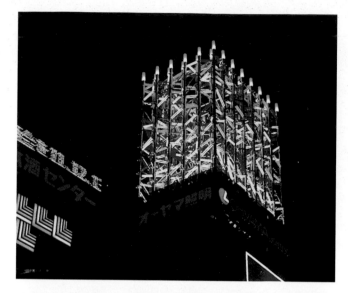

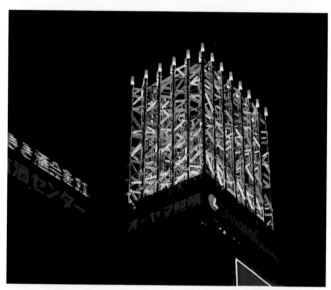

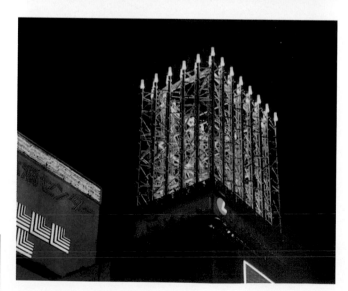

Sculpture as Time

A fascination with time pervades contemporary sculpture. Many sculptures demonstrate the changes that occur as time passes. The amount, frequency, and means of change vary widely. Placed atop the corporate offices of a lighting company, Fumaki Nakamura's *Light Communication* (9.52) presents a simple metamorphosis in a spectacular way. The 88 neon poles gradually illuminate the interior of the structure in three 30-second cycles. The beauty of the light combined with the hypnotic sequence of change simultaneously animates and illuminates the night sky.

Sculpture is also used to demonstrate the impermanence that is an essential characteristic of time. To create *curcuma sul travertino* (9.53), Shelagh Wakely covered the entrance hall to a British school with a thin layer of yellow turmeric spice. As visitors passed through the room, they gradually erased the dust. Thus, during the week-long exhibition, visitors were marked by their passage through the room, and with spice on their shoes, they subsequently marked each new room they entered.

Time itself is the subject of Jim Campbell's *Digital Watch* (9.54). An ominous ticking noise accompanies the installation. On the massive screen, viewers see themselves twice: in real time to the left of the clock and in a two-second delay on the clock face itself. The repetition and delay create a disturbing psychological effect. The persistent sound of the watch freezes time with each tick, while pushing time forward in a relentless pattern.

Sculpture as Self

It has often been said that all artwork is autobiographical. This is especially true of sculpture. As the physical manifestation of thought, sculpture has an immediacy similar to that of a living person.

Both traditional and contemporary sculptors have explored this theme in many marvelous ways.

9.52 Fumaki Nakamura, *Light Communication*, Oyama Lighting. Installed at Ginza 4-chome (main intersection). Eighty-eight poles on a box frame with 400 flashing lamps and projection lights underneath, front 26 ft 3 in. w. × 19 ft 8 in. d. × 29 ft 4 in. h. (8 × 6 × 12 m). Neon tube total length 546 ft 2 in. (1500 m).

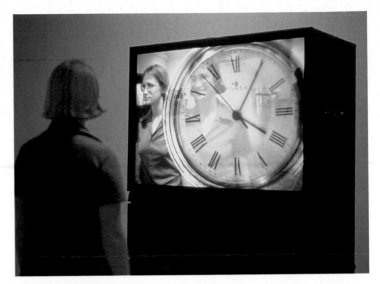

9.54 Jim Campbell, *Digital Watch*, 1991. Watch, camera, video cameras, electronics. Dimensions variable.

9.53 Shelagh Wakely, *curcuma sul travertino*, 1991. Turmeric powder on travertine marble floor (smell of turmeric filled the space), swept up after 3 weeks, 46 ft × 11 ft 6 in. (14 × 3.5 m).

9.55 *Maori Meeting House*, called "Rautepupuke," New Zealand, 1881. 56 ft × 13 ft 10 in. (17 × 4 m).

The indigenous people of New Zealand, the Maori, have often combined sculpture with architecture to create a genealogical self-portrait. The face of a prominent ancestor is placed on the front gable of the sacred meeting house (9.55). The ridge at the top of the roof is his backbone, the rafters form his ribs, and the four corner posts represent his arms and legs. Faces of other ancestors are carved on the exterior of the building and on interior posts. Finally, carvings of the Earth Mother and Sky Father are placed over the porch. Through a combination of representation and symbolism, every aspect of the building is designed to honor the past and inspire the present people.

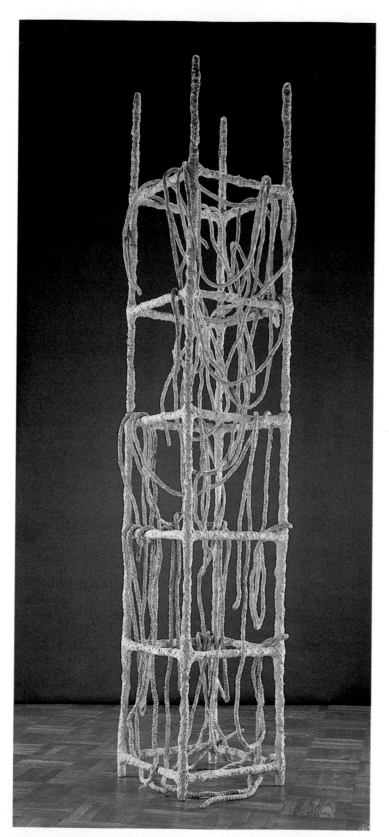

9.56 Eva Hesse, *Laocoön*, 1966. Acrylic paint, cloth-covered cord, wire, and papier-mâché over plastic plumber's pipe, bottom 130 × 23½ × 23 in. (330.2 × 59.7 × 58.4 cm), top 130 × 21½ × 21½ in. (330.2 × 54.6 × 54.6 cm).

Eva Hesse's *Laocoön* (9.56) is a more abstract self-portrait. As noted in Chapter Seven, the ancient Greek sculpture *Laocoön and His Two Sons* (see 7.23, page 7-7), depicts a scene from the Trojan War. Laocoön warns against accepting the large wooden horse the Greeks offer as a gift. The Greek goddess Athena sends two serpents to attack and kill Laocoön, thus gaining entry into Troy and victory in battle for the Greeks hidden in the horse.

Like the snakes that bind Laocoön and his sons, the cords in Hesse's sculpture are messengers of death. They choke the ladder structure and foreshadow Hesse's own death at age 34 from a brain tumor. As she noted, "My life and art have not been separated."[1]

Cornered (9.57), by Adrian Piper, offers a very different self-portrait. Piper, who identifies herself as African American, calmly discusses racial classifications in the 17-minute video, noting the prevalence of mixed ancestry in all Americans. Beginning with the statement, "I'm black. If you feel that my letting you know that I'm not white is making an unnecessary fuss, you must feel the right and proper course of action for me to take is to pass for white." In this installation, Piper's self-identity turns into a social statement.

Attention's Loop (9.58A–B), by Elizabeth King, offers yet another type of self-portrait. In this installation, six highly detailed mannequins are presented in a variety of poses. Carefully articulated arms and hands in three additional display cases line the back wall of the gallery, while an 11-minute video loop animates the mannequins. The combination of supreme craftsmanship, robotic machinery, and the fluid animation communicate a complex range of ideas. The mannequins are both fascinating and disturbing. It appears that human consciousness has been trapped in the mannequin's body.

9.57 Adrian Piper, *Cornered*, 1988. Seventeen-minute video installation with table, lighting, and birth certificates.

Expressing Ideas in Physical Form

Over the past century, the range of ideas, materials, and approaches used by sculptors has expanded. Any concept is now fair game, from the most personal to the most political. To express such complex ideas, contemporary sculptors use a wide range of materials and fully exploit the physical forces of gravity, tension, torsion, compression, and expansion. By exploring the meaning as well as the structural strength of each material, the sculptor can increase the conceptual complexity of each artwork.

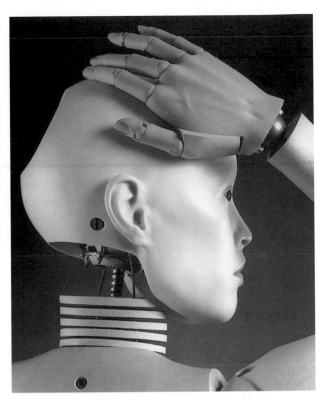

A

9.58A and B Katherine Wetzel (photograph), Elizabeth King (sculpture), *Pupil* from *Attention's Loop,* 1987–90. Installation at the Bunting Institute, Radcliffe College, 1997. Porcelain, glass eyes, carved wood, brass. One-half life size.

B

Profile:
Rick Paul, Sculptor
Physical, Virtual, and Cerebral

Rick Paul is a professor in the Department of Visual and Performing Arts at Purdue University and chairperson of the Art and Design division. Paul has been involved with foundations design courses throughout the entire 30 years of his teaching career, and for 10 years, he was foundations design coordinator at Purdue.

Paul received his BFA in sculpture from the University of Florida and his MFA in sculpture from Pennsylvania State University. During the 1980s, he made room-sized architectural installations, including exhibitions at The Contemporary Arts Center, Cincinnati; The Cultural Center, Chicago; The Fort Wayne Museum of Art; and The Institute of Contemporary Art, Philadelphia. In 1992, Paul was awarded a Master's fellowship by the National Endowment for the Arts.

Paul's earliest computer work dates from 1974. It was the advent of the personal computer and CAD software that prompted him to use computers to make sculpture. His current work is almost entirely virtual but still maintains many of the characteristics of earlier, site-related sculptures. The relationship between structure and form, the use of environmental context, and the significance of symbolic substitution continue to be issues addressed by his art.

MS: How and why did you start making art?

RP: I started making art as a sophomore in college. At that time I was majoring in another creative area, chemistry, and taking art courses as electives. The first two art courses I enrolled in were photography and three-dimensional design. I enjoyed these classes so much that I continued to take at least one art course each subsequent semester. It took me five years of undergraduate school to decide my major. Once I realized that art could be as creative and challenging as the sciences, I changed my major from chemistry to art and finished my BFA in two semesters.

MS: You have been making sculpture for some 35 years. What qualities attract you to three-dimensional art and design?

RP: As a child I found building my own toys much more interesting than playing with packaged toys. The raw materials for my projects came from the neighborhood trash cans. I had a large walk-in closet full of all sorts of mechanical and electrical parts cataloged and stored in columns of shoeboxes. I was totally fascinated with the variety of materials and forms used by industry and the many ways to combine the parts.

I also made large dioramas and miniature architectural structures. These were often based on the book I was reading at the time. My father forbade me to use his

workshop and tools but that did not stop me from using them when he was not around. Looking back, I am convinced that these childhood experiences helped me to develop my intuitive sense of space and dexterity. It also led me to understand the specific physical properties of each material (strength, hardness, malleability, color, texture, grain), which every sculptor uses to advantage.

I have always enjoyed posing questions and solving complex problems. I enjoy the challenges of construction—how can I design an object which possesses structural integrity and withstands the forces of gravity? And, every sculptural question has an ideal as well as a pragmatic answer. When and where do you compromise the ideal solution to get the job done?

MS: Tell me about your creative process. How do you generate, develop, and implement an idea?

RP: My creative process starts with an initial spark—usually a response to an intriguing idea, site, material, or process. Ideas usually come from looking at an ordinary everyday experience from an unusual viewpoint. For example, my 10 years of working with Gatorfoam started with a scrap I carried with me in my truck for over a year. Occasionally I would examine it while stopped at a red light. I was convinced that it had very special properties that I could take advantage of to make very special sculptures. I was right. Gatorfoam, which is like foamcore with

a hard surface, permitted me to construct very large, light structures very easily. *Kepler's Dream* at The Contemporary Arts Center in Cincinnati (1981) was the first piece I built with this material.

My virtual objects usually start as sketches. Some of my best ideas occur when I am traveling. During travel, I am physically and psychologically free of my usual daily routine and obligations. I have time for new ideas and more freedom to explore. I would never think of going to my studio to sketch. I like to sketch while in an unrelated, contrasting environment such as a restaurant. I have a collection of napkins and paper placemats from various eating establishments from around the world. I also have a sketchbook that I carry with me. I have one simple rule for using my sketchbook: there are no rules! Drawings are combined with text and computer pseudocode. My sketchbook is a record of where my head has been and where ideas might lead me in the future. Brainstorming on paper is a great way of generating new ideas. Other methods can be applied later to develop and refine what you started.

MS: What do you do when you hit a wall?
RP: I guess I am a contrarian. Often I deliberately turn left where other people would go forward. I make a point of

searching for the less obvious. In the process I am willing to obliterate or discard an approach I've worked on for hours.

MS: Why are your pieces so big?
RP: I enjoy orchestrating the movement of the viewers through a given space. I challenge them with spaces that are inviting but are at the same time too small to occupy, are physically inaccessible or uncomfortable. I ask them to conjure what it would be like to experience these spaces. I want the images invoked within the viewers to be more stimulating than the actual experience. This is why my work is large. Then too, many of the spaces where I have exhibited are also very large.

MS: What is the importance of scale?
RP: I consider two kinds of scale when building a sculpture. The first is the scale of the work itself. How big is it relative to the viewer or space it occupies? If I use architectural elements, they are two-thirds scale. This scale makes for a more intimate environment and can provide for more information within a limited space. Rarely is the viewer aware that such elements as stairs are subhuman in scale. In this way they accept the various architectural elements as larger than they really are.

Rick Paul, *DC Object*, 1998. Virtual sculpture, wood and canvas (virtual materials), 36 × 13 × 13 ft (virtual size).

The second kind of scale is "material scale." Material scale is actually a scale range that is defined by the physical characteristics of the material. For example, corrugated cardboard works fine for small-scale constructions, but it is an unlikely material for a tiny matchbox sculpture or the construction of an object 20 feet tall. You learn what the scale range of a material is by working with it. Typically students are unaware of the potential of a material. This is why I encourage them to study and experiment with unfamiliar materials before using them.

MS: In our discussions of teaching, you talked a lot about the advantages of limitations, which can help students focus their energy and explore an idea more deeply. What are the limitations in your own work? How do you push past the boundaries?

RP: I accept the limits of a problem as a challenge rather than a hindrance. The most significant limits to creativity are self-imposed, rather than external. Humans often become inhibited with age. Many of these inhibitions are arbitrary. Knowing yourself and how to work around self-imposed limits is an important asset to creativity that takes a long time to develop.

MS: How do you compare your tangible art with your virtual objects?

RP: For me there is no boundary separating the material world from the virtual world. My work moves back and forth between the two, drawing from both. I am currently working on a series of virtual objects built for specific real environments. Compare *Object at Rest* and *DC Object*, for example. Both were conceived with a specific site in mind. They are roughly equal in size. They are made of the same materials (wood and fabric). Both were conceived as floating objects to be exhibited in an out-of-context environment. There are advantages and disadvantages to both ways of working.

MS: It is clear that you are equally committed to your teaching and your artwork. Do you have any advice for my students?

RP: Realize that there is no substitute for experience. Art and design require mastery of many skills, investigation of many emotions, and exploration of many ideas. There are no shortcuts. Persistence is much more important than talent. No matter how much talent you have, nothing will happen without a sincere and sustained commitment to your work.

Rick Paul, *Querschnitt*, 1989 installation. Gatorfoam™, wood, and fabric, 36 × 24 × 20 ft.

Top: Rick Paul, *Object at Rest,* 1994 installation. Wood and fabric, 24 × 24 × 12 ft. Bottom: Rick Paul, *Expanding History,* 2000. Virtual sculpture, wood and fabric (virtual materials) 36 × 26 × 14 ft (virtual size).

Summary

- A pile of wood at a construction site is stacked for convenience and accessiblity. A pile of wood in a sculpture is designed to communicate ideas and emotions.

- Art gains power from its connection to life. Through art, commonplace experiences are distilled, re-examined, and transformed.

- Physical and psychological boundaries can connect or separate art and life.

- A base can distinguish a sculpture from its surroundings, provide structural stability, and expand aesthetic content.

- Physical forces, such as gravity, compression, expansion, tension, and torsion, can be used to express ideas while providing structural strength.

- The materials a sculptor selects can both heighten and deepen the meaning of the artwork.

- Traditional Western sculpture is massive, representational, figurative, and narrative.

- Contemporary sculpture is generally more spatial, abstract, and nonfigurative. Many contemporary sculptors use specific sites, audience participation, temporal change, and explorations of the self to create powerful works.

Keywords

absence	gravity	presence
abstract	installation	representational
base	mass	tangibility
boundary	nonobjective	tension
compress	oxidation	torsion
condensation	pedestal	vitalistic
earthworks	performance art	weight
expansion	permanence	
filtration	plinth	

As you begin your studio work, consider:

1. How is your artwork similar to everyday life? And, what distinguishes it from everyday life?

2. Can a boundary or base add physical or conceptual strength to your work?

3. What can gravity, compression, expansion, tension, or torsion contribute to your design?

4. How would a change in material affect your artwork, both physically and conceptually?

5. What can happen when your project is placed in a specific setting?

6. What can the viewer learn or feel through an encounter with your artwork?

7. What does your artwork reveal about yourself and the world around you?

John Beardsley, *Earthworks and Beyond: Contemporary Art in the Landscape*. New York, Abbeville Press, 1998.

Jack Burnham, *Beyond Modern Sculpture: The Effects of Science and Technology on the Sculpture of This Century*. New York, George Braziller, Inc., 1968.

Nicolas de Oliveria, Nicola Oxley, and Michael Petry, *Installation Art*. Washington, DC, Smithsonian Institution Press, 1994.

Nicholas Penny, *The Materials of Sculpture*. New Haven, Yale University Press, 1993.

Arthur Williams, *Sculpture: Technique, Form, Content*. Worcester, MA, Davis Publications, Inc., 1993.

A

abstract form In film, a multiple-image structure, in which the parts are related to each other through their visual characteristics, such as shape, color, scale, or direction of movement.

abstract shape A shape that is derived from a perceptual source but is so transformed that it bears little visual resemblance to that source.

abstraction The reduction of an image or object to an essential aspect of its form or content.

accent A specific note in music that has been emphasized, or a shape, volume, color, and so on in visual art that has been emphasized. Using an accent, a designer can bring attention to a specific part of a composition and increase rhythmic variety in a pattern.

accent color A color that stands out from its surroundings. Often used to attract attention to a specific part of a design.

act A major division in a film or theatrical event. Acts are generally constructed from a group of sequences that gradually increase in intensity.

action-to-action transition In comic books, the juxtaposition of two or more panels showing a sequence of specific actions. This is the most common transition in American comic books.

actual lines Lines that are physically present in a design.

additive color Color created by combining projected beams of chromatic light. The additive color primaries are red, green, and blue; the secondaries are cyan, magenta, and yellow.

additive sculpture A physical object constructed from separate parts that have been connected using glues, joints, stitching, welds, and so on.

afterimage In visual perception, a ghostly image that continues to linger after the actual image has been removed.

amplified perspective The exaggerated use of linear perspective to achieve a dramatic and engaging presentation of the subject. Amplified perspective is often created using an unusual viewing position, such as a bird's-eye view, accelerated convergence, or some form of distortion.

analogous color A color scheme based on hues that are adjacent on a color wheel, such as red, orange, and yellow.

analogy A similarity or connection between things that are apparently separate and dissimilar. Analogies are often used to explain a difficult concept or unfamilar skill. For example, when a teacher describes wet plaster as having the "consistency of cream," she is using an analogy.

angle of framing The position of the frame in relation to the subject it shows. The frame may be above the subject, creating a bird's-eye view, straight on, or below the subject, creating a worm's-eye view. Also known as the camera angle.

anomaly An obvious break from norm in a design. Often used to emphasize an aspect of a design.

aspect-to-aspect transition In comic books, the juxtaposition of two or more panels showing different views of a single setting or event. This transition is often used in Japanese comic books.

assemblage An additive method in which the artist or designer constructs the artwork using objects and images that were originally created for another purpose. Essentially, assemblage can be defined as three-dimensional collage.

asymmetrical balance An equilibrium among visual elements that differ in size, number, weight, color, or texture. Asymmetrical balance is generally nonaxial and highly dynamic.

atmospheric perspective A visual phenomenon in which the atmospheric density progressively increases, hazing over the perceived world as one looks into its depth. Overall definition lessens, details fade, and contrasts become muted. In a landscape, a blue mist descends.

attached shadow A shadow connected to the surface of an object that defines its form through tonal modulation.

B

backlight A light source positioned behind a person or object that can create a silhouette or separate the person or object from the background.

balance An equilibrium among interacting and/or opposing forces in a visual composition.

base A horizontal support for a physical object, such as a marble block for mounting a bronze sculpture.

beat 1. A unit of musical rhythm that creates the pulse of a sound. 2. In acting, the most basic element in a story. A beat is an exchange of behavior, based on action and reaction.

boundary The point of division between objects, images, or experiences.

brainstorming Any of a number of problem-solving techniques that are designed to expand ideas and encourage creativity. List-making, mapping, associative thinking, and metaphorical thinking are common strategies used.

C

calligraphic line Derived from the Greek words for beautiful and writing, a flowing, and expressive line that is as personal as handwriting. Calligraphic lines generally vary in thickness and apparent velocity.

carving The removal of materials from a larger mass, gradually revealing an image or object. Carving is a subtractive process.

cast shadow A dark shape, created by the absence of light, that results from placement of an opaque object in the path of a light source.

categorical form In film, a multiple-image structure that is organized based on categories, or subsets, of a topic. For example, a film on Hawaii might focus first on the sea, then on the volcanoes, then on the plant life, then on indigenous animals.

causality The interrelation of cause and effect, based on the premise that nothing occurs without cause.

cause-and-effect A critique in which the viewer seeks to determine the cause for each visual or emotional effect in a design. For example, the dynamism in a design may be caused by the diagonal lines and asymmetrical balance used. Also known as formal analysis.

centrifugal balance Balance created when visual forces in a composition imply an outward expansion.

centripetal balance Balance created when visual forces in a composition imply an inward movement, suggesting a compression of space.

characteristic texture The inherent, or familiar, texture of a material. The gleaming reflective surface of a steel teapot and the gritty texture of clay are two examples.

chroma The purity, intensity, or saturation of a color.

chromatic gray A gray made from a mixture of color plus white rather than simply using black and white.

chronology The order in which events occur.

close-up In film, a type of framing in which the scale of the object shown is relatively large, as in a close-up of an actor's face.

closure The mind's inclination to connect fragmentary information in order to create a completed form. Closure is an essential aspect of Gestalt psychology.

collage An image constructed from visual or verbal fragments initially designed for another purpose.

color key A color that dominates an image and provides an overall visual or emotional effect.

compare/contrast critique A critique in which similarities and differences between two designs are analyzed. Often used in art history classes to demonstrate connections and divisions between historical periods.

comparison Recognition of similarity in two or more compositions. Often used in art history to demonstrate connections between images done by different artists or in different periods. The images being compared may be similar in balance, color, content, style, and so on.

complementary colors Hues that oppose one another on a traditional color wheel. When juxtaposed, complementary colors create contrast; when mixed, complementary colors neutralize each other, creating a variety of browns.

composition The combination of multiple parts to create a harmonious whole.

compression The forcing or crushing of material into a smaller, denser condition and its visual dynamics and implied psychological effects.

concentric balance The repetition of a boundary in diminishing size to create a bull's-eye effect. Concentric balance can harness both the expanding energy of centrifugal balance and the compressive energy of centripetal balance.

concept A well-developed thought or a comprehensive generalization.

condensation To be reduced to a denser form, as with the transition from a vapor to a liquid

cone of vision In perspective drawing, a hypothetical cone of perception originating at the eye of the artist and expanding outward to include whatever he or she wishes to record in an illusionistic image, such as a perspective drawing. The cone's maximum scoping angle is 45 to 60 degrees; anything outside of the cone of vision is subject to distortion.

connection 1. A unifying relationship in a composition. 2. A physical joining, through joints, welds, stitching, and so forth.

contact The meeting point between visual or structural elements in a design.

content The emotional and/or intellectual meaning or message of an artwork.

continuity A fluid connection among compositional parts.

contour line A line that describes the edges of a form and suggests three-dimensional volume.

contradictory texture The unfamiliar use of a texture or the addition of an unusual texture to the surface of an object. Meret Oppenheim's *Object*, a cup, plate and spoon covered with fur, is a familiar example.

contrast The degree of difference between compositional parts or between one image and another. High contrast tends to be eye-catching and is often used by graphic designers to create dynamic, highly readable images.

contrasting colors Colors that are substantially different in hue, value, intensity or temperature.

convergent thinking A problem-solving strategy in which a predetermined goal is pursued in a linear progression using a highly focused problem-solving process. Six steps are commonly used: (1) define the problem, (2) do research, (3) determine your objective, (4) devise a strategy, (5) execute the strategy, (6) evaluate the results.

critique Any means by which the strengths and weaknesses of designs are analyzed. Common strategies include comparision, description, formal analysis, and inventing alternatives.

cropping The manner in which a section of an image or a fragment of observed reality has been framed. For example, photographers select a fragment of reality every time they look through the viewfinder of the camera. Part of the scene is included, while the remainder is cut away. Photographs are often cropped further in the darkroom, leaving only the most significant information.

cross contour Multiple, curving, parallel lines running over the surface of an object horizontally and/or vertically that describe its surface configuration topographically, as in mapping. This process is much like wireframing in three-dimensional computer modeling. Cross contours can also be used in drawing to suggest three-dimensional form through tonal variation.

crosscut In film, an abrupt alternation between two or more lines of action.

cross-hatching A technique used in drawing and printmaking to shade an object using two or more networks of parallel lines. Darker values are created as the number of line networks increases.

curvilinear shape A shape whose contour is dominated by curves and flowing lines.

cut In film, the immediate change from one shot or frame to another

definition 1. The degree to which a shape is distinguished from both the ground area and from other shapes within the design. 2. The degree of resolution or focus of an entire image. Sharply focused shapes tend to advance while blurred shapes tend to recede.

denouement The outcome, solution, or point of clarification in a story.

density The extent to which compositional parts are spread out or crowded together. The visual connections that occur easily in a high-density composition are often less obvious in a low-density composition.

depth of field The range of focus in a photographic image, from foreground to background. In a photograph with great depth of field, an object that is 15 feet from the camera is in focus, as well as an object that is 5 feet from the camera.

descriptive critique A critique in which the viewer carefully describes what he or she sees when observing a design. Descriptive critiques are used to heighten awareness of visual relationships, for both the artist and the viewer.

descriptive shape A shape that is derived from specific subject matter and strongly based on perceptual reality.

diegesis The world created in a film or video.

dissolve A transition between two shots during which the first image gradually disappears while the second image gradually appears.

dissonance The absence of harmony in a composition; often created using disharmonious colors.

distribution The manner in which colors, shapes, or other visual elements are arranged within the format.

divergent thinking An open-ended, problem-solving strategy. Starting with a broad theme, the designer explores in all directions, expanding ideas in all directions.

duration 1. The length of time required for the completion of an event, as in the running time of a film, video, or performance; 2. the running time of events depicted in the story (plot duration); 3. and the overall span of time the story encompasses (story duration).

dynamic Energetic, vigorous, forceful; creating or suggesting change or motion.

E

earthwork An artwork that has been created through the transformation of a natural site into an aesthetic statement.

editing In film, selecting and sequencing the details of an event to create a comprehensive whole.

elevation In orthographic projection, the front, back, and side views of an object or architectural structure.

emotional advertising Use of emotion to sell a service, product, or idea. This strategy is often used when a product is neither unique nor demonstrably better than a competing product.

emphasis Special attention given to some aspect of a composition, which gives it prominence.

exaggerated advertising Pushing an idea to an extreme to make a point.

expansion The extending outward of a material to fill more space.

eye level In linear perspective, the eye level is determined by the physical position of the artist. Sitting on the floor creates a low eye level while standing at an easel creates a higher eye level. Also known as the horizon line. All vanishing points in one- and two-point perspective are positioned on the eye level.

F

fade A gradual transition used in film and video. 1. Fade-in: commonly, a dark screen that gradually brightens as a shot appears. 2. fade-out: a shot that gradually darkens until the screen goes black.

fidelity The degree of connection between a sound and its source. For example, when we hear the sound of a helicopter and see a helicopter on the screen, the sound matches with the image, creating close fidelity.

figure The primary or positive shape in a design; a shape that is noticeably separated from the background. The figure is the dominant, advancing shape in a figure-ground relationship.

figure/ground reversal An arrangement in which positive and negative shapes alternatively command attention. Also known as positive and negative interchange.

fill light In cinematic and theatrical lighting, a diffused light that is used to decrease contrast between light and dark areas.

filtration The process of separating a solid from a liquid by passing it through a porous substance such as cloth, charcoal, or sand.

flashback In film, an alternation in chronology in which events that occur later in a story are shown first.

floodlight A softly defined light with a broad beam.

form 1. The physical manifestation of a design as opposed to the content, or the idea behind a design. 2. The organization or arrangement of visual elements to create a unified art form.

format The type of shape used for the outer edge of a design.

frame A single static image in film or video.

freestanding sculpture Sculpture that is self-supporting and is designed to be viewed from all sides.

function The purpose of a design or the objective that motivates the designer. For an industrial designer, the primary purpose of a design is often utilitarian. For example, he or she may be required to design a more fuel-efficient automobile. For a sculptor, the primary purpose of a design is aesthetic: he or she seeks to create an artwork that engages the viewer emotionally and philosophically. However, a sculpture, like an automobile, must be physically well-constructed, and a car, like a sculpture, must have aesthetic appeal.

fusion The combination of shapes or volumes along a common edge.

G

geometric shape A shape derived from or suggestive of mathematics. Geometric shapes are characterized by crisp, precise edges and mathematically consistent curves.

gestalt A German word for "form." A complete configuration that we perceive through psychological closure. This configuration is more complete than the sum of its parts. In a gestalt, all elements operate in relation to the whole.

gesture drawing A vigorous drawing that captures movement and the overall orientation of an object, rather than describing specific detail. Often used as a basis for figure drawing.

gloss 1. In writing, words of explanation or translation inserted into a text. 2. A secondary text within a manuscript that provides comments on the main text.

gradation Any gradual transition from one color to another or from one shape or volume to another. In drawing, shading created through the gradation of grays can be used to suggest three-dimensional form.

graphic relationship In film, the juxtaposition of two or more separate images that are compositionally similar. For example, a graphic relationship can be created when a basketball is shown in the first panel, an aerial view of the round free-throw zone is shown in the second, and the hoop of the basket itself is shown in the third.

gravity The force that tends to pull all bodies toward the center of the Earth.

grid A visual or physical structure created from intersecting parallel lines. A grid can provide the compositional framework for a design.

grisaille A gray underpainting, often used by Renaissance artists, to increase the illusion of space.

group In sequential structure, a collection of images that are related by subject matter, composition, or source.

gutter In bookbinding, the center line of a book, where the two pages meet.

Happening An assemblage of improvised, spontaneous events performed by the artist and audience alike, based on a general theme. There is no rehearsal, and any location, from a parking lot to a factory interior, can be used. The Happening is most commonly associated with Allan Kaprow and is a precursor to performance art.

hard-sell advertising An advertising approach in which a major point is presented in a clear, direct manner. The narrative is usually linear, and the message is usually explicit.

harmony A pleasing or soothing relationship among colors, shapes, or other design elements.

hatching A technique used in drawing and printmaking to shade using a range of gray tones created from multiple parallel lines.

high definition Sharply focused visual information that is highly readable.

horizon line In linear perspective, the line on which all vanishing points are positioned. More accurately described as the eye line or eye level.

hue The name of a color, such as red or yellow, that distinguishes it from others and assigns it a position in the visual spectrum and on the color wheel.

humorous advertising Use of humor to sell a service, product, or idea. By entertaining the viewer, the designer can make the product memorable.

illusionary space The representation of an object or scene on a two-dimensional surface so as to give it the appearance of three-dimensionality.

implied line 1. A line that is suggested by movement or by a gesture rather than being physically drawn or constructed. 2. A line that is suggested by the positions of shapes or objects within a design. With either form of implied line, the viewer mentally connects the points.

installation art An artwork or a design that presents an ensemble of images and objects within a three-dimensional environment.

intensity 1. The purity, saturation, or chroma of a color. For example, fire engine red is a high-intensity color, while brick red is a low intensity color. 2. In theater, the power, concentration, and energy with which an action is performed or the quality of observation of an event.

interdisciplinary art The combination of two or more different disciplines to create a hybrid art form.

interdisciplinary thinking Use of skills and knowledge from more than one discipline.

in the round A three-dimensional object that is self-supporting and is designed to be viewed from all sides, as in freestanding sculpture.

joint A physical connection between elements or parts in a three-dimensional object. Some joints are fixed, such as ones that are bolted together, while others can be moved, as with a hinge or a ball-and-socket joint.

junction 1. A conceptual intersection between ideas or events. 2. A physical intersection between elements or parts in a three-dimensional object.

key light The primary source of illumination used by filmmakers and set designers.

kinesthetic Bodily perception of position, balance, movement, tension, and so on.

kinetic form A static form that suggests motion or a form that actually moves.

lap dissolve In film, a dissolve in which two shots are temporarily superimposed.

layers of space Separating compositional space into foreground, middle ground, and background to intensify expressive possibilities and spatial complexity.

line 1. A point in motion. 2. A series of adjacent points. 3. A connection between points. 4. An implied connection between points. Line is one of the basic elements of design.

linear perspective A mathematically based system for projecting the apparent dimensions of a three-dimensional object onto a two-dimensional surface called the picture plane. Developed by artists during the Renaissance, linear perspective is one strategy for creating the illusion of space.

long shot In film, a type of framing in which the scale of the subject shown is relatively small, as with an image of a human figure within a landscape.

loudness The amplitude of a sound wave; the strength of a sound.

low definition Blurred or ill-defined visual information that is difficult to read.

maquette A well-developed, three-dimensional model, comparable to a two-dimensional thumbnail sketch.

mass A volume that has weight, density, and bulk.

medium shot In film, a type of framing in which the scale of the subject shown is of moderate size, as in a view of an actor from the waist up.

metaphor A figure of speech in which one thing is directly linked to another dissimilar thing. Through this connection, the original word is given the qualities of the linked word. For example, when we say, "she's a diamond in the rough," we attribute to a woman the qualities of an unpolished gem.

meter The basic pattern of sound and silence in music or of positive and negative in design.

model In three-dimensional design, a model is a technical experiment or a small-scale version of a larger design.

modeling An additive sculptural process by which a plastic material is formed into an artwork or design.

moment-to-moment transition In comic books, a transition in which a character or situation is simply being observed over time. This transition is often used in Japanese comic books but rarely in American comic books.

monochromatic color system A color system based on variations in a single hue. For example, a light, pastel blue, a medium navy blue, and a dark blue-black may be used in a monochromatic design.

myth A traditional story collectively composed by many members of a society. The creation of the world, sources of evil, the power of knowledge, and even the nature of reality may be explained through these grand expressions of the imagination.

negative shape 1. Any clearly defined area around a positive shape; the receding shape or ground area in a figure-ground relationship. 2. A shape created through the absence of an object rather than through the presence of an object.

nonobjective shape Circles, squares, and other shapes that are not based on a specific perceptual source.

non-sequitur transition In comic books, the juxtaposition of two or more frames or shots that have no obvious conceptual relationship.

objective criticism The assessment of strengths and weaknesses in a design based on the visual information presented. Essentially, objective criticism focuses on the ways in which lines, shapes, textures, volumes, and so forth are combined to create a cohesive whole.

one-point perspective A form of linear perspective in which the lines receding into space converge at a single vanishing point on the eye level or horizon line.

opponent theory An explanation for the electric glow that occurs when two complementary colors are placed side by side.

organic shape A shape based on forms from the natural world or suggestive of living organisms. Also known as biomorphic shape.

orientation The angle at which a visual element is positioned.

orthographic projection A drawing system widely used by artists and designers to delineate the top, bottom, and four side views of a three-dimensional object. Orthographic means "true picture." Unlike perspective drawing, which is designed to create the illusion of space, an orthographic projection is constructed using parallel lines that accurately delineate the object.

overlap Placement of one shape in front of another to create the illusion of space.

oxidation A common form of chemical change used in creating a patina, or colored surface, on a metal sculpture.

P

panel A single frame in a comic book.

pattern A design composed of repeated elements that are usually varied to produce interconnections and implied movement.

pedestal A vertical support for a sculptural object.

performance art A live presentation which may combine elements from a variety of art forms, such as film, video, theater, and dance.

permanence The degree of durability, or resistance to decay, in a given material or design.

perspective A graphic system used to create the illusion of space on a two-dimensional surface.

picture plane The flat surface on which an artist creates a pictorial image.

pitch In music, the relative highness or lowness of a sound. Pitch is determined by wave frequency, as compression and expansion occur within the sound wave.

plane In three-dimensional design, an area with measurable width and height. Shapes that have been combined to create three-dimensional structures are called planes.

plan view The bottom view of a three-dimensional object or architectural structure, drawn orthographically or freehand.

plinth A horizontal support for a sculptural object.

polyhedra Multifaceted volumes, such as tetrahedrons.

positive shape The principal or foreground shape in a design; the dominant shape or figure in a figure-ground relationship.

primary colors Colors from which virtually all other colors can be mixed. The additive (or light) color primaries are red, green, and blue. The subtractive (or pigment) color primaries are yellow, magenta red, and cyan blue.

primary contour The outer edges of a physical object, such as the extremities of a carved sculpture.

principles of design The strategies most commonly used by artists and designers to unify disparate visual information into a cohesive whole, including balance, emphasis, rhythm, and proportion.

proportion A comparative relationship between the parts to a whole. For example, in figure drawing, the model's head is often compared to the overall height of the body.

prototype A well-developed model, as with the fully functional prototype cars developed by automobile companies.

proximity The distance between the parts of a structure or between an object and the audience.

R

radial symmetry A form of balance that is created when shapes or volumes are mirrored both vertically and horizontally, with the center of the composition acting as a focal point.

rational advertising A type of advertising in which logic and comparisons of quality are used to sell a service, product, or idea. A rational approach is most effective when the message is compelling in itself or the product is truly unique.

realistic advertising Use of a familiar setting or situation to involve the viewer and relate a product, service, or idea to use in everyday life.

rectilinear shape A shape whose edges are created by straight lines and angular corners.

relief Sculpture in which forms project out from a flat surface. The degree of projection ranges from low to high relief.

repetition The use of the same visual element or visual effect a number of times in the same composition. Can be used to increase unity in a

composition, produce a rhythmic movement, or emphasize the importance of a visual idea.

representation The lifelike depiction of persons or objects.

representational shape A shape that is derived from specific subject matter and strongly based on perceptual reality.

rhetorical form In filmmaking, a type of sequential organization in which the parts are used to create and support an argument. Often used in documentary films.

rhythm 1. The repetition of multiple parts in a composition to create a pattern of sound and silence, positive and negative, or other contrasting forces. 2. In filmmaking, the perceived rate and regularity of sounds, shots, and movement within the shots. Rhythm is determined by the beat (pulse), accent (stress), and tempo (pace).

rhythmic relationship The juxtaposition of multiple images to create a deliberate pulse or beat.

S

saturation The purity, chroma, or intensity of a color.

scale A size relationship between two separate objects, such as the relationship between the size of Mount Rushmore and a human visitor to the monument.

scene In film, continuous action in continuous time and continuous space.

scene-to-scene transition In comic books, the juxtaposition of two or more frames showing different scenes or settings.

scope Conceptually, the extent of our perception or the range of ideas our minds can grasp. Temporally, scope refers to the range of action within a given moment.

screenplay The written blueprint for the film; commonly constructed from multiple acts.

secondary colors Hues mixed from adjacent primaries. In paint, the secondary colors are violet, green, and orange.

secondary contour The inner edges of a physical object, such as the internal design and detailing of a carved sculpture.

section In orthographic projection, a slice of an object or architectural structure that reveals its internal structure and detail.

sequence 1. In filmmaking, a collection of related shots and scenes that comprise a major section of action or narration. 2. In narrative structure, any collection of images that have been organized by cause and effect. In a simple sequence, action number two is caused by action number one. In a complex sequence, there may be a considerable delay between the cause and the effect.

series In sequential structure, a collection of images that are simply linked together, as with cars in a train.

serious advertising Advertising that treats a topic in a somber or solemn manner. Often used for public service announcements, such as drunk driving commercials.

setting In time design, the physical and temporal location of a story, the props and costumes used in a story, and the use of sound.

shade A hue that has been mixed with black.

shading In drawing, a continuous series of grays that are used to suggest three-dimensionality and to create the illusion of light.

shape A flat, enclosed area created when 1. A line connects to enclose an area. 2. An area of color or texture is defined by a clear boundary. 3. An area is surrounded by other shapes.

shot In film, a continuous group of frames.

sidelight A light positioned to the side of a person or object. Can be used to increase the sense of dimensionality.

sight line 1. In perspective, a viewing line that is established by the arrangement of objects within one's field of vision. 2. A straight line of unimpeded vision.

simile A figure of speech in which one thing is linked to another dissimilar thing using the word *like* or *as*. Through this connection, the original word is given the qualities of the linked word. For example, when we say, "He's as strong as a lion," we attribute to a man the strength of an animal.

simultaneous contrast The optical alteration of a color by a surrounding color. For example, when a square of blue is placed on a yellow background, the blue appears dark and cool. The same blue will appear much lighter when it is placed on a black background.

soft-sell advertising An advertising approach that uses emotion, rather than reason, to sell a service, product, or idea. The narrative is often nonlinear, and ideas or actions may be implied.

space One of the basic elements of three-dimensional design. The distance between images or points in a design. The artist/designer physically contains and thus defines space when constructing a three-dimensional object.

spatial relationship In film making, the juxtaposition of two or more images that are spatially different, such as a close-up, a medium shot, and a long shot.

split complementary A complementary color plus the two colors on either side of its complement on the color wheel.

spotlight A light that produces a small, clearly defined beam.

static An equilibrium of forces. In design, a composition that is at rest or an object that appears stationary.

style The distinctive artistic treatment of an image or idea.

subject The person, object, event, or idea on which an artwork is based.

subjective criticism The assessment of strengths and weaknesses in a design based on nonobjective criteria, such as the narrative implications of an idea, the cultural ramifications of an action, or the personal meaning of an image.

subject-to-subject transition In comic books, the juxtaposition of two or more frames showing different subject matter.

subtractive color Color created when light is selectively reflected off a pigmented or dyed surface. For example, when an object is painted red, the molecular makeup of the red pigment absorbs (subtracts) all of the spectral light except the red wavelength, which is reflected back to the viewer's eyes. The subtractive primaries are yellow, magenta red, and cyan blue.

subtractive sculpture Any process by which an artist or designer removes materials from a larger mass, gradually revealing the form within.

symbolic color A color that has been assigned a particular meaning by the members of a society. For example, in the United States, the white color of a wedding gown symbolizes purity, while in Borneo it symbolizes death.

symmetrical balance A form of balance that is created when shapes are mirrored on either side of an axis, as in a composition that is vertically divided down the center.

tactile texture Texture that can be felt physically.

take In film or video, one version of an event.

tangibility The substantiality of an object or the degree to which an object or a force can be felt.

temperature The physical and psychological heat generated by a color.

tempo The pace at which music and time-based art occur. A fast tempo is generally used in action films while a slow tempo is usually used in a dramatic film.

temporal relationship How the shots in a film relate in time.

tension The distortion of an object through stretching or bending.

tertiary color A hue that is mixed from a primary color and an adjacent secondary color.

testimonial advertising Use of a trustworthy character or celebrity to provide endorsement for a product, service, or idea.

texture The surface quality of a two-dimensional shape or a three-dimensional volume. Texture can be created visually, using multiple marks; physically, through surface variation; or through the inherent property of a specific material, such as the texture of sand as opposed to the texture of polished glass.

three-point perspective A form of linear perspective in which the lines receding into space converge at two vanishing points of the eye level (one to the left of the object being drawn and one to the right of the object being drawn), plus a third vanishing point above or below the eye level. Used when the picture plane must be tilted to encompass an object placed above or below the eye level.

three-quarter work A physical object that is designed to be viewed from the front and sides only.

timbre The unique sound quality of each instrument. For example, a note of the same volume and pitch is quite different when it is generated by a trumpet rather than a violin.

tint A hue that has been mixed with white.

tone A hue that has been mixed with black and white.

torsion The distortion of an object through a twisting movement.

transition The process of changing from one state or form to another. For example, the surface of a metal sculpture as it shifts from a smooth to a rough surface or the manner in which a computer drawing morphs from one form to another.

triadic harmony A color scheme based on three colors that are equidistant on a color wheel.

tromp l'oeil A French term meaning "to fool the eye." A flat illusion that is so convincing the viewer believes the image is real.

two-point perspective A form of linear perspective in which the lines receding into space converge at two vanishing points of the eye level (or horizon line), one to the left of the object being drawn and one to the right of the object being drawn. Used when the object being drawn is placed at an angle to the picture plane.

typestyle The distinctive quality of the letterforms within a given font. For example, Helvetica type has a very different look than Palatino type.

unity The oneness, or wholeness, in a design that occurs when all parts work together to create a cohesive whole.

value 1. The lightness or darkness of a color. 2. The relative lightness or darkness of a surface.

value scale A range of grays that are presented in a mathematically consistent sequence.

vanishing point In linear perspective, the point or points on the eye level at which parallel lines appear to converge.

variety The differences that give a design visual and conceptual interest; notably, use of contrast, emphasis, differences in size, and so on.

visual book An experimental structure that conveys ideas, actions, and emotions using multiple images in an integrated and interdependent format. Also known as an artist's book.

visual texture 1. A surface treatment that simulates an actual physical texture. 2. Any covering of a surface with multiple marks.

visual weight 1. The inclination of shapes to float or sink based on their solidity and compositional location. 2. The relative importance of a visual element within a design.

vitalistic sculpture A sculpture that appears to embody life in an inanimate material, such as plastic, stone, or wood.

volume 1. In three-dimensional design, a volume is an enclosed area of three-dimensional space. 2. In two-dimensional design, basic volumes such as cubes, cones, and spheres are created through the illusion of space. 3. In time design, volume refers to the softness or loudness of a sound.

volume summary A drawing that communicates visual information reductively, using basic volumes, such as sphere, cubes. and cylinders to indicate the major components of a figure or object.

walk-through work An artwork or a design that presents an ensemble of images and objects within a three-dimensional environment. The viewer must walk through the space in order to experience the artwork fully.

weight The visual or physical heaviness of an object.

wipe In film, a transition in which the first shot seems to be pushed off the screen by the second. Wipes were used extensively in *Star Wars*.

Introduction

Books Consulted

Berger, Arthur Asa. *Seeing Is Believing: An Introduction to Visual Communication*, 2nd ed. Mountain View, CA: Mayfield Publishing Company, 1998.

Berger, John. *Ways of Seeing*. London: British Broadcasting Corporation, 1987.

Conran, Terance. *Terance Conran on Design*. Woodstock, NY: The Overlook Press, 1996.

Dondis, Donis. *A Primer of Visual Literacy*. Cambridge, MA: MIT Press, 1973.

Myers, Jack Fredrick. *The Language of Visual Art: Perception as a Basis for Design*. Orlando, FL: Holt, Rinehart and Winston, 1989.

Chapter Four

Works Cited

1. Mihaly Csikszentmihalyi, *Creativity: Flow and the Psychology of Discovery and Invention*, (New York: HarperCollins), pp. 55–76.
2. George Prince, "Creativity and Learning as Skills, Not Talents," *The Philips Exeter Bulletin*, June–October 1980.
3. Anne Lamott, *Bird by Bird: Some Instructions on Writing and Life* (New York: Anchor Books, 1998), pp. 18–19.

Books Consulted

Bayles, David; and Ted Orlando. *Art & Fear: Observations on the Perils (and Rewards) of Art Making*. Santa Barbara, CA: Capra Press, 1993.

Bohm, David. *On Creativity*. New York: Routledge, 2000.

Briggs, John. *Fire in the Crucible: Understanding the Process of Creative Genius*. Grand Rapids, MI: Phanes Press, 2000.

Csikszentmihalyi, Mihaly. *Creativity: Flow and the Psychology of Discovery and Invention*. New York: HarperCollins, 1996.

Dewey, John. *Art as Experience*. New York: Capricorn Books, 1958.

Gardner, Howard. *Art, Mind and Brain: A Cognitive Approach to Creativity*. New York: Basic Books, 1982.

Gardner, Howard. *Creating Minds: An Anatomy of Creativity Seen Through the Lives of Freud, Einstein, Picasso, Stravinsky, Eliot, Graham, and Gandhi*. New York: Basic Books, 1993.

Gardner, Howard. *Frames of Mind: The Theory of Multiple Intelligences*. New York: Basic Books, 1985.

Lamott, Anne. *Bird by Bird: Some Instructions on Writing and Life*. New York: Anchor Books, 1998.

LeBoeuf, Michael. *Imagineering: How to Profit from Your Creative Powers*. New York: McGraw-Hill, 1980.

Shekerjian, Denise. *Uncommon Genius: How Great Ideas Are Born*. New York: Penguin Books, 1991.

Wallace, Doris B.; and Howard E. Gruber, eds. *Creative People at Work*. New York: Oxford University Press, 1989.

Chapter Five

Works Cited

1. Keith A. Smith, *Structure of the Visual Book* (Fairport, NY: The Sigma Foundation, 1991), pp. 17–18.
2. Henry M. Sayre, *A World of Art*, 3rd ed. (Upper Saddle River, NY: Prentice Hall, 2000), p. 496.

Books Consulted

Adams, James L. *Conceptual Blockbusting*. Reading, MA: Addison-Wesley, 1986.

de Bono, Edward. *Lateral Thinking*. London: Ward Educational Limited, 1970.

Grear, Malcolm. *Inside/Outside: From the Basics to the Practice of Design*. New York: Van Nostrand Reinhold, 1993.

Johnson, Mary Frisbee. *Visual Workouts: A Collection of Art-Making Problems*. Englewood Cliffs, NJ: Prentice Hall, 1983.

Lakoff, George; and Mark Johnson. *Metaphors We Live By*. Chicago: University of Chicago Press, 1981.

Shahn, Ben. *The Shape of Content*. Cambridge, MA: Harvard University Press, 1957.

Von Oech, Roger. *A Kick in the Seat of the Pants*. New York: Harper and Row, 1963.

Von Oech, Roger. *A Whack on the Side of the Head*. New York: Harper and Row, 1986.

Chapter Six

Works Cited

1. Henry M. Sayre, *A World of Art*, 3rd ed. (Upper Saddle River, NY: Prentice Hall, 2000), pp. 298–99.

Books Consulted

Barnet, Sylvan. *A Short Guide to Writing About Art*, 6th ed. Reading, MA: Addison-Wesley Longman, 2000.

Barrett, Terry. *Criticizing Photographs: An Introduction to Understanding Images*, 2nd ed. Mountain View, CA: Mayfield Publishing Company, 1996.

Ocvirk, Otto G.; Robert E. Stinson; Philip R. Wigg; Robert O. Bone; and David L. Cayton. *Art Fundamentals: Theory and Practice*, 9th ed. New York: McGraw-Hill Companies, 2002.

Sayre, Henry M. *Writing About Art*, 3rd ed. Upper Saddle River, NJ: Prentice Hall, 1999.

Smagula, Howard, ed. *Re-visions: New Perspectives of Art Criticism.* Englewood Cliffs, NJ: Prentice Hall, 1991.

Tucker, Amy. *Visual Literacy: Writing About Art.* Burr Ridge, IL: McGraw-Hill Companies, 2002.

Chapter Seven

Works Cited

1. John Beardsley, *Earthworks and Beyond: Contemporary Art in the Landscape* (New York: Abbeville Press, 1998), p. 31.
2. Jonathan Fineberg, *Art Since 1940: Strategies of Being* (Englewood Cliffs, NJ: Prentice Hall, 1995), p. 383.
3. Alexander Theroux, *The Primary Colors: Three Essays* (New York: Henry Holt and Company, 1994), p. 86.
4. Theroux, op. cit., p. 6.

Books Consulted

Bachelard, Gaston. *The Poetics of Space.* Maria Jolas, trans. Boston: Beacon Press, 1969.

Ching, Frank. *Architecture: Form, Space, and Order*, 2nd ed. New York: Van Nostrand Reinhold, 1996.

Hibbard, Howard. *Masterpieces of Western Sculpture from Medieval to Modern.* New York: Harper and Row, 1980.

Lidstone, John. *Building with Wire.* New York: Van Nostrand Reinhold, 1972.

Wallschlaeger, Charles; and Cynthia Busic-Snyder. *Basic Visual Concepts and Principles for Artists, Architects and Designers.* Dubuque: William C. Brown, 1992.

Wong, Wucius. *Principles of Form and Design.* New York: Van Nostrand Reinhold, 1993.

Zelanski, Paul; and Mary Pat Fisher. *Shaping Space: The Dynamics of Three-Dimensional Design,* 2nd ed. Orlando, FL: Harcourt, Brace and Company, 1995.

Chapter Eight

Books Consulted

Andrews, Oliver. *Living Materials: A Sculptor's Handbook.* Berkeley, CA: University of California Press, 1988.

Dormer, Peter; and Ralph Turner. *The New Jewelry: Trends and Traditions.* London: Thames and Hudson, 1985.

Fong, Wen, ed. *The Great Bronze Age of China.* New York: The Metropolitan Museum of Art and Alfred A. Knopf, 1980.

Frantz, Suzanne. *Contemporary Glass: A World Survey from the Corning Museum of Glass.* New York: Harry N. Abrams, 1989.

Johnson, Paul. *Pop-Up Paper Engineering.* Bristol: Taylor & Francis, 1992.

Lane, Peter. *Ceramic Form: Design and Decoration.* rev. ed. New York: Rizzoli International Publications, 1998.

Lewin, Susan Grant. *One of a Kind: American Art Jewelry Today.* New York: Harry N. Abrams, 1994.

Lynn, Martha Dreyer. *Clay Today: Contemporary Ceramists and Their Work.* Los Angeles: Los Angeles County Museum of Art and San Francisco: Chronicle Books, 1990.

Miller, Bonnie J. *Out of the Fire: Contemporary Glass Artists and Their Work.* San Francisco: Chronicle Books, 1991.

Stern, Rudi. *Contemporary Neon.* New York: Retail Reporting Corporation, 1990.

Wong, Wucius. *Principles of Form and Design.* New York: Van Nostrand Reinhold, 1993.

Chapter Nine

Works Cited

1. Lucy R. Lippard, *Eva Hesse* (New York: New York University Press, 1976), p. 5.

Books Consulted

Beardsley, John. *Earthworks and Beyond: Contemporary Art in the Landscape*. New York: Abbeville Press, 1998.

Burnham, Jack. *Beyond Modern Sculpture: The Effects of Science and Technology on the Sculpture of This Century*. New York: George Braziller, 1968.

Hammacher, A. M. *Modern Sculpture: Tradition and Innovation*. New York: Harry N. Abrams, 1988.

Koplos, Janet. *Contemporary Japanese Sculpture*. New York: Abbeville Press, 1991.

Manzini, Ezio. *The Material of Invention: Materials and Design*. Cambridge, MA: The MIT Press, 1989.

Oliveria, Nicolas de; Nicola Oxley; and Michael Petry. *Installation Art*. Washington, DC: Smithsonian Institution Press, 1994.

Penny, Nicholas. *The Materials of Sculpture*. New Haven, CT: Yale University Press, 1993.

Schmidt, Jeremy; and Laine Thorn. *In the Spirit of Mother Earth: Nature in Native American Art*. San Francisco: Chronicle Books, 1994.

Sculpture Inside Outside. Introduction Martin Friedman. Essays by Douglas Dreishpoon, Nancy Prinenthal, Carter Ratcliff, Joan Simon. Profiles of the Artists by Peter W. Boswell and Donna Harkary. New York: Rizzoli International Publications, 1988.

Selz, Peter Howard. *Barbara Chase-Riboud, Sculptor*. New York: Harry N. Abrams, 1999.

Waldman, Diane. *Transformations in Modern Sculpture: Four Decades of American and European Art*. New York: The Solomon R. Guggenheim Foundation, 1985.

Watson-Jones, Virginia. *Contemporary American Women Sculptors*. Phoenix, AZ: Oryx Press, 1986.

Williams, Arthur. *Sculpture: Technique, Form, Content*. Worcester, MA: Davis Publications, 1993.

Wyatt, Gary. *Spirit Faces: Contempoary Native American Masks from the Northwest*. San Francisco: Chronicle Books, 1994.

General Art Historical Sources

Arnason, H. H. *History of Modern Art, Painting, Sculpture, Architecture,* 3rd ed. New York: Harry N. Abrams, 1986.

Fineberg, Jonathan. *Art Since 1940: Strategies for Being.* Englewood Cliffs, NJ: Prentice Hall, 1995.

Maltin, Leonard. *Of Mice and Magic: A History of American Animated Cartoons.* New York: New American Library, 1980.

Newhall, Beaumont. *The History of Photography: From 1839 to the Present Day.* 5th rev. ed. New York: Museum of Modern Art, 1982.

Preble, Duane; Sarah Preble; and Patrick Frank. *Artforms: An Introduction to the Visual Arts,* 6th ed. Reading, MA: Addison-Wesley Educational Publishers, 1999.

Sayre, Henry M. *A World of Art,* 3rd ed. Upper Saddle River, NJ: Prentice Hall, 2000.

Schneider-Adams, Laurie. *Art Across Time,* 2nd ed. New York: McGraw-Hill Companies, 2002.

Stokstad, Marilyn. *Art History, Volumes One and Two.* New York: Harry N. Abrams, 1995.

Thompson, Kristin; and David Bordwell. *Film History: An Introduction.* New York: McGraw-Hill, 1994.

Townsend, Richard F., ed. *The Ancient Americas: Art from Sacred Landscapes.* Chicago: The Chicago Art Institute, 1992.

The 20th Century Art Book. New York: Phaidon Press, 1996.

Wallis, Brian, ed. *Art After Modernism: Rethinking Representation.* New York: New Museum of Contemporary Art, 1984.

Chapter 6

Chapter 7

7.38, SuperStock, Inc.

7.39, Staatliche Museen, Berlin. Photo © Bildarchiv Preussischer Kulturbesitz.

7.40, Solomon R. Guggenheim Museum, NY, by exchange 1967 (67.1862). © Estate of David Smith/Licensed by VAGA, NY. Photo: David Heald, © Solomon R. Guggenheim Museum Foundation, NY.

7.41, Photo: © 1991 Dirk Bakker.

7.42, Collection, University of Illinois at Urbana, Champaign. Photo courtesy of the artist © Alice Aycock 1994.

7.43, Los Angeles County Museum of Art, Gift of Howard and Gwen Laurie Smits. Photo © 2002 Museum Associates/LACMA.

7.44, Albright-Knox Art Gallery, Buffalo, NY, gift of Seymour H. Knox, 1966.

7.45, Holly Solomon Gallery, NY. Photo: Peter Aaron, Esto Photographics.

7.47, Courtesy Dia Center for the Arts and Walter De Maria. Photo: John Cliett.

7.48, Museum of Indian Arts and Culture/Laboratory of Anthropology, Museum of New Mexico, Santa Fe. Photo: Doug Kahn.

7.49, Los Angeles County Museum of Art, Gift of Howard and Gwen Laurie Smits. Photo © 2002 Museum Associates/LACMA.

7.50, Dept. of Archaeology and Anthropology, University of Ibadan/The Bridgeman Art Library. Photo: Heini Schneebeli.

7.51, Photo: Dirk Bakker.

7.52, Collection: Staatliches Museum fur Volkerkunde, Munich. Photo: S. Autrum-Rulzer.

7.53, Los Angeles County Museum of Art, Gift of Howard and Gwen Laurie Smits. Photo © 2002 Museum Associates/LACMA.

7.54, Edition of Six. Courtesy Alexander and Bonin, NY. Photo: Orcutt & Van Der Putten.

7.55, Courtesy of Gallery Nii, Ginza, Tokyo.

7.56, Private collection. Courtesy of the artist.

7.58, Courtesy Fisher-Price.

7.59, Courtesy of Toshiyuki Kita/IDK Design Laboratory, LTD, Japan.

7.60, Courtesy George J. Sowden/ Milan Pacific.

7.61, Courtesy Michael Graves & Associates. Photo: William Taylor.

7.64, Collection, Whitney Museum of American Art, NY. Purchase, with funds from the Louis and Bessie Adler Foundation, Inc., Seymour M. Klein, President, the Gilman Foundation, Inc., the Howard and Jean Lipman Foundation, Inc., and the National Endowment for the Arts (79.4). © The George and Helen Segal Foundation /Licensed by VAGA, NY. Photo: Duane Preble.

7.65, Museo del Templo Mayor, Mexico City. Instituto Nacional de Antropologia e Historia (INAH). Photo: Gabriel Figueroa Flores.

7.67, Corning Museum of Glass, Corning, NY (84.3.234).

7.69, Photo courtesy Inuit Gallery of Vancouver Ltd. Photo: Kenji Nagai.

7.71A–B, Chesterwood Museum Archives. Chesterwood, a National Trust Historic Site, Stockbridge, MA. Photo: De Witt Ward, by order of the sculptor in 1922, to demonstrate lighting problems in the memorial.

7.72, Designers: Bill Cannan, Tony Ortiz, H. Kurt Heinz. Design Firm: Bill Cannan & Co. Client/Mfr: NASA Public Affairs.

7.73, Busch Lobby, MIT Permanent Collection, gift of the Albert and Vera List Family Collection. Photo: Julia Fahey.

7.74, Courtesy Lance Fung Gallery, NY.

7.75, Courtesy Barbara Gladstone.

Chapter 8

8.1, Solomon R. Guggenheim Museum, NY, purchased with funds contributed by the Louis and Bessie Adler Foundation, Inc., Seymour M. Klein, President, 1985 (85.3276). Photo: David Heald, © Solomon R. Guggenheim Museum Foundation, NY.

8.3, Courtesy of Humanscale, NY.

8.4, St. Peter's, Rome. Canali Photobank, Milano, Italy.

8.5, Santa Maria degli Angeli, Rome. © Mauro Magliani/SuperStock, Inc.

8.6, Transparency 2104(2) Courtesy Department of Library Services, American Museum of Natural History.

8.7, Collection Kröller-Müller, Otterlo, The Netherlands.

8.8, Client/Mfr: Corona Clipper Co.

8.9, Collection: Hokkaido Asahikawa Museum of Art, Asahikawa City, Hokkaido, Japan. Photo: Yasunori Ookura.

8.10, Solomon R. Guggenheim Foundation, NY, Peggy Guggenheim, Venice (76.2553.50). © 2001 Artists Rights Society (ARS), NY/ADAGP, Paris. Photo: David Heald, © Solomon R. Guggenheim Museum Foundation, NY.

8.11, Partial gift of the Arts Club of Chicago; restricted gift of various donors, through prior bequest of Arthur Rubloff; through prior restricted gift of William Hartmann; through prior gifts of Mr. and Mrs. Carter H. Harrison, Mr. and Mrs. Arnold H. Maremont through the Kate Maremont Foundation, Woodruff J. Parker, Art Institute of Chicago. © 2001 Artists Rights Society (ARS), NY/ADAGP, Paris. Photo © 2001 Art Institute of Chicago. All rights reserved.

8.12, Museum of Modern Art, NY, given anonymously. © 2001 Artists Rights Society (ARS), NY/ADAGP, Paris. Photo © 2002 Museum of Modern Art, NY.

8.13, Photo © Fratelli Alinari/SuperStock, Inc.

8.14, Museum of Modern Art, NY. Purchase. © 2001 Artists Rights Society (ARS), NY/ADAGP, Paris. Digital image © 2001 Museum of Modern Art, NY.

8.15, Collection: Edition 1, Museo Nacional Centro de Arte Reina Sofia, Madrid. Edition 2, Los Angeles County Museum of Art; Modern and Contemporary Art Council Fund. Photo: Gary McKinnis.

8.16, Commissioned by the port city of Algeciras, Spain.

8.17, Ministero degli Esteri, Rome. © Canali Photobank.

8.18, Courtesy the National Ornamental Metal Museum, Memphis, TN. Collection of the artist. Photo: Seth Tice-Lewis.

8.19, © 2001 Artists Rights Society (ARS), NY/ADAGP, Paris. Photo © CNAP Command Publique, Ministère de la Culture, Paris.

8.20, © 2001 Artists Rights Society (ARS), NY/ADAGP, Paris/FLC. Photo: Ezra Stoller © Esto Photographics.

8.21, Nelson Atkins Museum of Art, Kansas City, MO, gift of the Hall Family Foundation (F99-33/1 a-dd). © Magdalena Abakanowicz/Licensed by VAGA, NY/Marlborough Gallery, NY. Photo: E. G. Schempf.

8.22, Photo: Don Hamilton, Spokane, WA.

8.23, Installation: San Francisco Museum of Modern Art. Courtesy Paula Cooper Gallery, NY.

8.24, Courtesy Mary Boone Gallery.

8.25, Installation: Capp Street Project, S. F. Courtesy Alexander and Bonin, NY. Photo: Ben Blackwell.

8.26, © 2001 Artists Rights Society (ARS), NY/ADAGP, Paris. Photo © Bernard Bansee/SuperStock, Inc.

8.27, Private collection.

8.28, Museum fur Kunst und Gewerbe, Hamburg.

8.30, Musée d'Orsay, Paris. Reunion des Musees Nationaux/Art Resource, NY. Photo: Herve Lewandowski.

8.31, Collection Walker Art Center, Minneapolis. Acquired with Lannan Foundation support in conjunction with the exhibition *Sculpture Inside Outside*, 1991.

8.32, Solomon R. Guggenheim Museum, NY, gift, Mr. and Mrs. Sidney Singer, 1977 (77.2325.a-.bbbb) © 2001 Estate of Louise Nevelson/Artists Rights Society (ARS), NY. Photo: Robert E. Mates, © Solomon R. Guggenheim Museum Foundation, NY.

8.33, Courtesy Agnes Gund Collection. © The Joseph and Robert Cornell Memorial Foundation/Licensed by VAGA, NY.

8.34, Museo National de Antropologia y Arqueologia, Lima. Photo: © 1991 Dirk Bakker.

8.35, Photo: © 1996 Don Pitcher/Alaska Stock.com.

8.37A, Wright State University, Dayton, OH. Photo: Susan Zurcher.

8.38, Product: Cleret™ Glass Cleaner. Client/Mfr: Hanco.

8.39, Courtesy Artimede.

8.41, Collection Majorie & Arnold Platzker. Photo: Tom Vinetz.

8.42, Kunstindustrimuseet I Oslo, (Museum of Decorative Arts & Design) Norway. Photo: Teigens Fotoatelier AS.

8.43, Art Institute of Chicago, Grant J. Pick Purchase Fund (1967.386). © 2001 Artists Rights Society (ARS), NY/VEGAP, Madrid. Photo © 2001, Art Institute of Chicago. All rights reserved. Photo: Michael Tropea, Chicago.

8.44, Courtesy of the Artist and Spacetime C. C.

8.46, Collection: Detroit Institute of Arts, Detroit, MI. Courtesy of the artist. © 2001 Sol LeWitt/Artists Rights Society (ARS), NY.

8.47, Albright-Knox Art Gallery, Buffalo.

8.48, Raymond Loewy International Group Ltd., London.

8.49, UCLA Fowler Museum of Cultural History (X64-395a-c). Photo: Don Cole.

8.50, Photo: Timothy Hursley/The Arkansas Office.

Chapter 9

9.1, © George Glod/SuperStock, Inc.

9.2, Photo: Shigeo Anzai, Tokyo.

9.3, Temporary Installation, New York Public Library, 1998. Courtesy Ronald Feldman Fine Arts, NY. Photo: Dennis Cowley.

9.4, Saint Peter's Basilica, Vatican, Rome. Photo: Copyright Alinari/Art Resource, NY.

9.5, Left to right: Private collection, Collection Martha Schwartz; Collection Oakland Museum of Art. Photo: Mark Johann.

9.6, Private collection. Photo: M. Mimlitsch-Gray

9.7, Courtesy of Michele Oka Doner. Collection of the Art Institute of Chicago.

9.8, With permission Gianfranco Frattini. Courtesy Acerbis International SPA, Milan, Italy.

9.9, University of California, Berkeley Art Museum. Photo: Benjamin Blackwell.

9.10, Kukje Gallery, Chrong Ku, Seoul, Korea.

9.11, Near Charlotte, NC. Copyright Maya Lin. Landscape Architect and Photo: Henry Arnold.

9.12, Private collection. © The George and Helen Segal Foundation /Licensed by VAGA, NY.

9.13, Courtesy of the artists and New Langton Arts.

9.14, BLUE SKIES 1990 (installation view) © Susan Trangmar.

9.15, Photo: Yoshiki Nakano.

9.16, On loan to The Philadelphia Museum of Art, Philadelphia, PA.

9.17, Metropolitan Museum of Art, Bequest of Mrs. H. O. Havemeyer, 1929. The H.O. Havemeyer Collection. Photo © Metropolitan Museum of Art.

9.18, Giovanni e Paolo, Venice. Bridgeman Art Library.

9.19, Philadelphia Museum of Art, the Louise and Walter Arensberg Collection (50-134-18). © 2001 Artists Rights Society (ARS), NY/ADAGP, Paris. Photo: Graydon Wood, 1994.

9.20, Museum of Modern Art, NY, Acquired through the Lillie P. Bliss Bequest. Photo © 2002 Museum of Modern Art, NY.

9.21, National Geographic Society Headquarters, Washington, DC. Photo: Steve Raymer/NGS Image Collection.

9.23, Collection Rothko Chapel, Houston, dedicated to Reverend Martin Luther King, Jr. © 2001 Barnett Newman Foundation/Artists Rights Society (ARS), NY.

9.24, Courtesy of P.P.O.W., NY.

9.25, Courtesy of the artist. © Beverly Pepper/Licensed by VAGA, NY/Marlborough Gallery, NY.

9.26, Collection of Denver Art Museum, Denver, CO, gift of Ginny Williams. Courtesy Joseph Helman Gallery, NY (BH 1912). Photo: Edward Smith.

9.28, Photo: Colophon & Robert Witanowski.

9.29, Courtesy Jay Jopling Gallery/White Cube, London. © Antony Gormley. Photo: Antti Kuivalainen.

9.30A, © 2001 John Chamberlain/Artists Rights Society (ARS), NY. Photo: Ellen Page Wilson, courtesy Pace Wildenstein.

9.30B, © 2001 John Chamberlain/Artists Rights Society (ARS), NY. Photo: Ellen Page Wilson, courtesy Pace Wildenstein.

9.31, Installation at SITE Santa Fe, 1999. Photo: Herbert Lotz Photography.

9.33, Courtesy Sonnabend Gallery, NY.

9.34, Corning Museum of Glass, Corning, NY (86.4.180).

9.35, Photo © Copyright The British Museum.

9.36, Collection Caltrans, City of Los Angeles, San Diego Freeway Northbound, Mulholland Drive Exit. Los Angeles.

9.37, © 2001 Artists Rights Society (ARS), NY/VG Bild-Kunst, Bonn. Photo © Hans Haacke.

9.38, © Ronald Dahl. Assistance provided by Minneapolis College of Art.

9.39, Waterworks Gardens: The Grotto. Lorna Jordan © 1996.

9.40, Photo © Copyright The British Museum.

9.41, © Dale Chihuly.

9.42, Photo: John Davies.

9.43, Courtesy Jack Shainman Gallery, NY. © 2001 Artists Rights Society (ARS), NY/VG Bild-Kunst, Bonn.

9.44, Image # 1448(4) American Museum of Natural History, NY.

9.45, Museum of Modern Art, NY. Katherine S. Dreier Bequest. © 2001 Artists Rights Society (ARS), NY/ADAGP, Paris. Photo © Museum of Modern Art, NY.

9.46, Art Institute of Chicago, gift of Margaret Fisher in memory of her parents, Mr. and Mrs. Walter L. Fisher (1957.165), view 1. Photo © 2001 Art Institute of Chicago. All rights reserved. Photo: Robert Hashimoto.

9.47, Museum of Modern Art, NY. The Sidney and Harriet Janis Collection. © 2001 Artists Rights Society (ARS), NY/ADAGP, Paris/Estate of Marcel Duchamp. Photo © Museum of Modern Art, NY.

9.48, © Skyscan Balloon Photography.

9.49, Courtesy of the Henry Moore Foundation and the artist. Photo: Jerry Hardman-Jones.